Critical Acclaim for Lev Raph*

"A maliciously funny campus myst
escaped academic, Lev Raphael ha
ous recall of the entertaining world he left
behind."

—*New York Times Book Review*

"A witty, fast-paced mystery that is also a
hilarious send-up of academia at its quietly
snarling worst."

—*Booklist*

"Nick's smart-alecky sensibility wedded to his
evident love of literature give this novel its
deliciously wicked appeal."

—*Washington Post Book World*

"Darkly amusing… sneaky, subversive fun."

—*Publishers Weekly*

"Do yourself a favor. Curl up with a box
of assorted chocolates and *Little Miss Evil*.
Indulge!"

—*Tikkun*

"A joy throughout, thanks to heroes with
brains, heart, and nerves to spare."

—*Kirkus Reviews*

"Lev Raphael skewers academic pretensions
with wicked glee and Dickensian flair. Few
writers are as adept at lampooning academic
inanity."

—*Chicago Sun-Times*

Tropic of Murder

Also by Lev Raphael

Nick Hoffman Mysteries
 Let's Get Criminal
 The Edith Wharton Murders
 The Death of a Constant Lover
 Little Miss Evil
 Burning Down the House

Fiction
 Dancing on Tisha B'Av
 Winter Eyes
 The German Money

Nonfiction
 Edith Wharton's Prisoners of Shame
 Journeys & Arrivals

Co-Authored
 Dynamics of Power
 Stick Up for Yourself!
 Teacher's Guide to Stick Up for Yourself
 Coming Out of Shame

Tropic of Murder

A NICK HOFFMAN MYSTERY

Lev Raphael

PERSEVERANCE PRESS · JOHN DANIEL & COMPANY
PALO ALTO / MCKINLEYVILLE, CALIFORNIA

This is a work of fiction. Characters, places, and events are the product of the author's imagination or are used fictitiously. Any resemblance to real people, companies, institutions, organizations, or incidents is entirely coincidental.

A Perseverance Press Book
Published by John Daniel & Company
A division of Daniel & Daniel, Publishers, Inc.
Post Office Box 2790
McKinleyville, California 95519
www.danielpublishing.com/perseverance

Book design by Eric Larson, Studio E Books, Santa Barbara
www.studio-e-books.com

Cover painting by Patricia Chidlaw

10 9 8 7 6 5 4 3 2 1

LIBRARY OF CONGRESS CATALOGING-IN-PUBLICATION DATA
Raphael, Lev.
 Tropic of murder : a Nick Hoffman mystery / by Lev Raphael.
 p. cm.
 ISBN 1-880284-68-5 (pbk. : alk. paper)
 1. Hoffman, Nick (Fictitious character)—Fiction. 2. Americans—Caribbean
Area—Fiction. 3. College teachers—Fiction. 4. English teachers—Fiction.
5. Caribbean Area—Fiction. 6. Michigan—Fiction. 7. Gay men—Fiction.
I. Title.
 PS3568.A5988T76 2005
 813'.54—dc22
 2003028300

To Philippe Bourguignon,

who helped make this book possible

The Cast

In Michiganapolis at SUM
 Nick Hoffman, professor of English composition
 Stefan Borowski, his partner & writer-in-residence
 Juno Dromgoole, Canadian Studies professor
 Serena Fisch, acting chair of their department
 Peter de Jonge, graduate student in their department
 Byron Summerscale, ex-chair of a defunct department
 Rusty Dominguez-St. John, professor
 Cash Jurevicius, adjunct professor
 Avis and Auburn Kinderhoek, professors of creative writing
 Dulcie Halligan, secretary in their department
 Merry Glinka, provost of SUM
 Tyler Mooney-Mauser, her assistant

On Serenity Island
 Bruno Zaragossa, manager of the Club Med resort
 Anouchka Warmerdam, Club Med staffer
 Vincent Pereira, Club Med staffer
 Dominique Grosbisous, French literary critic
 Clovis Frescobaldi, her lover and a novelist
 Claire de Jonge, Peter de Jonge's wife
 Franklin Pierce, her father
 Heath Wilmore, Pierce's assistant
 Campbell Scott, chief of security

"Amer savoir, celui qu'on tire de voyage."
(Travel teaches bitter lessons.)

—Baudelaire, *"Le Voyage"*

Prologue:

The Man of La Mancha

I WAS a nice Jewish boy who had gone astray.

No, I wasn't an alcoholic, or a convert—or even a neo-conservative. My errant path was criminal; that is, I had unfortunately been involved in some crimes at the State University of Michigan (SUM).

I'd grown up in New York City when it was dirty and dangerous, and in my mind, Michigan had always seemed bucolic, pristine. Yet despite never having been mugged in New York, or even witnessed a mugging, in scenic Michigan I'd encountered murder not once but several times.

I'd helped solve the murder cases, not that it was remotely my job to do so. Though I loved reading mysteries and was getting ready to teach a mystery course, I was basically a composition professor, so crimes against the English language were supposed to be my beat. And despite my unexpected forensic success at SUM, the administrators weren't remotely grateful, because I'd been part of news stories that threw the mud of bad publicity at our particular ivory tower.

Like vampires, universities don't do so well in bright sunlight. Whether the administrators liked it or not, though, and whether I did, I had stumbled into becoming a middle-aged amateur sleuth, the kind of figure you tend to find only in novels. Mystery novels, at that. Pretty déclassé.

For my parents, this accidental avocation was as disappointing as my chosen career path. My mother and father were Belgian Jews who had escaped Europe before the Holocaust, but lost most of their families, and in their quiet, critical eyes, I had not made enough of myself.

While my parents hadn't been hidden during the war, or deported to concentration camps, they had escaped Hitler's grasp and they felt like survivors, which made me in some sense a child of survivors, or 2G as it's called: Second Generation. So the burden on me to make my parents happy and proud—to erase all their losses—was larger than usual for Jewish children, who generally have all their ancestors as well as most of the non-Jewish world watching their progress, which can leave them with a macro-chip on their shoulders.

Like other 2G kids, I had to somehow make the Holocaust go away. I'd authored a book, sure, but it was only a bibliography, and of Edith Wharton, whom my parents had barely heard of despite their deep respect for literature. To them, Wharton was a minor Henry James with pearls.

My father was actually the publisher of a fine luxury art press like Rizzoli, though much smaller, which made my poky, fat bibliography even more disappointing to him, despite the fact that it helped scholars and students around the world. It catalogued and summarized everything that had ever been written about Wharton in every language, but even though it had taken me five years to finish, to my parents the "bib" was even less compelling than a road atlas. My mother had leafed through it dispiritedly, saying, "So many numbers," like a gardener softly despairing of eradicating persistent weeds. As for my author's photo, she merely glanced at it and glanced away.

They never really said it was a letdown. They didn't have to. I knew. Expectation was the air I breathed from the doctor's first slap that set me wailing. If I could have spoken at that moment after birth, I probably would have said, "Okay, okay! I'm doing the best I can! Give me a chance!"

The list of silent accusations vulturing around me was substantial. I'd written an insignificant book. I hadn't gone into my father's business. I hadn't committed myself to carrying on his legacy. I had taken a job in the upper Midwest, which to my cultured, multilingual parents might as well have been Bulgaria. Make that rural Bulgaria. In the twelfth century. I wasn't married and I wasn't going to supply them with grandchildren that they could share complaints about me with.

And if my strange mix of obscurity and notoriety weren't bad enough, to my own surprise, I had just agreed to do some private investigation for Peter de Jonge, a graduate student who needed help and was offering information in return.

We'd had a very strange semester at SUM. The university was talking seriously about a Whiteness Studies Program; the new provost had appointed "ambassadors" to each college in the university, who would in effect spy on departmental meetings and report back to her; the knives were out again in my department in the race for chair, which involved two friends of mine and one wild card; I'd been mysteriously roughed up and threatened; my colleague and cohort Juno Dromgoole was rammed in her car and wound up in an emergency room. It wasn't an accident.

Peter de Jonge, a graduate student in EAR, had come to see me and hinted that all these events were connected in some way (like a bad thriller, I guess), and said he wanted me to investigate something going on in Neptune, the small college town he lived and worked in, an hour and a half south of us. It sounded like a *quid pro quo*: I helped him out, he'd explain what was really going on at SUM. My partner, Stefan, a child of Holocaust survivors, had taken to Peter because of his background. Peter's Dutch parents were the only ones in both families to survive the Holocaust, but having been hidden during World War II, they stayed hidden even in America, keeping their Jewish identity secret and instilling terrible fear in their son. It seemed ironic or at least sad that he had become a psychologist and was a counselor at Neptune College, where he helped students with their problems, and no one knew who he really was, not even his wife.

Peter was staring at me right now in my living room, wide-eyed with gratitude and surprise because I'd accepted the deal, even though it didn't make much sense. I guess I was following the advice from an Auden poem: "Leap before you look."

I confess I stared back a little at Peter, or tried not to. It wasn't his Dutch good looks, it was the way, at fortyish, that he seemed costumed as someone half his age: Fubu parka, white T-shirt under a baggy Abercrombie & Fitch flannel shirt, and baggy jeans. Though he wasn't visibly pierced or tattooed, he did have the sideburns, soul patch, and wool hat pulled down almost to his eyebrows of countless college students. And he looked very out of place in a large airy room that was very traditionally furnished. The first time my cousin Sharon had seen the room, she said, "'Father Knows Best' marked you for life, didn't it?"

A long silence had followed my signing on to Peter's proposal, and finally he said, "Thank you."

"But I haven't done anything yet."

"Yes you have. I'm desperate, and there wasn't anyone else I could ask. You said yes."

And I was already regretting it. "I understand Neptune's a really small town, but couldn't you look for a real private investigator somewhere else? What about Jackson or Ann Arbor? Or Detroit?" The irony was that I had decided the main focus of my mystery course should be America's best contribution to the genre: PI novels from Raymond Chandler to Dennis Lehane.

"The Pierces, that's my wife's family, they founded Neptune. Her father is the president of Neptune College. Pierces have been mayors, state senators, you name it. They're too well connected, they know too many people around the state. They'd know what I was up to."

"Then can you be sure they haven't followed you here?" It seemed like a logical question in an illogical situation. Was I entering a paranoid fantasy, and if that was the case, was I checking in overnight or for an extended stay?

"Oh, don't worry, they'd never take you—"

"Seriously?"

He didn't blush or seem remotely embarrassed. Chin up, he nodded as if we were drunks at a bar exchanging weighty trivialities. "That's right. I know you're for real, but they wouldn't suspect I was asking you for help. They're pretty powerful, and you're just a college professor." He didn't need to add: who teaches writing. Though you'd think it's the foundation of everything else in an English department, teaching composition is considered little better than serfdom by other academics because it's so labor-intensive.

"So you do think they're following you?"

"I'm not sure."

"And your family, sorry, your wife's family is somehow connected to all the bizarre stuff that's been going on at SUM, and Juno Dromgoole's accident, and my getting threatened? They're like, what, small-town Sopranos or something?"

He didn't answer, but his silence had an edge of discomfort.

"You're not really sure about anything," I said. "Are you? You don't have evidence. And you want me to clear it up for you, right? Why aren't you tilting at your own windmills? Why hire someone?"

"I can pay you whatever you want."

I considered the offer. "You said I might still be in danger, and Juno, too."

"I didn't say that."

I thought back a moment, and realized he was right. I'd drawn that inference from what he said.

Apparently sensing my doubt, he pressed me further: "So when can you start?"

PART I:

Ship of Fools

Chapter One

I WAS planning to tell Stefan about Peter de Jonge's visit, and that I'd put Peter off at the end of it, saying I would have to think about when and how I'd start the investigation. But my intention evaporated with the bad news Stefan broke when he returned from campus later that afternoon. "We've been summoned to the provost's office."

I sank onto a stool at the kitchen counter. If I'd expected to be rebuked and fired for everything I'd been doing at SUM that fall semester, I was catastrophizing, but this was the threat of real trouble. "Wait a minute. You said *we* have. Why both of us?" I knew what I had done most recently to deserve censure—I'd argued with my chair and been accused of instigating campus protests. But Stefan? He was blameless.

"All of us, really. EAR."

That was the acronym for English, American Studies, and Rhetoric. Luckily our university did not have EYE, NOSE, and THROAT departments, too.

"Wait—it's not just me and you? It's everyone? The whole department? What's going on?"

Stefan fished into a pocket for a folded goldenrod sheet, which he handed to me. It was a memorandum from our acting chair, Serena Fisch, saying that the entire department had been summoned to meet with the provost, Merry Glinka, at 7:30 the next morning at

the Administration Building. "Summoned," not invited. That was ominous.

I was appalled. "Seven-thirty! A breakfast meeting?"

"It doesn't mention food, and I doubt that breakfast for a horde is Merry Glinka's plan."

When we'd entered the department about five years ago, there had been almost eighty EAR faculty, but in the past few years, the numbers had dwindled due to retirements and deaths (and several arrests). Still, sixty-five to seventy people made a sizable crowd if they all showed up, and wouldn't they feel compelled to?

"You're right. I don't think Glinka is interested in breaking bread, either. She probably wants to break heads."

Stefan finished his coffee. "You think she's planning to abolish the department?" Stefan's fantasies didn't usually run that apocalyptic, but as the university saw it, EAR was full of troublemakers, myself included, and if someone could get their hands on a low-level neutron bomb, they would undoubtedly have used it on us. The department's troublesome image wasn't helped at all by the fact that Parker Hall, the nineteenth-century sandstone building housing EAR, was a crumbling, increasingly rat-ridden wreck where floors groaned like a ghoul's coffin, walls were cracked as if after an earthquake, and there were rumors that any day now, heavy file cabinets or desks might start to plunge through to the floor below.

"Close down EAR," I said, "and do what with the faculty? Dump us somewhere? Crop and Soil Science?"

"The provost could do whatever the hell she wants, you know that. She could be planning revenge, blaming us for what happened at the Campus Center." Just within the last few weeks, a ceremony honoring all professors at SUM who had published books in the last five years had turned into a riot, led by the overbearing Byron Summerscale, newly shunted into EAR from the disbanded Western Civilization (WC) department. Big and shambling and obtuse, he had seemed as harmless as a belligerent hobo until that act of defiance, and now it seemed he was capable of anything.

"Great. Collective punishment. Line us all up and fire every fifth

professor. And if she doesn't fire me, I'll be forced to share Summer-scale's closet office." That was no exaggeration—as a sign of contempt, the university had moved the former Western Civilization chair into a former supply closet. "They'll turn it into a loft like a student dorm room. Better yet—they'll put me in a trailer in the parking lot. Though that might actually not be so bad—it would be more space. And I could offer an independent study in Trailer Trash, which would really fit with White Studies."

"Stop." Stefan hated hearing about the university president's latest dim idea: a program of Whiteness or White Studies (depending on who was describing it) to give white students a voice and an understanding of their "culture"—as if the whole culture didn't belong to them already.

I poured myself another cup, mentally backing up tomorrow morning's schedule from the meeting, figuring out when I'd have to get out of bed to be fully conscious. It was dispiriting. Unless, of course, I just went over there in a stupor. Full consciousness might actually be a hindrance to dealing with our new provost; this was a different version of John Belushi's advice in *Animal House*: "Start drinking heavily."

"Let's make an early dinner, something nice," Stefan announced.

"When don't we have a nice dinner?"

"I didn't mean that. But with everything going on, and tomorrow looming—"

"Like the condemned man eating a hearty meal? Okay. But I don't feel like cooking, though, and I don't really want to go out either."

"Then why don't we have that leftover caponata and make some garlic bread."

"Agreed." As we warmed up the caponata, we opened a bottle of the perfect Australian bistro red we'd recently grown fond of, a blend of Shiraz and Cab. We ate in the kitchen, or gobbled would be more accurate, as if we were athletes carbing up before an event. And we killed the bottle. The wine and the recently remodeled room with its granite counters and island dulled the anxiety, and for a while we talked about the Caribbean trip we were considering for spring break

in March, and my cousin Sharon's slow recovery from brain surgery.

Sharon had undergone a successful operation here in Michiganapolis to remove a benign tumor on her auditory nerve that also threatened an entwined facial nerve, and was back home in New York. While it was technically not a brain tumor, they had to enter her skull to operate, so Stefan and I had been unable to draw the finer distinction. To us, it was a brain tumor that called for brain surgery. She saw it the same way.

Weeks after the surgery, Sharon was still feeling like she'd emerged from a train wreck, and still profoundly shaken by the fear that one side of her face might always be paralyzed. Though she worked at Columbia University as an archivist, she was a former model, so the disfigurement was an even more terrible threat. Stefan and I were just glad she hadn't died, but the recovery was not going to be easy, because meningitis was always a possibility. And a nurse had confided to her: "Don't believe the surgeons—it'll be months before you feel ready to get out of bed." Did that mean even the guardedly optimistic projections were false?

But even though we were worried about Sharon, it was inevitable that we returned to the mysterious summons.

"Why would Merry Glinka need to see the whole department?" Stefan asked.

"Maybe one of her minions uncovered some kind of plot against her."

"Treachery?"

"Treachery, lechery, archery, all of that."

Stefan looked doubtful. "Who would have the time to waste on a conspiracy?"

"Hello? Twisted, bitter academics, that's who. We've seen them commit murder around here—a conspiracy is just something to do over coffee."

"You have a point, but what could they really do if they don't like the provost? Nothing."

To distract ourselves after dinner, we watched the DVD of *Blade Runner* in bed. It had been on my mind a lot lately. With its repli-

cants, urban decay, violence, freaky characters, and general grimness, the movie seemed to sum up everything about our department and our last few years there. In the middle of the movie, Stefan turned to me and asked, "Do you think the provost will be late? Again?"

The provost had kept us waiting an unconscionably long time at the awards ceremony, which had created a groundswell of protest leading to the unprecedented violence.

"I hope not. We'll be in her palace—people will know where to find her."

"You make it sound like the French Revolution."

"Well, don't you think heads are gonna roll?"

"Maybe."

"And mine could be the first one."

Stefan fell asleep early, thanks to the wine, but I couldn't, so I lay there debating whether to call Sharon in New York. She was my sounding board, my ardent defender and loving critic, and our phone calls anchored my life. But since her operation, she had been much fonder of e-mail than the phone because she was self-conscious about her voice, which she thought was a lot more slurred than I did. I could make out what she said just fine, so could Stefan, but it bothered Sharon to listen to herself, so I didn't push her, and she'd been calling less often than usual. She didn't like talking about her recovery—which was what most interested me—because it seemed so slow, and she still felt under the influence of the anesthesia, as if her brain were fogbound. It was hard for her to read, and even complex movies seemed too difficult to follow.

We'd had some sad conversations on e-mail. Sharon had lived a very glamorous life as a model (size eight, with "lingerie legs," as she put it). Before giving it up and going back to school, she'd done commercials, print ads, fashion magazine covers, and had traveled the globe. Despite the career change, she was still getting invitations to booming, hot new nightspots in New York, places where the music was so loud it rearranged your DNA. "Even if I were well, I would hate techno!" she had once said.

In her late forties, she was elegant, beautiful, a taller version of

Claudette Colbert with all of that actress's sass, and twice as much neck. But since her surgery, she had to heavily muffle the paralyzed side of her face on those rare occasions she braved dizziness and went out. Otherwise, people stared.

"The children are the worst," she had e-mailed me. "They stare like they're looking at a witch. It breaks my heart, and then their mothers drag them away as if I'm contagious."

I'd written back: "The nerve will regenerate, it'll come back." That was what her doctors had said. Sharon's reply was: "My face may come back, but my nerve? Sweetie, I don't know anymore. I think I've lost my nerve."

She'd had so much—beauty, money, and a type of fame—that I wondered if she didn't think the karmic bill had come due. Who could blame her for her doubts, and I tried not to be too facile a cheerleader, lest she think I wasn't taking her seriously.

I wanted to be able to promise her that she would be completely herself again, no, more. Like Keir Dullea in *2010*, I wanted to assure her that "something *won*derful" would happen, but I could only offer my love.

Chapter Two

IT WAS cold and nasty the next morning. Not quite the bitter chill of Keats's "The Eve of St. Agnes," but bad enough. Even though there was no prediction of snow, the wind felt damp and despite my warm layers, I was uncomfortable. I hadn't wanted to eat a healthy breakfast—I wanted pancakes and sausages instead—but there wasn't time.

Stefan was too groggy to complain as I drove the few minutes to SUM's vast campus, so I did the grumbling for two. Pathetic fallacy or not, it was the appropriate weather for a summons to the Administration Building. On the other side of the Michigan River from Parker Hall and SUM's older buildings, SUM's command-and-control center was a concrete and glass monstrosity, half Greek temple, half Aztec pyramid. This was an appropriate mix since unseen forces were worshiped there, and hearts were certainly devoured on a regular basis.

We left my car behind Parker Hall and started the ten-minute walk over to the meeting. Several paths snaked along from Parker to converge near the Administration Building, and on each of them, like boats bobbing in a ragtag fleet, clusters and knots of EAR faculty struggled and straggled along in the same direction. There weren't many students, cars, or bikes around, and in the clear morning air, voices carried. Or more accurately, sounds of woe did. I could hear

the thin whine of put-upon EAR faculty members complaining as if they thought this walk was as horrendous a trial as the Bataan Death March.

Demoralized, under-funded, and riven by dissension, EAR was one of the least respected departments on campus, and like any black-sheep member of a family, it often acted in ways to bring itself into more disrepute. It could never present a united front against a threat, but was always likely to turn comatose, or cannibalistic.

I was not looking forward to any new scenes of chaos, but I thought them possible. Apparently so did the provost. SUM administrators usually met with departments on their own turf, which was no doubt why Merry Glinka had made such a different choice. The break with tradition was alarming, and no doubt she hoped to intimidate us by forcing us to come to *her*. Of course, she may also have worried about entering a building as decrepit as Parker Hall, one of the university's oldest. While no one had been hurt in or near it, the building had lost pieces of its ornate coping and the rumors were growing more intense that renovation was impossible, given its condition.

As I glanced around, I saw that our acting chair, Serena Fisch, seemed to be taking point, out ahead of her troops. Given to '40s retro clothes and hair styles that made me think of her as one of the Lost Andrews Sisters, Serena had been weirdly free-spirited before becoming acting chair, but now she was becoming as humorless and prim as a previous chair, Coral Greathouse, who'd had all the exuberance of a Mother Superior. The scotch in Serena's veins was turning to concrete.

Behind Serena lumbered Byron Summerscale and the cronies he'd acquired in the department since challenging the provost (and Serena and Juno, who were both running for chair). Volatile and stentorian, he was EAR's wild man and wild card because he had decided to campaign for department chair, too. Whether it was some kind of antic viciousness or the approach of senility was hard to say.

Everyone seemed overwhelmed by the sudden—though not at all unseasonable—drop in temperature, and emotionally buttoned up,

too, against the cold winds that would blow inside the Administration Building. Whatever we were going to hear or be questioned about, it couldn't be good news.

Though I was a bit stunned and pissed off to be up and headed for such an early meeting, I kept getting distracted from my annoyance by the sheen of frost on stone and brick. Even with most of the trees bare, this mildly hilly part of campus was sensationally beautiful. It didn't have the brooding, hooded elegance of an English university or even the kitschy mock-medievalism of Yale, but it was ripe with Midwestern charm. I felt strangely affectionate toward this place—perhaps because it seemed so likely that I would be leaving.

"Nick!" Stefan and I stopped and turned to see Juno Dromgoole walking slowly along the path behind us, stepping as carefully as if she were crossing a shaky rope bridge over a chasm. She was clad in an ankle-length mink, black boots, and black fedora with a leopard-print band. She looked much better after her recent car crash, and even though she and I had argued about the dangerous way she had gone about trying to track down whoever had rammed her car and also attacked me at Parker Hall, I felt sorry for Juno again when she reached us, out of breath and pale. She was a spitfire, and having seen her in a hospital bed and now noting the neck brace under a thick leopard-print scarf, I was shocked by the way her flame had been banked by trouble. I asked why she wasn't still home recuperating.

"I was invited," she said, air-kissing both of us good morning, acting as if nothing had happened between us. I fell in with the charade instantly. After all, it's how I'd been brought up. Though they didn't think much of Edith Wharton, my Belgian Jewish parents were right out of her novel *The Age of Innocence*, the kind of people "who considered that nothing was more ill-bred than 'scenes,' except the behavior of those who gave rise to them."

"Invited? We were all invited," I said. "That's no reason to leave home." Watching our breaths puff clouds as we spoke made me feel even colder.

"No, I was *personally* invited. Merry Glinka's secretary called to

make sure I was coming." She frowned. "God, that woman's name drives me mad. Merry? She's the dourest human being alive."

"Dour or dire?"

Stefan asked Juno what happened during the phone call.

Juno shrugged her mink-clad shoulders, then winced. "I told her about the accident—surely she knew?—and she asked if I needed a university car to come get me and drop me off in front of the building. It was clear that I couldn't decline unless I were dying."

Stefan and I exchanged a puzzled glance.

"Yes, I thought it was rather strange myself," Juno said. "And I certainly wasn't going to take up her offer." Juno made it sound like the provost intended to drug and kidnap her. "Whatever can that witch be planning?"

"Do you need help?" Stefan asked, checking his watch.

Juno nodded gratefully, and slipped an arm through his. She gave me an uncertain look, and I read it as a question: Do you forgive me? I nodded because I did. I was no longer angry at her for her irresponsible amateur detective work, or the confusing way she flirted with me. She hadn't been at all near death after her accident, but seeing her borne off in a stretcher and remembering that now pre-empted a lot of my criticism.

I followed them, surprised, however, at Stefan's solicitude. Stefan didn't just think foul-mouthed, rackety Juno was over-the-top. He considered her a public nuisance, though I suppose even he could be sympathetic, given the attacker having sent her to the hospital.

I thought Juno was a glorious show of fireworks in our water-logged department. Juno was all Id, I thought, though most of EAR probably considered her all-idiot.

As we neared the ugly bare plaza in front of the Administration Building, the EAR faculty members drew closer to one another, though there was actually now more room. They could have been settlers crossing a plain, afraid of being attacked. Everyone seemed anxious and uncertain, and their voices fell to a hush as we all climbed the wide concrete stairs. The Michigan, SUM, and U.S. flags whipped the poles and there was a clanging from their metal

halyards that made me think of the cannibal kids beating tins together in *Suddenly Last Summer.*

"The meeting room is on the third floor," Serena announced inside, as stiffly as a teacher counseling no silliness during a fire drill. Most people streamed up the nearest staircase, not so much in a hurry, I thought, but unwilling to linger where there might be open speculation about the purpose of this meeting. Better to keep moving.

The lobby wasn't a place to encourage lingering, anyway: a sterile, dimly lit, gleaming cube floored in battered-looking, stained marble and hung with vaguely Pointillist paintings of SUM campus views. Avis and Auburn Kinderhoek, on the writing faculty, and a few of the temporaries muttered off by themselves, while everyone else was as silent as if they were about to be called to the witness box in a capital case.

Because they were both going to run for department chair, Serena and Juno avoided each other as if they were the stereotypical two women discovering that they've worn the same gown to a gala. But Serena glared at me. She and Juno both wanted my support for the coming election, and I was trapped whatever I did.

Luckily, we didn't all have to share an elevator since three arrived almost at the same time and were filled as rapidly as if we were rush hour travelers at a big city subway stop. Our elevator was silent during the ascent to SUM's Olympus—the floor where all the major administrators had their offices, pushed their papers, and contemplated how to invest their exorbitant salaries, or the color of their next Lexus. Administrators at SUM routinely made two to three times what even the best-paid faculty did.

Serena seemed to know where she was going because she briskly headed off to the left down a plushly carpeted hallway lined with framed photos of SUM teams during victorious games from the past. There was a sound system on this floor, playing suitably martial Muzak: John Philip Sousa or Wagner or Pink Floyd. The hallway was clogged with fifty or so faculty members and we streamed through an open doorway after Serena.

"Jeez," I murmured to Stefan. Down the center of a rectangular, darkly wainscoted, windowless thirty-foot room stretched an oval granite-topped table that could have been a menacing prop in a James Bond movie, the kind of furniture that had hidden panels and deadly torments. There was nothing hanging on the walls, except the seal of the State of Michigan next to SUM's seal, each large and shiny. A few dozen red velvet-backed chairs ringed the table; a few dozen more stood against the walls and even as people tried shrugging out of their coats, it was clear that this room wasn't just too small for the crowd that had arrived. It would never have been large enough to comfortably hold the entire department.

There was only one water pitcher on the table and one glass, both set on a small round silver tray in front of a chair with a higher back. This mini-throne waited at the middle of the table on the side near the door, which meant that Merry Glinka would be sitting between all of us and our exit.

Juno, who had removed her hat, was whispering this to me and Stefan. "It's really quite clever."

"You mean rude," Stefan replied. We three took chairs on the outer rim against the wall as far away from the door as we could, though in case of a fire, it meant we'd be doomed. I often thought of things like that. Even though my parents had escaped disaster in Europe, it shadowed them and me, and I was often painfully aware of my vulnerability in a big crowd if something were to go wrong. Films in which lovers or families were separated or riots occurred and people got trampled seemed like home movies to me: the panic and pain horribly intimate even though the Holocaust was for me something I knew only from books. Stefan, whose parents had been in the Holocaust, felt the same way, and it was good to have this shared *faiblesse*.

Around us, people stripped off coats and folded them onto their laps since there was nothing else to do. Did the provost not want us to feel even mildly comfortable? If so, it was working. This room should never have been used for a group so large.

It was almost 7:30 and so no one spoke very loudly in case they'd

be overheard through the open door. Serena sat with her elbows on the table and hands clasped as if meditating, her eyes half-shut. Glancing around, I wished Lucille Mochtar hadn't taken a semester away. Aside from her and Juno, I had no real friends in the department, and that was sad after five years. Almost everyone else in the department was either inimical to me, or simply indifferent. But Lucille was half-black, half-Indonesian and would likely wind up at a more prestigious university with a chair of her own, a large research budget, and a salary large enough to buy her all the Escada suits she could want.

Lean, tanned, burly Rusty Dominguez-St. John slouched in the corner opposite us, looking photogenic and mean, and when our eyes met, I felt scalped. He always had that effect on me, especially when he unleashed his huge, fake smile, as he did now. Though he had the sharp-jawed looks and loud voice and body language of a TV sportscaster, he was a professor of popular culture who had earned his master's and Ph.D. while serving twelve years for aggravated assault. He didn't attend many department meetings because he spent most of his time on tour with his Recovering Criminal seminars, plugging his book, videotape, CD-Rom, and cassette series, "Breaking the Bars That Imprison You." Though only half-Hispanic, he'd been hired as an affirmative action candidate and for the PR value he would supposedly bring with him, but had been a disappointment since he was never visible enough on campus to be shown off as a Person of Color, given all his travel.

Avis and Auburn Kinderhoek sat by Rusty, their voices so low they might have been trying to subliminally influence the people around them. The Kinderhoeks were part of the writing program, but they had so many temporary positions away from SUM that they seemed more like visiting professors than permanent faculty. Auburn was the essayist, Avis the poet, and students despised both of them for their drill sergeant manner in the classroom. In her mid-fifties, Avis was so short and fat she seemed squashed into her satiny-looking dresses that looked like cheap nightgowns. Auburn was no taller, but he was Bangladesh-thin, with the empty good looks of a politician.

Bedraggled Larry Rich, who always looked like he'd not only slept in his office but used it as a bathroom, muttered, "It's freezing in here." He wasn't exaggerating. The heat hadn't been on long enough to battle the overnight chill. Rich and his buddies, Les Peterman and Martin Wardell, were so shambling, loud, and obnoxious you might take them for street people who'd run out of meds. They struck me as wannabe jocks who were ashamed of having gone into academia, and so they had to drink, act boorishly, and otherwise undercut their own dignity. That way no one would take them for anything less than he-men. Whether their attitude was an act or the real thing, it was grotesque.

"Damned cold," Rich said. Summerscale and other EAR heavyweights shook their heads, whether in agreement or disapproval it was impossible to say.

Cash Jurevicius, the department's Ryan Phillippe manqué, all in black, was simmering as he often did in departmental gatherings. The grandson of one of EAR's beloved former chairs in the 1950s, who had a now-dismantled departmental library named after her, he was only an adjunct professor, while Grace Jurevicius had been SUM royalty. The low status ate at him like the vulture that used Prometheus as a buffet, and Cash hated lots of us in EAR. That included me, even though I didn't have tenure, but because my partner was EAR's writer-in-residence, and because we had recently gotten into a fight. Cash had threatened to end what was left of my SUM career and revealed that he had allied himself with the provost, despite his low opinion of her, because she was going to appoint him a special assistant of Diversity Affairs, given that he was part-Mexican and part-Ojibway. He was an opportunist and a thug, someone who would use whatever power he achieved as a weapon to harm others, not as a means of righting the kinds of injustice he had escaped.

So who in this room would vote for Juno and who would vote for Serena, both of whom expected my support and had threatened me if I withheld it? Should I just stand up and ask the questions and see if I could get it all out in the open? Or would everyone assume I'd lost my mind?

"Perhaps she won't show up," Juno said in a stage whisper. "And she's giving us the cold shoulder." Ripples of nervous laughter spread through the room, and as if she'd been invisible until that moment, several people asked Juno how she was feeling.

"Like revenge," she said brightly. That's when Merry Glinka entered the conference room, followed by her flunky, Tyler Mooney-Mauser, in a dark, stylish suit, dark tie and shirt. Matronly and affectless at the same time, Glinka had been hired from ultra-conservative Neptune College at the outrageous salary of $250,000 because the Board of Trustees wanted a scandal-free provost *fast*. Glinka was the darling of Rush Limbaugh and other rightwingers, and if she'd been younger, blond, and mini-skirted, she would probably have joined them on the talk show circuit to hawk a book blaming liberals for all the world's evils.

Mooney-Mauser was her appointee as "ambassador" to EAR. Now he closed the door behind her, and stood nearby since there weren't any empty chairs. What the hell did he think he was, one of her *consiglieri*? The silence was immediate and stifling, and Juno squirmed a bit inside her coat, which was open now over a clinging black wool dress. I'm sure the brace was very uncomfortable.

I tried not to stare at Juno. This was increasingly my problem. She was voluptuous, stylish, and unnervingly, surprisingly attractive to me. It wasn't a diva thing, like a gay man worshiping Diana Ross. I didn't think she was faboo; I wanted to rock her world.

Thankfully the provost distracted me. Merry Glinka was a sight. Though she usually looked and dressed like Betty White on "Golden Girls," she was amazingly wearing a jeans pants suit, as if she'd deliberately dressed down for the occasion. The contrast with her typically frilly outfits was immense, but despite her current dress, she still had the fastidious air of Marie Antoinette holding her skirts up to avoid the mire as she stepped into a carriage. It helped that Glinka had such a pinched nose and such thin lips—both features gave her face a permanent look of displeasure. Settling into her chair, the provost put a pile of papers face down in front of her and nodded as if she were wired and had been given the go-ahead by someone in an-

other office. Mooney-Mauser's eyes had glazed over by this point as if he were channeling a guardsman at Buckingham Palace, but he still looked as if he could turn as mean as one of those creatures in *Aliens* coming out of the cave wall to slash and devour Sigourney Weaver's landing team.

"Good morning," the provost said, eyes glancing around the room so quickly she didn't seem to really look at anyone for long. She didn't wait for a reply; this was no kindergarten. "There has been a great deal of controversy surrounding your department in recent days." She let that statement lie a moment, and around the room, professors dropped their eyes or lifted their chins pugnaciously. "And I understand that the animosity over the coming election for chair is already so intense that it's being spoken of throughout the College and across the campus. Given your department's recent history, that is completely unacceptable."

Her news was a shock, and a low blow. Even as I recognized it as the cheapest means of intimidation—a vague story about rumors—I experienced the shame she wanted us to feel. The room suddenly felt a lot colder. How could anyone respond? Ask for specifics? Ridiculous. The previous provost had once warned me that at SUM it was crucial that people not only thought well of you, but spoke well of you, too. She'd made it sound as if one adverse comment could turn into a filibuster of complaint and denigration. Clearly she and Glinka had the same playbook.

The provost surveyed the abashed faces with quiet satisfaction. "To avoid bitterness and any more controversy, to keep the situation from getting out of hand, I have decided to step in before it escalates." Glinka milked this moment for all it was worth, and the roomful of professors could have been the wonderstruck spectators in *Close Encounters* seeing the gigantic spaceship land. They goggled at her, waiting to see where this remarkable announcement would lead. What the hell did "stepping in" mean, I wondered.

"There will be no election," she said flatly, and then, as the murmurs began, she raised her voice. "I will appoint the EAR chair."

Chapter Three

"YOU CAN'T do that," Cash Jurevicius said magisterially. His lineage apparently convinced him that he was the one to declare what was acceptable in EAR and what was not. Serena's eyes hadn't even widened, and next to me, Juno was motionless and speechless. She hated the arrogant Cash as much as I did, for good reason. He may have been right to be outraged, but he was an asshole and a schemer, and I distrusted this public display.

Glinka slowly turned to Cash as if she were a gun turret on a tank, lining him up in her sights. I expected her to blast him with, "I *am* doing it," but she surprised me by saying, "Really? Why not?" Her tone wasn't mocking, but as straightforward as if she actually wanted to know, not why, but why he thought she couldn't. As if his opinions sincerely intrigued her.

It was creepy, and he faltered before he said, "The Board of Trustees will never accept it."

"You're wrong. I have the board's full approval."

Cash frowned. "The Faculty Senate—" But he didn't even bother finishing the sentence. SUM's faculty representatives had no more power than a garden slug; the slightest whiff of disapproval from the administration was like a pinch of salt that would leave it a tiny, sizzling heap. The provost waited, eyebrows slightly raised, but Cash just shook a hand in front of his face as if to make the room vanish.

Then he rallied. "What about the department by-laws?"

Merry Glinka just smirked. That was answer enough. Even I knew that while the by-laws governed intra-department procedure, the university could manipulate and overrule whenever and however it wanted to. SUM administrations were rarely benevolent, just ranging from high-handedness to autocracy. Still, this power grab was a surprise. What was the point? I could feel the tension starting to radiate from Juno on my right and Stefan on my left.

"When?" Juno asked quietly, and everyone shifted nervously in their seats. She was volatile enough on a good day, so who knew how Juno would act this soon after having been in an accident. Tyler Mooney-Mauser had been slouching a bit, but now he straightened up and squinted as if ready to take a bullet for his boss should Juno run amok. He didn't know what I knew, that Juno actually owned a gun, a Glock. I wondered how many other people in the room were armed, legally or otherwise, and why it's postal and factory workers who go crazy and not academics.

"There's no point in making you wait," Glinka observed.

"That's fair enough," Serena said in a voice sandblasted of feeling. She looked at Juno for agreement. They had once been good friends, so if anything passed between them in that glance, like a decision to hang fire until they could talk this over, I don't think outsiders would have tuned in.

Juno nodded, but Byron Summerscale rumbled out an impotent threat: "We'll see." Glinka flicked a glance at him and he shrank back into himself, the bluster fading right away.

For all my criticism of EAR and my own checkered—even houndstoothed—past in the department, it was humiliating to see the three candidates for chair quashed by the provost. I felt sorry for them.

"Yes," Glinka said calmly. "You *will* see." It was more menacing for the striking lack of menace in her voice. The room was starting to smell of winter clothes that hadn't been aired recently enough, and of quiet despair. EAR was clearly a pariah department, one that couldn't handle its own election for chair. But what about singling out the individuals who had caused the most trouble? I was sure people

were wondering why the provost wasn't disciplining Summerscale for his eruption at the faculty awards ceremony, or Avis Kinderhoek for her intemperate remarks about White Studies, which had set off a student protest.

"Given the acrimony that was in existence even before there was a third candidate for chair," the provost began, "the time to act is now. I've decided that English, American Studies, and Rhetoric needs new blood to transcend the old rivalries. That's why I'm appointing Byron Summerscale for the five-year term."

Remember when Ross Perot was against NAFTA because he said jobs would flow to Mexico with a giant sucking sound? Well, that's what filled the conference room as the faculty breathed in so sharply it was a wonder the paint didn't peel right off the ceiling and Mooney-Mauser's tie get ripped from his throat. Serena looked as incredulous as almost everyone around the table except for Summerscale himself, whose face was twisted with scorn.

"Is this a joke?" he asked.

The provost shook her head. "It's effective immediately."

"Why?"

"Because there's no time to waste. The situation has to be stabilized."

Jeez, she could have been talking about the core of a nuclear reactor rather than a crummy little election. But how could she think appointing Summerscale would be a good move? It was like a line from Tacitus: "They make a wilderness and call it peace."

As if he were at a tennis match, Cash Jurevicius's head swiveled from Summerscale to Glinka and back again. His expression was what the English call "gobsmacked." I hated the news, but was glad to see it hit him so hard.

"Make your own arrangements," she said to Summerscale, and then waved at Serena without deigning to turn her way. Given Serena's past as chair of the former Rhetoric department, which had been dissolved and its faculty forced upon the then–English and American Studies department, I thought Glinka's peremptoriness was especially mean-spirited.

Stefan was shaking his head and when he looked at me, I thought

he was picturing the same triumphal procession of one: Byron Summerscale leaving the semi-Stygean depths of Parker Hall's malodorous basement for the office of the chair, from which Serena would have already slunk away.

"Of course, you can pick your own associate chairs," the provost continued to Byron. "Whenever you like." I sensed some anticipatory rustling in the crowd, as if the assembled professors were beauty pageant contestants pulling their shoulders back and wetting their lips to look eminently pickable. If this wild move went through, Summerscale would be the recipient of so much sucking-up he might go deaf.

"She's the Antichrist," Juno said under her breath.

"You're not religious," I whispered.

"I am when it comes to evil."

Behind the provost, Tyler Mooney-Mauser might have been smiling. But there was no joy anywhere else in Mudville. Perhaps Juno and Serena might join forces after the meeting to fight the provost's unprecedented, outrageous decision, but for the moment, we all acted as if she'd said, "I am Borg. You will be assimilated. Resistance is futile."

Stefan must have been right, I thought: Glinka apparently wanted revenge on EAR *and* Summerscale, and this was her fiendish plan. If it proceeded, it was perfect revenge. Summerscale would be saddled with an antagonistic, unruly department and EAR would suffer. We might all go down in flames, which might be what Glinka wanted: disband a dysfunctional, feuding department, tear down Parker Hall as rumors said she wanted to do, scatter and suppress the faculty. The mid-Michigan version of Stalin's policy for dealing with troublesome nationalities.

"Now, since you're all here," she said, as if we'd met accidentally, "there are other matters to discuss."

"The pillory?" Juno murmured for only me to hear. The smoldering anxiety in the room, along with the strength of Juno's perfume, and the weight of her mink-draped thigh pressing against mine, were starting to make me dizzy. I hoped the provost wasn't planning

a marathon, because I was starting to get turned on, being squeezed between Stefan and Juno. Now that would be a wild time, I thought, but just as quickly tried to focus on something as sexless as possible to calm myself down. I looked at Merry Glinka's mouth.

"The university needs to demonstrate its commitment to diversity."

Demonstrate rather than *be* diverse; university PR-speak was a bath of banality. Unconsciously revealing the shallowness of his campaign against Michael Dukakis, the first President Bush had once said, "Message: I care." That was SUM in a nutshell. Pick an image—make people believe it's real.

"That is why," Merry Glinka went on, "we applaud your office manager's Diversity Tree and intend to do much more than honor Dulcie Halligan for her efforts at the end of the semester."

My mind wasn't just spinning, it was doing the Virginia Reel. What would Glinka say next? That Dulcie, an EAR secretary, was going to be given an administrative position of something like Diversity Czar? The tree was ridiculous enough—a scrawny thing that had been put up in the department office despite EAR's policy of not recognizing the holidays.

"From next year onward, at the holiday season, we intend to place a large Diversity Tree in the plaza fronting this building, a shining beacon to everyone at the State University of Michigan that we are diverse, that all are welcome here and celebrated. And to further that stance, we are redesigning the university seal to place a Diversity Tree at its center."

Tyler Mooney-Mauser smugly crossed his arms as if daring anyone to challenge the provost, looking as pugnacious as Robert De Niro.

"This tree will be a key element in our newest initiative." The provost called Mooney-Mauser over and he picked up the pile of papers in front of her and started passing them around. They were accepted, passed on, and inspected with as little avidity as if they were bank statements registering a negative balance. Was there anything so vain, time-consuming, and obnoxious on campus as another

set of reform proposals conjured up with as much fanfare (and lack of originality) as if they were one of those bi-yearly congressional ker-fuffles about the Pentagon wildly overpaying for toilet seats and spare parts?

When I got my own handful of stapled sheets, I was startled. This latest SUM farce was titled "DIVERSITY UNIVERSITY" INITIATIVE. The nerd in charge of packaging this hash had probably thought that the cute rhyme in the first two words would be a helpful selling point. But the initials!

"DUI," Stefan said very softly. "Driving under the influence." But we were both too tired and bedraggled to smile. I skimmed the outline; it was the typical boilerplate, trotted out with piddling alter-ations whenever SUM had to gussy up its image. Noble-sounding goals, meaningless changes, business as usual. This had to be a response to the recent demonstration outside Parker Hall.

The provost wasn't done, not hardly. "There's one aspect of this diversity initiative that concerns your department directly. For now, I've decided to forgo the task force process."

Avis looked stricken, her round face quivering a bit as if she were an infant about to wail after its cookie had been snatched away. No White Studies task force, no clout for her.

Her mouth and shoulders tight, the provost went on. "I intend to fund a Whiteness Studies Program for three years. Experimentally. Whiteness Studies will be housed in your College and I expect your department's full cooperation and enthusiastic participation. To that end, I'm also going to appoint Byron Summerscale acting director of the program."

Silence hit the room like a meteor.

Merry Glinka clearly didn't want or expect any discussion, because she rose, thanked us for coming, and with Tyler Mooney-Mauser opening the door for her, swept from the room as if chagrined at having wasted any time with us at all.

Chapter Four

WITH THE provost gone, I expected the kind of pandemonium you see in the *Airplane* movies to break out, with people rushing off in all directions, screaming, flailing away at each other. Instead, almost everyone began to file from the room quietly, perhaps eager to leave the scene of departmental humiliation with as little fuss as possible. Chastised and chastened, they all avoided looking at Serena, who sat with her head slightly bowed, looking not just lost in thought but adrift. I couldn't imagine what it must feel like to be ousted from your position as acting chair so publicly, to be so casually mocked and disregarded. It didn't matter that the provost was a troll; her actions still left Serena more tainted than Juno, who was merely running for the position Serena had lost.

We didn't join the quiet exodus. Since we were far from the door, Stefan asked me to wait till the path was clear; we usually did the same thing at crowded theaters. Though he and I had both grown up in New York, Stefan never had my occasional love for plunging into and through a mass of people to get to the other side. "Crowd walking," I called it with enjoyment, even though mob scenes in movies freaked me out as much as they did Stefan. He called it rude. The urge might hit me full-force when we were back in the city, but I'd occasionally had it pop up on campus whenever I saw a throng. The New Yorker's love of speed and getting ahead of others can be

satisfied through crossing a street quickly just as readily as by seeing a show in previews twice before most people have heard of it, or calling a restaurant tired before it's even been reviewed in the *New York Times*. It could even come down to a cocktail (when I first heard about Cosmopolitans, Sharon had already been drinking them for more than a year).

Juno was muttering to herself like some toothless hag on a front porch in the rural South. She made no move to leave. Rusty sat back in his chair across the room, studying Juno with amusement. As if to show how manly he was and resistant to the cold, he wore just jeans with his snakeskin boots, a thin black V-neck sweater over a blindingly white T-shirt, and a leather jacket.

"I told you you'd never be chair," he called, but Juno ignored him, and Rusty got up and strutted out as if he thought he was Shaft, profiling every step of the way. Juno and Rusty had married years ago but never divorced, which I suppose explained the heat lightning that sometimes flashed between them.

Martin Wardell, Les Peterman, and Larry Rich had gathered around the still-seated Byron Summerscale as if in deference to his apotheosis, an unlikely trio of angels. I couldn't make out what they were saying, but the tone sounded congratulatory. Avis and Auburn Kinderhoek surveyed the room with a-plague-on-both-your-houses contempt, and stormed out into the hall, though given their stature, squalled out might be more accurate.

Cash leaned across the table to Serena and said with great sympathy, "It's not right," but she didn't reply and he moved around the table to the door where he addressed the room. "It's not right." Was that going to be his battle cry, or was it his white flag? Could we trust anything he said?

I felt strangely calm. Because the provost had staged a sort of coup, that meant there would be no acrimonious campaign, no election, and no electioneering. I wouldn't have to choose between Serena and Juno and could feel sorry for them both, while neither would be harassing me for my vote. That may have been short-sighted, but given the nature of the department and SUM, was there a better way to plan?

"*Gotterdämmerung,*" Stefan said flatly. "Total disaster." That was *my* kind of hyperbole, but he didn't sound truly upset; his words were more like a cigarette butt flicked from a speeding car. He sounded as if he were taking in the scene from a very long—and safe—distance. Not a bad plan, either.

Summerscale stood and headed for Serena, who flinched. He may have been clownish with his long, wispy white hair, Birkenstocks, and mad reddened eyes, but he was big enough and odd enough to be menacing. "I'll expect you to have your office—" He laughed. "*My* office, that is, cleared out by five o'clock." He lumbered off with the Three Stooges chortling in his wake. The fact that he'd been picked not just as chair of EAR but as director of a program he considered bunk did not seem to bother Summerscale. Power had hit him like heroin; what would he be like between fixes?

Serena stood up as shakily as if she were the one who had been in a car accident and not Juno. She walked over to us and Juno rose. Without a word, they hugged à la Hollywood, hands on each other's shoulders, cheeks almost brushing tenderly.

"I'm so sorry," Serena said.

"I am, too."

About their rift, their loss—or both?

"Your accident," Serena said. "Are you okay?"

Juno nodded and thanked her for asking, then reported on her injuries, the ER, and her drugs while Serena interjected sounds of alarm and sympathy at the appropriate moments.

Their tone was so sisterly I couldn't help thinking of the Oscar Wilde line that women call each other sisters only after having called each other a lot of other things first. But perhaps the sole way to bring them back together as allies—if not friends—was to present them with a common enemy or common wrong.

Serena turned to go, and Juno challenged her. "That's it? You're giving up?"

"You can't fight the provost and the Board of Trustees."

"Honey, I can fight *anyone.*"

Serena smiled wanly. "But you won't win." She trailed from the room, coat in one arm.

"How about some coffee?" I asked. "Before the trek back across Siberia. We can try the café downstairs." One of Merry Glinka's changes upon becoming provost had been to turn a basement office suite in the Administration Building into a deluxe little cappuccino café, idiotically called Le Bistro (it didn't serve anything but coffees and desserts). None of us had ever ventured there yet, and so with some anticipation we trooped out into the hall, where Tyler Mooney-Mauser was loitering.

"I thought you might be moving in," he sneered.

Juno walked right up to him so that her mink brushed his suit. "You know what I'd love to do some day? Strap on a black leather dildo, bend you over your desk, and make you scream."

Mooney-Mauser looked like he might vomit and he backed away before rabbiting down the hall. I tried not to laugh at his distress. Stefan stared at Juno, who shrugged. "This isn't the time for bon mots," she said.

"I guess not," Stefan said softly. Introverts register their surprise by a deeper than usual stillness, a sort of aural black hole—or my introvert did, anyway. Having lived with him so long, I had my own personal Richter Scale to measure his reactions. I registered a 6.0.

We rode the elevator to the basement. Le Bistro proved to be a bit kitschy but inviting with its terrazzo floor, azure wrought iron tables and chairs, azure and sunflower-yellow striped awning over the counter, and walls hung with Van Gogh posters. The music playing on the sound system was one of Bizet's *L'Arlesienne* suites. The café's colors were meant to suggest the south of France, but they were also very close to the colors of the University of Michigan, SUM's bitter rival, which struck me as pretty strange. Surely someone was going to alert the provost before alumni complaints began to pile up?

We weren't the only EAR faculty to have thought of a hot beverage, however, perhaps because those who hadn't headed right out had remembered how unpleasant the weather was and wanted to delay re-experiencing it. The Kinderhoeks lurked in one corner, hissing at one another. Rusty and Summerscale and his posse invested another corner, and Cash Jurevicius was gloomily hunched over

espresso cups with Serena, doing as much brooding as talking, it seemed. Perhaps she regretted not having responded to his overture upstairs, and as Grace Jurevicius's grandson, he felt obliged to offer her his obnoxious condolences. Noblesse besiege.

Luckily the café was large enough for the three of us to sit unmolested by any of these groups. At least that was my hope.

The pimply, pierced teenager in a Busta Rhymes T-shirt behind the counter seemed no more addled than most of the young help in town (or the typically juvenile publicists Stefan had to deal with in New York) and she suggested the hot chocolate. The chill of the day had deepened with the provost's imposition of Summerscale as chair, which I suppose is why we all ordered the chocolate. I studied the clerk's ragged short hair while she prepared our drinks; she looked as pale and disheveled as a European woman shaved at the end of World War II for sleeping with German officers.

We brought our incongruously blue-and-yellow mugs to a table by the trompe l'oeil window, and when we sat down, guffaws erupted from the circle around Summerscale as if he were a '50s lounge singer having his ego massaged by hangers-on.

"They all want to be associate chair, but Summerscale won't give a single one of them a position," Juno predicted, sounding fully in control again. "Except perhaps supine, so he can trample them."

"Because they're men?" I asked.

Juno shrugged out of her mink and pushed it back over her chair. "I don't think he gives a fuck about gender balance, and why should he? Besides, if he did, he's gotten official approval from the provost not to worry about it: Merry Stinker picked a man over two women, didn't she? That took balls. No, it's their eagerness and their lack of sense. They think that if he was treated like scum and now he's at the top, the same thing can happen to them. Dream on, turds."

I glanced their way and couldn't help thinking of the homeless men in the Seattle mystery series by G.M. Ford who helped the amateur detective out because they were "invisible"—no one noticed them in public. In their loose-buttoned faded tweed blazers, scuffed loafers and shiny Hush Puppies, Wardell, Peterman, and Rich had a

shabby, ratty air about them that made them seem as if they could easily have spent the night in a homeless shelter. Who knew? Maybe they actually slept in their offices. It wasn't unusual for an EAR professor to drink or be unwelcome at home. Professors are really marginal characters. Given far too much free rein in their work lives and not working long hours anyway, they're likely to blossom into all sorts of eccentricities if they're kind, and cruelties and crudities if they're not.

Juno shook her head menacingly, one hand clutching her mug as if it were a weapon. "But it still doesn't make sense. What's she up to with this bloody Diversity Tree business?"

"I think the tree and White Studies are supposed to balance each other out," I said. "Each one is going to be offensive to somebody, but each one will have supporters, so no one can complain. It's preemptive."

"Preemptive bloody stupidity," Juno snarled. "What do *you* think she's after?" Juno glared at Stefan, waiting for him to explain the provost.

He shrugged. "Don't ask me."

"But you write fiction, you must have some understanding of human psychology. Or are you so postmodern you don't believe in the notion of character and fixed identity?"

Stefan admitted that he drew a blank about the tree and White Studies, but he thought Glinka wanted revenge on EAR.

"And so she picked the worst candidate to be chair?" Juno asked rhetorically. She nodded as if in approval of the strategy, as if she would do the same thing, given the chance. "To destroy us all, she hopes. Of course it's possible, but she'd have no guarantee that it would work. It's a gamble. Dynamite would be more effective." She grimaced. "Or the Big Bad Wolf huffing and puffing, if Parker Hall is as dilapidated as everyone's saying."

Incredulous, I said, "You think there's a chance in hell that Summerscale can be a good EAR chair? Everyone who would have voted for you or for Serena will try to undermine him. It'll be *Mutiny on the Bounty*!"

"Keep your voice down," Stefan warned me.

"Perhaps not," Juno said, squinting as if making out a distant target. "Summerscale was chair of Western Civ, wasn't he? He knows how to run a department. He's crazy, but he's not incompetent. He could win people over."

"Wait a minute," I said. "Are you *defending* him?"

Juno leaned forward and lowered her voice. "I'd rip his fucking brains out and feed them to my dog if I could, though she'd probably want something more nourishing. But that doesn't mean I can't see how he could pull it off."

Low enough for just the three of us to hear and to make me feel like a conspirator, I said, "His office is down the hall from mine in the basement. I see him all the time and he's like a coked-up jack-in-the-box. The only thing he could pull off is *himself.*"

Juno didn't respond with even a Mona Lisa smile, though she did at the moment have Bette Davis eyes. "Then the provost must want White Studies to fail," Juno went on, working it out for herself. "So that's why Summerscale's going to direct the program. He's the insurance. If it sinks, he gets the blame."

"Right! She ends up being seen as responsive to all requests and demands—nobody's respected, but everybody gets heard, or thinks they are."

"They?" Stefan asked, smiling.

"Don't argue with me about pronoun references right now." Stefan was a purist and liked to remind me that "they" couldn't refer to a singular noun, while I sided with the language-is-changing mavens. I taught my writing students what the rules were, but also what the prevailing usage was and how to choose.

Juno glanced at the other tables as if surveying a board game and contemplating the pieces and how they might move. I could imagine her rising, slamming a fist on the table, and demanding who was behind her getting stabbed in the back like this. I must have had some kind of psychic connection with her, because she covered her mouth with both hands briefly, shook her head, and said, "They all hate me."

I chimed in with, "Join the club," though it wasn't quite accurate, since I didn't think I was as unpopular as Juno. I didn't want to think that, anyway. A professor of Canadian Studies, Juno had entered the department as a temporary replacement and through a twist of fate had been granted tenure. She was brash and aggressive and foul-mouthed and told people what she thought of them, which generally wasn't much.

Stefan neutrally asked Juno what she was planning to do about the canceled election, since she had criticized Serena for not taking up arms.

"I'll speak to the president," she said.

I finished my chocolate. "Forget it. Even if you can get an appointment, President Littleterry is an ignorant blowhard who doesn't *know* anything and he won't *do* anything. He just likes to stand around and be fawned on by alumni who think that talking to SUM's ex-coach about the big game they remember from their freshman year, and donating to SUM, makes them special. It's pathetic, and so is he."

"I can still try," she insisted.

Rusty Dominguez-St. John had snuck up on us and he pulled a chair around backwards and sat in it as if posing for a photographer: arms crossed on the back, strong, cleft chin high. "Interesting turn of events, huh?"

So much for my hope that we wouldn't be bothered. His reception was chilly, but his smile didn't dim. It couldn't—his teeth were iceberg white and his eyes too filled with self-satisfaction.

"I'm glad I suggested it," he said.

That got our attention.

"I sure did. I e-mailed the provost after the last meeting when Byron announced he was running and I told her Byron would be the only chance for EAR to settle down. I guess she liked the idea."

"Motherfucking shithead. I don't believe you," Juno said, as still as a snake about to strike. But her next comment belied what she'd said. "You did it to spite me."

Rusty dismounted his chair. "If I did, it worked." He swaggered

back to the group around Summerscale, his boots sounding a mocking farewell on the terrazzo floor.

"Somebody should shove him down a flight of stairs," Juno muttered. "That would put a dent in his smile."

"How can you say that after what you and Nick have been through?" Stefan leaned forward so sharply I thought he was going to smack her till she chimed. He pinned her with his eyes as if trying to put her into a trance. "You don't know what the hell you're talking about," he said steadily and quietly. "It must be the painkillers they put you on."

She didn't snap at him or try a riposte, either.

Feeling embarrassed by the scene, and the lowered voices around us that indicated we were being eavesdropped on, I wanted to switch subjects, but Stefan stood up from the table and said, "Nick, I'm going back to Parker Hall. I'll wait for you in my office."

Stefan had been right to quell Juno, if only for a moment, but I didn't enjoy watching her off-balance. I was still too intrigued by her, too drawn. And now that we were alone at the table, I felt even more aware of her body under the clinging black dress I imagined was very, very soft.

"It's cashmere," she said.

"How'd you know I was thinking about your dress?"

"You were thinking about its contents, too, weren't you?"

I nodded, unable to lie. That was my eyes again, giving too much away. But if she read me so easily, did Stefan see the same things? And if so, why hadn't he confronted me yet?

I switched subjects and told her about my conversation with Peter de Jonge.

She was the soul of dubiety: "You're kidding, aren't you?"

I shook my head.

"You mean we didn't figure out what was going on here? We don't know who was really after us? And it's bigger than SUM? Who's behind it all? The Rosicrucians? The former East German secret police? Michael Jackson?" Her scorn fizzled out as quickly as it had flared and she looked very tired. But before I could express any

empathy, she sat straight up, eyes glowing. Hell, even her hair and her nails were glowing.

"You said yes, of course? And told him I'd help you?"

"Wait a minute—"

"Don't you dare try to keep me out of this. We're going to find whoever beat you up and put me in the hospital, and we're going to make him suffer. Think what a team of detectives we could be!"

That's right, I thought. Starsky and Bitch.

Chapter Five

I DID not try to talk Juno out of her enthusiasm, just said I had to go, and I trudged back to crumbling Parker Hall, leaving Juno awash in plans for becoming a super-sleuth.

There was a phone message for me from Peter de Jonge, but I crumpled it up, unwilling to deal with that whole question. It was as crazy, no, crazier than everything that had been happening around me lately.

When I got to Stefan's office, he was looking a little wild, too.

"We're going to the Caribbean," he announced.

"I know that—in March, for spring break."

"No—next week, right after finals. I made some calls and I found us an even better deal. It's a Club Med—totally isolated, on the most eastern island in the Bahamas. It's got great scuba diving!"

"We don't dive."

"Who cares! I have to get the fuck out of here *now*."

"But we're not ready to go anywhere this soon."

"We will be. Come on, let's go have lunch and talk about it." We bundled up and dashed across Michigan Avenue to a sub place and Stefan wore me down, well, almost. He was so passionate about escaping SUM as soon as we could, if only for a week, that it was hard to resist. But I had never really liked a sudden change of plans, and this one especially seemed too big.

Back at Parker, I stopped at the grimy main office to check my mail. Even on a sunny day, the Nile green walls made you think of an aging state loony bin, but today the mood in the EAR office was more that of a funeral parlor. Serena stood behind the counter in deep and solemn conversation with Dulcie Halligan and the other secretaries, who seemed as lugubrious as Anne Boleyn's attendants seeing her off to the headsman. Perhaps they also mourned the ratty Diversity Tree that had been stolen from the counter and tossed from the roof of Parker Hall by an unknown guerilla landscaper. I faltered when I saw their tableau and started to back out of the office, running into Byron Summerscale, or more accurately, the box of books and knickknacks he held in front of him.

"Whoa!" he said, as heartily and condescendingly as some '50s TV dad about to tell his teenage son to slow down. I smiled, sidled off in the direction of the mail boxes, grabbed my mail, and hustled downstairs to my office. From the hall I heard Summerscale boom, "I'll just start leaving some boxes here for now."

At a moment like this, a feisty college friend of mine from Bay Ridge would have said, "Gee, wouldja jump in my grave as fast?" I imagined that Serena had a more elevated reply. Though I was sure she could go back to her old office (which hadn't been re-assigned to anyone, pending the election for chair), and not have to take up residence in Summerscale's basement supply closet, being evicted was an added indignity. I cringed at the vision of her departure, as I did when I saw pratfalls in movies. I knew I was supposed to laugh, but I always felt embarrassed and miserable instead.

The next afternoon, I had a phone message from EAR that Byron Summerscale wanted to meet with me urgently.

All I could think of was that he wanted me to serve on some department committee or in some other way join his administrative team. Driving over, I practiced various ways of saying "Thank you, but no." At the EAR office, the secretaries looked aggrieved and shell-shocked, and I was waved in to the chair's office as if my presence were an annoyance.

Summerscale had worked fast, either moving the contents of a whole room at home to this office, or he'd called Rent-a-Cliché. The room had been utterly transformed into the vision of a manly intellectual's lair: green velvet drapes blocked the windows; mahogany bookcases held antique-looking sets of Dickens, Thackeray, and Balzac; and hunting prints and framed autographs covered the walls. The chairs were all leather and the mammoth desk teemed with enough Levenger catalogue desk doodads to stock a raffle. The file cabinets were oak, and I noticed that the floor under them must have been sagging, because they did not line up well at all.

Summerscale loomed behind the desk, stony-faced, dressed in a heavy dark tweed suit and thick black turtleneck. In keeping with the office's new appearance, he looked a bit leathery himself. "Please sit down," he said, not reaching out to shake my hand. He didn't even gesture, and the deep creases in his forehead and on either side of his nose looked harsh and minatory in the relatively low light.

The leather chair was comfortable, but I wasn't. In fact, I was starting to feel trapped.

"You know, Nick, I don't like your attitude."

"What?"

"There! That's it exactly—that hostility and contempt."

I gulped, hoping my throat didn't sound contemptuous or hostile.

"You have a hostile expression, Nick. I've seen you look at me. Even your body language."

I didn't move.

"And you're uncooperative. Snide. I asked for your help and you wouldn't give it to me."

Earlier in the semester, Summerscale had urged me to join him in some kind of wild campaign to purify and cleanse the department of whatever he saw as filth. It had sounded lunatic, and I had no intention of being his minion.

I tried to mollify him. "But you had just gotten here—"

"Are you implying I'm lazy?"

"No! I mean that you weren't chair when you asked me...."

"That makes it worse, much worse. You're an opportunist, too."

He shook his head and I felt like I was in front of the Red Queen shouting, "Verdict first, trial afterward!"

Summerscale wasn't done. "You picked the wrong horse to back in this race. Juno didn't win, neither did Serena."

"But I didn't pick anyone!"

Now he glared at me as contemptuously as if I were a teenage driver and he was a state trooper giving me my first ticket.

"Couldn't even make up your mind. Pathetic."

Clearly, nothing I said would pass muster with him, and being silent was just as bad. Even if I were to pass out and crash to the floor, he would probably object to some aspect of my coma.

Summerscale sighed grandiloquently and seemed to be trying to arrange his features in a smile, but Sisyphus had better luck with his stone.

"Listen, Nick, these are the things I want you to do: Be a team player. Get along. Contribute to the group welfare and well-being."

"Be part of the solution, and not the problem?"

I expected him to thunder his disapproval of the cliché, which had popped out despite my efforts to keep from quipping, but he said, "Yes. That's it exactly." He waved his hand like a Roman emperor belittling inadequate tribute, and I was dismissed, not sure what the hell he wanted from me and what I had agreed to, if anything. I was so rattled that I didn't call Stefan about the meeting on my drive home, and in fact when I got home, I parked in the driveway and headed across the street first to the look-alike Colonial our friends Didier and Lucille lived in. Didier greeted me at the door in a robe. "*Salut*, Nick!" he said with more enthusiasm than he'd been exhibiting lately. "Come on in—I was headed for the hot tub." Exactly what I needed.

Lucille was away for the semester at Duke, and Didier was often alone brooding over his second career. Born in Quebec, Didier was a sixtyish ex–high school English teacher who looked exactly like Mr. Clean except for the earring. After retiring, he'd sold a memoir for a massive advance, a book about his and Lucille's years-long attempts to have a child. But following a corporate shuffle, his publisher was

easing out of its commitment to the book's success, and Didier was in despair. He'd planned on being the next Frank McCourt and now he was just himself. It didn't look like he'd have much of a book tour or advertising or TV interviews or anything.

But thanks to his advance (which the publisher at least wasn't asking him to return, even partially), he still had plenty of good scotch on hand, and I joined him out back for two fingers of Bowmore thirty-year-old Islay single malt and a soak in his hot tub. Despite his age, Didier was very fit, as tight and tanned and bulging as a club chair, and I often felt his superb physical condition as a kind of quiet accusation that I should be taking better care of myself.

Still, I felt less self-conscious than usual stripping down in front of Didier and sliding into the steamy water. Was it because I somehow felt more masculine, being attracted to Juno? God, that was seriously screwed up.

"Have you lost weight?" Didier asked. "You're looking leaner."

"Really?" I eased back to enjoy the setting. "Thanks."

Though their house was identical to ours, the plot sloped behind the house, which made the four-person hot tub on the two-level deck more scenic, while a six-foot fence gave it privacy. The usual lavish deck appointments—a wrought iron mosaic-topped table and matching chairs, and a mammoth Frontgate cooking island/grill— were stored for the winter. Sometimes I fantasized switching houses and what we could do with Didier and Lucille's backyard, though Stefan gently mocked my reveries, suggesting a ruined temple, sheep, and a reflecting pool with island.

I loved the hot tub in this weather, loved the chilly air on my face and neck and the way it made the rest of me even warmer. And now, it was also a relief not being inside the house, which was an oppressive example of Christmas excess. Porcelain Santas (with reindeer and without) grinned from every bookcase and shelf; large and small red velvet bows decorated chair backs, picture frames, and doors; angels and sleigh bells hung from all the doorknobs; strings of flashing lights wound through curtain rods, around window frames, and up the staircase; miniature glass Christmas tree ornaments studded each

house plant; the crèche on the sideboard was as intricate as a fanatic's miniature railroad setup; and the Christmas tree itself was so densely packed, swathed, and gleaming you could barely see an inch of green. It was as busy as a Dickens novel and made me feel just as itchy.

Didier stretched his brawny, thick dark arms along the back of the hot tub, luxuriating in the heat. A real gym rat, he and Stefan worked out together and both had better upper body mass and definition than I would have even if I took steroids and worked out eight hours a day with Jake the Body. I was actually glad to have gotten off the treadmill of weight training, which I had never really enjoyed or found very effective. The view of other men might have been good, but you could just as easily buy a skin magazine or watch a DVD and sweat a whole lot less. When I swam, I was removed from voyeurism, competition, from everything but my own enjoyment.

"You know, sitting here makes me forget what a hole this town is," Didier complained. He had been living in Vancouver and had come to Michiganapolis because of Lucille's position at SUM.

"It could be a lot worse."

"How? There's nothing here—no culture, no art film house, no decent deli, nothing. It's having SUM here that kills it for me. All those jerks at the university pretending they're better than the yahoos in town just because they have degrees—they make me want to puke. Maybe if we were in the wilds of Bolivia it might be worse, eating llama steaks, but I doubt it."

"Do people eat llamas? I thought they were only prized for their wool."

"*Arrêt!* That's not my point." Didier went on grousing about Michiganapolis's faults, and while there was some truth to his complaints, I knew he was really upset about the fate of his book. He'd never complained like this about Michiganapolis before the bad news from his publisher.

Considering that Stefan and I had both grown up in New York, we'd adapted very well to life in mid-Michigan. At first I missed the theater, but discovering the Stratford Festival was a few hours away

by car made a huge difference, since we'd ended up seeing more plays in a summer than we ever did living in or near New York, including shows that went on to open on Broadway, like Christopher Plummer's *Barrymore*. Chicago's Art Institute was plenty of museum for me, and a nice excuse to take a weekend out of town, and we'd seen amazing exhibits there of Sargent, Monet, and Van Gogh. As for delis, well, my life hadn't revolved around pastrami for a very long time.

Didier eventually fell silent, and after a while, he said, "Something on your mind?"

Chapter Six

I NODDED, and although I'd imagined I might tell him about Byron Summerscale or Peter de Jonge, I actually found myself spilling the whole story of my "thing" for Juno, if that's what it was. I explained about her having had me over for dinner recently, and how sexual the conversation had become. I felt comfortable telling Didier because I had never met a straight man who talked about sexuality so readily and with such quiet confidence about himself. Even better, he was completely relaxed around me and Stefan. He also wasn't judgmental about anyone's private life and he took a lenient view of his wife's extramarital interests, though I didn't know any specifics about what they were, and didn't want to know.

"Sounds pretty hot," Didier said. "And you and Juno went gun shopping together? *Mais, ç'est super!* 'I'll show you my gun if you show me yours.' "

"It wasn't like that. The gun was separate. I think."

Didier shrugged. "Good food, good booze, hot momma, and a gun—how can you separate that? It all goes together—it's the American Dream. How did it start—with the gun, I mean?"

I took him through every nuance of applying for the permit right down to the color of the form I signed, and he was as hungry for the details as if I were describing a holiday in his favorite city.

"Amazing. How did it make you feel?"

"Freaked out."

"I'll bet. And what was your idea? You would go after who was harassing you like Clint Eastwood?"

"It's not like I was planning on shooting anyone. First thing, I don't know how. I wanted a gun to feel safe."

"You Americans are *dingue*, you're nuts. Well, just don't shoot yourself, whatever you do."

"I haven't bought one yet, and I would need to go to a firing range to practice. Juno said she'd come with me."

"Juno and you at a firing range? I can just see her standing behind you, helping you squeeze your trigger, pressing herself against you, squeezing her trigger...."

I flushed at the image.

"To coin a phrase, Nick, it's a pretty loaded situation." He grinned.

"But do you think Juno's serious?" I asked.

"About guns? No? About teasing you? Women are always serious about teasing a man, any man. It's a passion for them. They excel at it. And she mentioned Cash Jurevicius to you when you had dinner, you said? Then it's certain. Women love riling you up by talking about other men. Classic technique, trust me. You said she talked about sex? Dead giveaway. Didn't it work?"

"Yes. No. That's not the point. Do you think Juno's interested in me? Seriously. I can't figure her out."

"*Mec*, that's just what I'm saying to you. She's serious, all right. Seriously screwed up. Nick, that *pitoune* wears leopard-print everything—she's a cat—she likes toying with you. I'm telling you, sadism is what women do best. And someone like her—" He gave a Gallic shrug. "She's a champion, I bet."

I didn't ask how his assessment of women connected with all the battered wives and girlfriends out in the world. Or if he even classed his wife as a sadist. And I didn't bother asking what the Québecois slang word he'd used to describe Juno meant; it sounded nasty enough.

"So, what does Stefan think about all this?"

"I haven't told him."

He said, "Okay" flatly, but it was a question.

"But why me? Why did she pick me?" I sipped some more of his amazing scotch. Didier could rhapsodize about all its various tastes and aromas—I just enjoyed it.

"It's not as if you aren't handsome enough. But hey—maybe Juno's never fucked with a gay man's head and she's having fun. Branching out, eh? Sounds like maybe you want to do some branching out yourself."

I muttered.

He frowned. "Spit it out!"

"I don't know."

"Don't know if you're really gay? Are you kidding? Are you bisexual?"

"I don't know. I don't think so."

Didier laughed. "You're not a teenager—you should have figured it out by now, eh?"

I thought of Olympia Dukakis asking Daryl Hannah in *Steel Magnolias*, "Are you married or not? This is not a difficult question."

"I hate that word," I said. "Bisexual. It gives me the creeps."

"What's wrong with it?"

"I still remember how it was so trendy in the seventies. Like mood rings. Pet rocks. And *Saturday Night Fever*."

"But isn't bisexuality hip again, with all those kids who say nobody should define them one way or the other?"

"That's what I mean—it's just a pose. Some frat boy gets high and dances with another guy at a rave and suddenly thinks he's cutting edge."

"Forget him—what about you? You're telling me you've never wanted to sleep with a woman before? That it just popped into your head? Into both heads, just like that? Now? Haven't you done therapy? No? But you're a writer—how can you not have gone deep inside yourself?"

"Jesus, Didier, I'm not a writer, I'm a bibliographer. People compliment my facts, not my prose."

"So, are you worried about your students?"

"What do you mean?"

"Because you're a role model—"

"Me? What the hell kind of role model would I be? I'm a bibliographer! Who looks up to that?" Even as I said it, I remembered a recent graduate student in EAR whose feigned admiration for my bibliography had almost snowed me. "I don't have tenure and I'm unlikely to get it. And I'm a walking PR disaster with all the murders I've been involved in."

"Not that. I mean you and Stefan being together so long. For—what?—over fifteen years? That's got to mean a lot to some students. Hell, most marriages don't last that long."

"I don't talk about my private life in class. Or in my office. Neither does Stefan."

"Okay, so then what's the big deal, anyway, if you *are* bisexual? I don't get it."

I couldn't answer that because I didn't know, though I suppose it wasn't as bleak a fate as being a closet heterosexual.

Didier continued, "Don't married women with kids suddenly figure out they're gay and it just hits them? Happens all the time, no? They're forty, fifty years old, they never had a clue, and suddenly Michelle Pfeiffer looks a little too good to them?"

"Yeah, you hear about it."

"And didn't Stefan once sleep with a woman?"

I nodded. "He was in love with her. He even put her in one of his books. And boy, did he get slammed for it."

"By her? No? Then why?"

"Because lots of queers freak out at the idea of crossing the line to sleep with someone of the opposite sex. It shakes things up. They get confused, and angry. He got letters accusing him of betraying the Cause."

"Is that what you're afraid of?"

Once again, I didn't know.

"Even though the book's been out of print a long time, once he put up a Web site, people wrote nasty things in the guest book,

which is why he gave that up. And they've posted on Amazon.com about it, on the pages for other novels of his, really bitching him out. At least Amazon got rid of the stuff when he complained. It was like 'tagging' a train. Cyber graffiti."

"Punks," Didier said. "Yahoos. Schmucks. *Petits cons*." I'm sure he was thinking of his publishers.

Didier's vehemence turned me around. "I can see their point, I guess. They get so many messages about how sick they are, so anything can attack their self-esteem and make them feel inferior." I was a bit drunk and on a roll. "The idea of a gay man being attracted to a woman is too shameful for them. It upsets all their categories. They're responding out of a deficit, out of internalized homophobia and shame. Otherwise it wouldn't strike so deep—"

"Can the psycho-babble! A novel isn't a mental health guide and people who don't know the difference are pathetic. Nobody knows how to read anymore! They think everything is about them, not about discovering something beyond what they are, and they complain if they have to look up one lousy little word or they don't understand a reference. Your Philip Roth is right—there are hardly any readers left anymore. *Real* ones."

"He's not my Philip Roth. Or Stefan's."

"He's an American, no? And Jewish?"

I finished my scotch and asked him not to say anything to Stefan about our talk, since I hadn't shared with Stefan my confusion about Juno.

Didier shrugged. "Not a problem," he said, but I could tell he also believed I was making a mistake by keeping it from Stefan. "There's nothing wrong with being fucked up," he said. "I'm quoting Jung."

"Jung never said that."

He shrugged. "What he said, truly, was that the great problems of life are never solved."

"That's uplifting."

I suddenly felt embarrassed to have revealed so much to Didier. I grabbed a towel and hurried inside to dry off and get dressed.

Stefan greeted me as sunnily as if the wild meeting we'd lived through had never happened. I told him that I had stopped by Didier's and had a soak in the hot tub.

"Great! Has he added any mechanical figures? Santa and his elves? The Massacre of the Innocents?"

"It's turning into a Macy's Christmas window over there, isn't it?"

He shook his head. "I never would have thought Lucille and Didier would go overboard like that on Christmas tchotchkes."

"Me neither. I would have pegged Didier for the kind of guy who gets depressed at Christmas, but he seems more cheerful lately."

"It's all that glitter in the house," Stefan said. "It's working like light therapy." In the kitchen we cut slices of buttermilk coffee cake and sat at the island with cups of fresh Kona.

I told him about Summerscale's weird, vague threats.

Stefan got very quiet. Then he said, "We just have to keep our heads down," as if continuing a conversation he'd been having with me in my absence. "Teach our classes, live our lives. Let the university go down in flames if that's what people want to do with it."

"And carry a fire extinguisher at all times?"

He didn't lose focus. "We stay neutral about Summerscale, stay out of trouble, and keep our heads down."

"I hate that expression," I said, but Stefan was on a roll and didn't deal with my complaint.

"My classes don't have anything to do with Whiteness Studies, neither do yours, so we'll just ignore it." He looked as pleased as if he'd handed me a gift.

"Well, I may not have any classes, soon. You know they're going to can me."

He vigorously shook his head. "Glinka's already forgotten you. You're not important enough. She's out to destroy the whole department, or at least Summerscale."

"But if she does that, it has to affect us. You can't pretend it won't be happening."

With a Patrick Henry steeliness in his voice, "I intend to live in denial for as long as it takes."

"Why just keep our heads down?" I said, disgusted by the image of being subservient and inoffensive. "We could prostrate ourselves. But of course there's always the danger of being stepped on...." There was an old Yiddish expression, *"Shah, shtill"* that meant stay quiet and you'd be all right. But it certainly hadn't turned out that way for the Jews.

"Oh, I forgot, Peter de Jonge called you—I heard your answering machine."

"It's not important. Tell me more about this Club Med."

Stefan grinned like a drunk at Mardi Gras who'd been tossed more beads than he could possibly wear. As he unreeled his travelogue, I thought with relief: the Caribbean. Club Med. Sunshine and isolation, good food, and doing nothing I didn't want to do, far away from the cold and SUM, Juno and Peter de Jonge and violence and everything else that was making me crazy. And we didn't have to wait until March, we could get away *now*.

PART II:

Flying Down to Rio

Chapter Seven

"I HATE small planes," Stefan muttered for the fourth or fifth time since we'd flown out of Nassau on the hour-long flight to the tiny island of Serenity. Barely habited and probably best known for its Club Med of the same name, if known at all, the island was further east than any other island in the Bahamas. Christopher Columbus had supposedly stopped there first, but I suppose he had moved on, unimpressed, and hadn't bothered to name his discovery. "Serenity" came later.

"At least it's not a prop plane," I said. "It's a jet."

"It's a *small* jet."

"Stefan, there are thirty seats."

"That's what makes it a small jet," he repeated.

"At least we're not dancing on the wings!"

He looked blank.

"You know—like in that Fred Astaire and Ginger Rogers movie? The chorus girls?"

He shrugged, too uncomfortable to enjoy or even track the reference. For a man whose idea it had been just a few days ago to fast-forward our spring vacation, and escape Michigan snow and campus madness early, he was surprisingly unhappy.

I would have flown in the tiniest plane available just to leave behind worrying about tenure and Juno, as well as all of the semester's

disturbing events: the provost's coup, EAR's Diversity Tree, the faculty riot, the student protest, my run-ins with Serena Fisch, Byron Summerscale, and the provost's stooge Mooney-Mauser, shopping for a gun with Juno, and the quixotic decision to help Peter de Jonge, then backing off. The Caribbean was even more anodyne a locale than northern Michigan, where Stefan and I had a getaway cabin, so how could it not be a restorative week?

But like so many of life's gifts, the trip came with a sting. Already! For me it was leaving Sharon in New York. Cell phones apparently didn't work on the island we were going to, and we'd been warned that the phone lines were often jammed. I knew that between her parents and good nursing care, she wasn't in danger of being or even feeling neglected, yet it bothered me to be colorfully going about my life so soon after she had faced losing hers. She was eager to be able to swim again, to do yoga, to fly. What would be possible and when, no one could predict.

"Don't worry, I have my books," she'd assured me. She had taken up Agatha Christie and Ngaio Marsh again, and she found those classic mystery writers as comforting as cocoa with a shot of rum.

Stefan had no such worries, but he had his perpetual sensitivity about his career, and it had been ruffled by bringing the wrong book as his first vacation read: a recent hot new literary novel which had been slavishly well reviewed all across the country as "dazzling" and all the rest of that critical bushwa. It was that current cliché: a "brilliant debut novel." There are so many of those around, I don't know why bookstores don't have a separate section for them, and publishers don't automatically stamp them "BDN."

Stefan was hating the 600-page saga of a dysfunctional family. Vocally. "God," he grouched while reading in the plane from Detroit, in the airport on Nassau, and even now en route to Club Med, as he picked it up and tried to continue. "This is just recycled Anne Tyler!" He'd also named Salinger, Bellow, and even John le Carré in his various sad tirades. "He doesn't have anything new to say. Why did I bring this?"

I smugly fondled my copy of *Georgiana, Duchess of Devonshire*, a

big fat dessert of a book. It had history, politics, sex, and great clothes. Perfect for the beach, beside the pool, or on a balcony with an ocean view.

Stefan relented for a moment. "Well, he's a gifted stylist, and some of his sentences are breathtaking."

"You know, sentences are fine, but what about the story, the characters, the setting, the action, the psychology? I'm sick of reviewers going on and on about individual sentences. Did they say that about Austen or Faulkner?"

"Or Edith Wharton. Point taken. This is awful, whiny, badly edited stuff. So why is it so successful, why did he get a two-page spread in *Newsweek*?"

It was an unanswerable question. Living with an author, I had come to suspect that some books had good karma—they appeared at the right time, won the right adherents, were praised in the right newspapers. It was as simple—and mysterious—as that.

"Anyway," Stefan concluded, "I can't believe people will be talking about this pretentious crap ten years from now."

"Right—they'll be talking about some other pretentious crap. Hey! Maybe someone will write an homage to *The Hours* by then—wouldn't that be even worse than *The Hours*?" We'd both howled at the novel's excessive prose, which America's reviewers and readers seemed to think was, of course, "brilliant." There was one particularly appalling image where an aging hippie was compared—seriously, sensitively, poetically—to a woolly mammoth. It was so bad, it felt like a tongue-in-cheek entry in the annual Bulwer-Lytton contest of bad writing.

"Don't get me started on *The Hours*!" Stefan smiled, and having purged himself for a few moments, he was silent. We both studied the dull blue water below, stirred here and there by waves. It's not that I expected buoys with signs saying THIS IS THE CARIBBEAN, but so far it wasn't very dramatic. Stefan sighed a little.

Since the owners and operators of Club Med were French and Stefan spoke it fluently, I tried cheering Stefan up with a subtle reminder:

"This is an amazing opportunity, coming here. We've never done anything like this—it might give you ideas for a book. *Il ne faut pas passer des bonnes choses,* right?" That was something like "don't look a gift horse in the mouth," at least I hoped it was.

He grinned. "Your accent is so American," he said. "I don't understand."

"Neither do my parents." As Belgian Jews they had spoken French to me from childhood, good French without Belgicisms, but it had somehow never taken, whereas Stefan had only studied it in school, but could speak French without any trace of American accent or inflection. It wasn't that he was mistaken for French, but he was never assumed to be an American, and that was a gigantic plus when traveling in France, whether in Paris or the Dordogne. Waiters, chambermaids, store clerks almost always said, *"Mais vous parlez bien, Monsieur,"* and asked where he had learned to speak so well.

I'd always thought it a double-edged compliment because it said that people knew he was a foreigner even though they thought he was doing a good job, but Stefan invariably beamed and thanked them and launched into annoyingly idiomatic chat that earned him the highest praise: a conversation. I'd nod and smile, hoping that no one would say, *"Et votre ami? Il ne parle pas français?"* because then Stefan or I would have to excuse my silence by saying I was the son of Belgians and we'd get an invariable dismissive shrug that meant "Nobody's perfect." It let me off the hook, since the French mock Belgians for their accent and supposed stupidity, but it wasn't comforting.

Well, Stefan might have the advantage in speaking to people, but I knew a hell of a lot more about Club Med than he did. Determined to learn more than what was in the packet of information Stefan had received from our travel agent, I'd searched the Web and found some surprises.

I'd always thought of Club Med as a mecca for swingers, and totally trashy, but I was wrong. Club Med had been founded after World War II to make life more beautiful, to "create an alternative way of experiencing time, leisure, and work, beyond cultural differ-

ences and social barriers." While sports and other activities were always at its core, so were seminars and forums with an intellectual bent. In recent years, Club Med had moved away from these, but the new CEO wanted to broaden the resort chain's appeal, and they had held literary conferences around the world.

We'd originally been talking about going to a Club Med in Cancún, because neither of us had been to Mexico before and we were curious. This particular Club Med on Serenity Island sounded more isolated and quiet, though. It had some of the best diving in the Caribbean, not that I cared, and attracted many repeat visitors from France who had written glowing reviews on-line.

"There it is," Stefan said, and we were circling around to land on a tiny island covered with palm trees except for a few spots, one of which was a small landing strip, where another much smaller plane was parked. We could also make out a large straggling collection of brightly colored square buildings along with some larger, drabber structures. That was Club Med, spreading like a gated semicircle back from bright white sand fronting water that was alternately blue and green and turquoise. Stefan was smiling, as if he had longed for just this view at just this moment. His fear of small planes seemed to have vanished.

Our arrival was clockwork chaos as a team of young tanned men in chino shorts and red polo shirts with the Club Med trident greeted us warmly outside the plane. I knew from my reading that in Club Med parlance we were called GMs *(gentils membres)* and they were the GOs, the *gentils organisateurs*. The GOs welcomed us in many languages while plucking our bags from the plane, hauling them into an arrivals building that was more like a painted shed, checking names on a list and simultaneously herding us toward clownish green buses with enormous windows and tiny seats. The heat and profusion of palm trees made me feel I was in a dream where my limbs had turned syrupy. As we rattled off down a dusty road lined with orange, purple, and white hibiscus, I wondered if this would be a truly relaxing week. The setting seemed as unreal as a painted backdrop, and as insubstantial.

Swaying next to me, Stefan said, "Having doubts?"

"Don't I always?" I added, "'But I intend to crush them,'" quoting from *The Importance of Being Earnest.*

We passed through a gate with a guard house, and were soon driving up to what looked like one of those sprawling colonial plantation houses from 1930s movies with a deep, shady veranda stretching its length. Our bus shuddered to a stop on a circular gravel driveway and the gray-brown building spread around us in a gentle, irregular semicircle. I assumed it was the Club's main structure, though I couldn't recall having seen it from the air.

Feathery palm trees swayed over the building and framed or structured every view, and the deep, shadowy eaves of its sharply pitched red tile roof made the veranda very inviting. The simple railings and posts were painted glossy white and the veranda was dotted with white wicker couches, chairs, and tables—everything spotless but slightly worn at the edges, with masses of bougainvillea framing the scene as if each shrub had been planted by a set designer. It was very tropical, of course, but under tight control.

I heard the slap and *shoosh* of waves from the other side of the building, and from where we stood I saw an office, a reception area immediately to its left, a game room, and what looked like a pro shop at a country club. Dozens of people padded by in tennis clothes, bathing suits, shorts and tank tops, everyone tanned and relaxed, though the GOs were the darkest as well as the youngest and most attractive. The air was still and clean and though the sun felt very bright, it wasn't hotter than the high 70s, and I couldn't feel a trace of humidity. What I could feel was Stefan unwinding by my side, and before we could figure out what to do next or someone told us, a tall, lanky, dark man with reddish blond hair who looked very like Richard Chamberlain swept out of the office to our right and headed over, his big tanned right hand extended.

"Bruno Zaragossa," he said. "I am the *chef de village.*" There was no drum roll, but there should have been.

Chapter Eight

STEFAN and I glanced at each other, both of us obviously wondering if this was a typical greeting.

Zaragossa's teeth were as white as the wicker chairs he guided us to on the veranda in front of his office, or the white moccasins on his long feet. His title meant he was the manager of this club, and in keeping with the colonial feel of the place, he carried himself—at no more than thirty-five, I guessed—with indolent authority. The tan shorts and red Club Med polo shirt looked more like a uniform on him than on the younger staff. He was focused on welcoming us, but I could sense him taking in everything that his staff was doing around us, watching, judging, recording. He was genial, but tough behind that showy smile and the perfectly manicured strong hands. I didn't think I would like working for him, despite his making good scenery.

Around us, other tourists were being taken charge of by a swarm of GOs, who included young women now.

"I recognized you from your photograph," Bruno said, as fruity-looking red drinks appeared at our table. Stefan smiled, but stopped when Zaragossa said, "I am a large fan of Edith Wharton, and your book was fascinating."

I had never had my bibliography complimented by someone so

handsome and in such a setting, the moment made even more exotic by his pronouncing Edith as the French did, "Ay-deet."

"Really?"

"A very underrated writer, I believe, especially her later novels—like *La récompense d'un mère*, which I confess I read in French first before the English. I am, in fact, reading it again, now, but also in French. She is perhaps more crisp in French, I think."

I loved *The Mother's Recompense*, too, for its fascinating portrait of a curious love triangle. Bruno's first comment was exactly what I believed and had written about in various articles, studying the critical neglect of those books, which I found quite deep and affecting, though they had long been dismissed as magazine hackwork.

I was so flattered I wasn't sure what to say. Then I asked, "Are you Spanish?" I sipped the sweet drink and wondered if there was alcohol in it or just sugar.

Bruno nodded, and I noticed he held his head slightly tilted, up and to the right, as if he had some kind of neck problem. It was a cross between odd and dashing.

"That's a good guess," he said genially, without an accent. "But no, my father was French, my mother Dutch. I was actually born in Amsterdam. The Spanish is some generations ago."

"Your English is terrific," I said, glaring at Stefan to warn him not to break into his perfect Tour-de-France French and leave me following along on my linguistic tricycle. To successfully negotiate an interaction like this in French after the flight from Detroit to Miami, Miami to Nassau, and Nassau to Serenity, I would have had to imagine it all in advance and practice questions and replies in my head before I'd be able to speak smoothly, without embarrassment. The last thing I wanted on my first half hour of vacation was to feel left out and ashamed—I had enough of that at SUM.

Stefan got it and nodded.

"Thank you," Bruno said, in reply to my compliment about his English. "I spent a year in Boston as an exchange student," Bruno explained. "And so I read Madame Wharton in English. I prefer it. We must talk of her while you're here, and other things." That

sounded a bit murky. I wondered if Bruno might ask me how to get published, which is what most strangers do when they find out you're a writer, even a bibliographer. Everyone seems to think he has a book in him, perhaps because the publishing world churns out so much trash, but in my experience, most people are unlikely to have more than a greeting card.

Bruno handed us two gray forms to fill out, and said he would be back in a few minutes to personally take us to our bungalow when we were finished. "And perhaps a little tour of the village en route if you're not tired?"

Before he could cross the ten feet to his office, the woman GO behind the reception desk called him over in a stage whisper. Tall, busty, athletic, she looked like she wanted to vault over the counter and assault him. Bruno sighed and went to the high glossy desk where he leaned in for a short, sharp conversation whose words I couldn't make out. But their tone was unmistakable. She was angry, Bruno was dismissive; in fact, he turned his back on her while she was still berating him and strode off to his office, looking like he wanted to slam the door. He didn't. It was mostly glass. But as he closed it, he was facing me, and he stage-whispered, "Staff problems" and grinned.

I tried not to stare at this GO who was busying herself at her desk, biting her full, pouty lips.

"Angelina Jolie," Stefan observed, studying her through narrowed eyes. "Doesn't she look like her?" He was right. Both of us were huge fans of *Lara Croft*.

"And Bruno could be Richard Chamberlain's Mediterranean cousin. Maybe this is a celebrity look-alike Club Med. You think there'll be a Brad Pitt or Keanu Reeves?"

Stefan groaned. One of his books had been optioned by Reeves's production company but the deal was in limbo for reasons as complicated as the War of the Austrian Succession.

"Sorry—that was stupid. Let's change the subject. What do you think was going on between Bruno and the Beauty?"

Stefan shrugged, glancing down at his card and starting to fill in

the personal information that was requested: name, address, length of stay, citizenship. Then he stopped and dug out his passport to copy the number.

"Stefan, you're a novelist—aren't you curious?"

"I'm on vacation," he muttered, propping open the passport with one hand while he squinted to make out the number and copy it onto the card.

As a dark-eyed, tall, trim GO with a runner's body bustled by, smiling broadly at me, I said, "You have a point." Palm trees weren't the only thing that was omnipresent here: the staff was uniformly and multi-ethnically attractive, as if Club Med had recruited from Gap models. I turned to my information form, as always feeling slightly anxious when faced with anything that vaguely, but menacingly, reminded me of test-taking in high school and college.

"Besides," Stefan said, "You're the one teaching a mystery course next semester, not me."

"But you read mysteries, you've started to, anyway." Despite our having been involved in a handful of our own mysteries, Stefan hadn't started sharing my enthusiasm for the genre until recently.

"I don't like puzzles."

"How can you say that? Everything in life is a puzzle. People are puzzles."

"Right. Puzzles that can't be solved. That's why I like thrillers. Ken Follett, Daniel Silva, Alan Furst. Even when the villain is crushed, you know there's more evil coming, it can't be stopped. It's a holding action. Mysteries wrap things up too much." He put down his pen and I could feel a quotation coming on. I was right. "'The motives of human actions are usually infinitely more complex and varied than we are apt to explain them afterwards, and can rarely be defined with certainty.'"

"Should I know that?"

He shrugged. "Dostoevsky. *The Idiot.*"

"Now that would have made a fun beach read. Why didn't I think of it?" I set my pen down and sauntered over to the counter.

"Hi," I said to the GO, whose narrow white enameled name tag read ANOUCHKA WARMERDAM. Behind Anouchka hung various boards with schedules for arrivals and departures and activities, and hanging clipboards. And at either end of a long rattan console table stood huge round celadon vases filled with hydrangeas, lilies, and stock.

"I need a new pen. Mine isn't working." I gestured back at where Stefan was sitting, without looking at him, because I was sure he was glaring at me. There was a tiny French flag and what I thought was the Dutch one as well at the end of Anouchka's tag and I asked what they meant as she handed me a replacement pen.

"I'm from Holland, and I also speak French." She had the lovely Dutch accent that makes English sound so soft and appealing. Close up, the resemblance to Angelina Jolie wasn't as strong, but she was just as tall and gorgeous, with a golden tan and large green eyes. The taut biceps and vascularity of her arms made me wonder if she did martial arts.

"And English, of course, but then we all do back home." She smiled even more broadly. "You're the writer, yes? From the States? Bruno admires you very much."

I knew from my reading that GOs were supposed to be helpful and friendly, but I sensed she was also making conversation to calm herself down from the little scene that had just erupted between her and Bruno.

"Actually we're both writers." I gestured back at Stefan again.

"Do either of you write detective novels?" Her face glowed with expectation.

"No." The glow flickered.

"What kind do you like?"

"It's easier to say which I don't like. The ones with a dead body on page one, or even in Chapter One. It's too obvious. It feels to me fake."

As if trying to impress her, I said, "I'm teaching a course on mysteries next semester."

"Ah."

Still trying to be interesting, I said, "I like Janwillem van de Wetering a lot."

Now she smiled. "He's been here! He enjoys the diving."

When I sat back down, Stefan leaned forward. "Are you done, Sherlock? Did you find out what happened, what their history is, and which one is trained in martial arts?"

"She knows Bruno pretty well."

He frowned. "How'd you figure that out?"

"He told her I'm a writer." I didn't add that he hadn't said what kind.

"So?"

"Come on, Stefan, they have to be close. He's the *chef de village*, he knows who's coming to the Club, but that doesn't mean he has to share the information—with anyone. It's not like they're planning an Edith Wharton festival, is it? You saw his face when he was talking about Wharton. It's a passion of his."

"That's a stretch."

"Hey, life is full of stretch marks."

He didn't roll his eyes, but a lesser man would have. "You're so smart, you haven't noticed there's a door connecting the reception area to Bruno's office. Of course they talk to each other. He talks to everyone. He seems like a friendly guy. Now, let's finish these forms and go to our room, okay? I could use a shower and a nap."

"What about the tour?"

"Oh, right." And just as we were done, Bruno rejoined us. "Here are your keys. You're in thirty-six, a lovely view. Your luggage is already there." He handed us cards with our phone codes, white cards for purchases at the Boutique, and white plastic bracelets, motioning for us to snap them on and explaining that they needed to stay on for the duration of the trip to identify us and allow us access to all the facilities. Then he took up our forms. "But you forgot to sign yours," he said to me, and handed it back. I did so quickly, and then he ushered us along the veranda and dropped the cards off at the reception desk without even glancing at Anouchka. We walked

through a cool, shady tile-floored lobby filled with oversized chairs and sofas, the walls hung with masks, shields, and spears that looked to me like they were from the South Pacific. "This way," Bruno said, and we followed him through the building to a wide veranda that matched the one we'd arrived at.

"Wow," Stefan said.

CHAPTER NINE

YES, WOW. The sudden move from the shade into bright light was as stunning as the moment in the movie *Enchanted April* when one of the English women opens shutters in the Italian villa they've rented to expose a lavish view of gold-flecked water. And hadn't we left a landscape as dreary as rainy London in that film?

The whole site seemed to stretch out in front of us, wide lawns lined by enormous palm trees and outlandish cacti, and crisscrossed by stone paths leading off to the left to dozens of what I figured were the "bungalows"—square, two-storied, balconied little buildings in turquoise, pink, sky blue, and banana yellow. The bright colors made them look like toys. Off to our right was a brilliant tapestry composed of the long white beach filled with sun-worshipers, people strolling, kids playing in the clear blue water, adults kayaking and wind-surfing, with the GOs woven through. It had the shimmering quality of a Seurat, made more beautiful by its isolation. There was no neighboring resort, no swollen cruise ship pulling in, not even a real town nearby, or so I understood from the Club Med literature I'd read.

Bruno beamed at us as if the view were his doing. "Lovely?"

Stefan and I chorused our agreement.

"The club is one of the newer ones. Almost one hundred acres, it

went through several hands before Club Med bought it, and originally it was a sugar cane plantation that never did very well. There's quite an intriguing history here and I'm doing research on it for a book."

We were momentarily alone on this section of veranda, and the view was stupefyingly beautiful. Taking it in, letting it possess me was like being wrapped up in seaweed and tinfoil at some day spa and having all the toxins purged from your body. But then the word "book" penetrated my state of ease, and I looked warily at Stefan, who was also worried we were about to be asked for help with getting published. We were wrong, because Bruno waved us down the veranda, slipping behind us so he could be on our left.

I glanced curiously at him and he gave me a wan smile, tapping his left ear. "Deaf. A car accident. I can only hear from my right ear."

Before I could figure out whether to say I was sorry or just ignore what he'd shared we came to a set of stairs that led down to one of the stone paths.

"That's the main house of the former owners," he said, pointing off to our left where a U-shaped, white-shuttered, one-story house painted turquoise spread its arms around a large swimming pool skirted with cracking flagstone. The pool was surrounded by chaises longues, most of them sporting a tanner. Stone urns filled with bougainvillea graced each corner of the pool, and with the balustraded steps up to the house and a mansard roof, it all had a mildly French feel. "The most recent house, anyway. It dates to the early eighteen-hundreds and was built after a hurricane destroyed the older one. There's almost nothing else standing on the property that wasn't built by Club Med. There's been a lot of damage over the years." He corrected himself: "Centuries."

I waited for him to lead us over to the owners' house, but eyes down, mouth twisting, he said, "I detest swimming pools. My baby sister drowned in one and I saw it happen. I will only swim in the ocean. I stay away—it's a superstition, I suppose."

I felt embarrassed that I enjoyed swimming in pools so much.

Bruno proceeded down the steps in the direction of the bungalows and as we followed, we could see the back of the house, which faced the ocean.

"What's wrong with those windows?" Stefan asked, pointing at two windows that were bricked up.

"We sometimes use the house for dinners and special parties, conferences, meetings, corporate getaways, weddings, but those rooms have been sealed. There have been some problems."

Now that we were on a path, GOs passed in both directions, smiling at us and nodding respectfully at Bruno.

Bruno seemed reluctant to continue, so I prompted him, "What kind of problems?" He crossed his arms, turning his back to the turquoise house.

"People say that part of the house is haunted."

"Were there slaves on this plantation?" Stefan asked. "Yes? So is that who the ghost is supposed to be, a slave?"

"No, it's more like a gothic novel. In the late eighteen-nineties the owner was from an English branch of the family, and very eccentric. He was one of many people who believed that the English were the Lost Tribes of Israel, and the real Jews were contaminated and polluted because they had mixed their blood with idolaters. He married a woman from Bermuda, an heiress, and gambled all her money away. It's said he killed her when he discovered she had Jewish origins. No one ever found her body and he claimed she was insane, a chloral addict, and drowned herself in the sea.

"He set himself on fire one night with his cigar while he was asleep. There's no evidence that it was suicide, so it was ruled an accident, even though the servants said they smelled their mistress's gardenia perfume in the room where he was found. Of course it was widely believed that she had come back from the dead to scare him or kill him." Bruno shrugged. His English sounded completely American, but the shrug couldn't have been more Gallic.

I could tell Stefan was as fascinated as I was, maybe more. He had the look of every novelist I've ever seen when he's in the presence of great material: excited, hungry, speculative. I've even seen writers

look envious at a conference when another writer talked in the hotel bar about being put in prison for tax evasion.

"Servants refused to work here afterwards and the son abandoned the property and moved to the U.S. to join relatives. His father may well have done away with his wife, but I don't believe in the ghost story," Bruno said dismissively. "My bedroom is on the second floor on the other side and I have heard nothing. Complete quiet. Still, the property *is* haunted in a way. Descendants of the family come here almost every year on vacation from the Midwest. Perhaps you saw a small private jet at the airport? That's their plane."

"They can't let this place go," Stefan observed, eyes dimmed by imagining who these people might be. "Even though they don't own it anymore."

"But why are the windows blocked up?" I asked.

"They were the missing woman's bedroom and sitting room. People who have used the rooms have been…uncomfortable. " He spat the word out a bit contemptuously, and waved us off as if away from a bad smell. He was clearly uncomfortable himself about this whole ghost business, though he would have to deal with it if he were writing a book about the island. And while he might be too rational to believe in ghosts, he did tell us the story, so it had to have some kind of hold on his imagination.

"What's it like inside?" I asked.

"Really quite beautiful," Bruno admitted. "The main rooms."

"I'd love to see it."

"That can be arranged," he said, his enthusiasm dimming considerably. Then he changed the subject: "Are you familiar with these theories?" Bruno asked us. "That the English are the real Jews? They were new to me."

"It's now called Christian Identity," I said. "That's what it's become." I'd read this in an article about SUM's nationally recognized archives covering the Klan, the John Birch Society, and every other radical hate group whether on the right or the left, dating back to the late nineteenth century when Christian Identity thinking took root in Michigan, a transplant from England.

And it seemed that Serenity Island had played some kind of transitional role in that development. Maybe the island should be called Lunacy instead. I looked around at the palms and brightly colored buildings, the radiant cloudless sky. So this place had apparently helped incubate hatred.

"I've read about it, too," Stefan said as Bruno, suddenly trying to distract us, pointed to the small, two-storied, decrepit stone building that was once a chapel but now housed a gym. It worked for me as I contemplated the changed use of the building, and thought, Different times, different religions.

"It was originally a movement called British Israelism," Stefan went on, not focused on the gym or the ghost story. "Very popular. They even had believers in the United States, in Michigan. The editor of Henry Ford's newspaper was one of them and there was an organization which had its first American convention in Detroit."

Now it was Bruno's turn to look fascinated and he handed Stefan his card and asked if he could send him the citations.

We were soon in a little courtyard surrounded by those pretty-colored bungalows and Bruno handed us our keys, pointing to the stairs leading to 36. "Each one has only four rooms, two per floor and they all have nice views. I put you on the second floor, I thought it would be quieter." He turned, then turned back. "I forgot these." He handed us a little stapled book with different colored pages. "They're for your drinks, with my compliments. If you use these up, let me know and I'll give you another. You don't need to pay for them."

Stefan grinned at me. I could tell he was thinking what I was: no one had ever before treated me to even one drink on the strength of my bibliography.

We thanked Bruno, who said, "*Vous êtes comme chez vous*, feel at home here and do as much or as little as you like." We climbed the white stairs to our room. Each floor of the bungalow was surrounded by a white-railed porch reminding us of the veranda at the main building. I couldn't hear anything from any of the neighboring bungalows, but then it was midafternoon and I supposed everyone who

wasn't at the beach was napping, or having (quiet) sex. Stefan led us to the door and when he opened it he let out another "Wow."

We closed the door and wandered about. As Bruno had said, our bags were waiting. The tiled-floor room, easily twenty by twenty, was decorated in sky blue and lime green floral prints, graced with glistening rattan furniture, and the air-conditioning had cooled off every square inch to perfection. Colorful framed Club Med posters from various years lit up the creamy, glossy walls, and elaborately carved wooden shutter doors framed the sliding glass doors to the white-railed balcony and a picture-perfect view of the sea. Adjoining the spacious bathroom was a large dressing area with a safe. Everything seemed brand new and very welcoming.

There were two large bottles of water on a desk laden with brochures and information about Club Med in general and this club's schedule of activities, and Stefan poured us each a glass. There was also a bottle of Beaujolais, with two wineglasses and a note from Bruno to me: "It's not The Mount, but I hope you will enjoy your stay." The Mount was Edith Wharton's chateau-like home in Lenox, Massachusetts.

"Star treatment," Stefan kidded.

We headed out to the balcony, which was very private since a barrier just like the shutters inside separated us from the balcony next door.

We slouched in the comfortable chairs, slowing down to the rhythm of the waves folding in on themselves.

"The water's bluer than I'm used to," Stefan mused. "And greener."

My reply wasn't restful. "When did you find out about that British Israelism stuff? I don't remember us talking about it before."

"I was checking out the archives at the library, didn't I tell you? About anti-Semitism."

"For a book? An article?"

"Not sure. I just got drawn in. Maybe because of the Michigan connection."

"Isn't Peter de Jonge doing some research on hate groups in Michigan?"

Stefan nodded and drank some water. "Maybe. I think he's fascinated by this whole notion that Jews like you and me—and him—are really descendants of Satan plotting to destroy the white race."

"I love it. The Brits are the real Jews. Margaret Thatcher? Benny Hill? Give me a break!"

"Well, that's not exactly how they see it. The true Jews are all of the Anglo-Saxons and they're in a life-and-death struggle with 'the Antichrist Jews.' We're the ones who cause all the wars and plagues and we're trying to destroy the white race through intermarriage, what they call race mixing."

"You've obviously done more reading about it than I have. Do you think they're dangerous or just crackpots? I mean, what are they planning?"

"The usual. Armageddon."

"And you think there's a book in this? Could you really stand touching this subject? It's disgusting."

"It is that. How about I unpack us after I shower?" Stefan suggested.

"Great, because I want to get down to that amazing beach and wipe out some of this Michigan white skin." It was an exaggeration, since Stefan and I had both done a few sessions at a tanning salon to create a base for the week's worth of sunshine, but compared to most of the people we'd seen already, especially Latin-looking Bruno and the majority of the GOs, we were very pale.

"We're here," Stefan said, squeezing my arm. "Hundreds of miles away from SUM and everything that's been making us crazy."

"Thousands of miles sounds better," I said. "Even if it's not exactly true."

"You're right." He let go, but ruffled my hair as if I were a kid or a puppy and then walked inside and stripped on his way into the shower. I watched his progress. Stefan, a dead ringer for Ben Cross in *Chariots of Fire*, may have been middle-aged, but he was still in amazing shape: a perfect balance of muscular and lean.

While he showered, I stepped back out onto the balcony where the air smelled of salt and sand, with a trace of the stucco the build-

ings were faced in and something juicier, harsher that I guessed might be all the palm trees and cacti. It was both bracing and seductive, an olfactory cocktail. The view was simplicity itself: waves licking and lapping, pale blue sky with absurdly white puffs of cloud, and the long stretch of beach almost as bright. Could you get bored with looking at this much beauty?

I went back inside and dug out my sunscreen and flip-flops, did a quick change into a T-shirt and swim trunks, and headed down to the beach. Downstairs I noticed what looked like a laundry in the basement of one of the bungalows, where a black woman was quietly folding towels at a counter. She smiled at me and then I saw the sign for members indicating they had to show their bracelets to get a towel for the beach. I nipped upstairs to put back the one I'd brought, and then got a towel according to Club procedure.

At our part of the Club, the ragged lawn sloped down to a path that formed a border between grass and sand. There weren't many people around, which made the jaunt more enjoyable still. I trooped along, noting that there wasn't a single cactus that looked like anything I'd ever seen before, and some of them were so bizarrely bristled that they could have been props. Even the trees looked stagey with their ropy trunks and enormous fronds licked by the breeze.

The path divided, leading ahead to the main building and left down to a sandy wide-open veranda with stone steps down to the beach. I descended, passing a thatch-roofed hut on stilts whose sign said BOISSONS/DRINKS. It had an entrance facing me and one on the opposite side, and I could make out some bare-chested revelers at the bar inside, where a beautiful brunette GO was mixing drinks.

The sound of the waves, blending with the happy cries of children and scraps of adult conversation wafting my way were all as enveloping as traffic noise, but the speed and smell were blessedly absent.

There were plenty of empty chairs and I dragged one to a spot that wasn't entirely surrounded by other sunbathers. Several burly pigeon-toed men ambled by, speaking in German, their enormous, hairy bellies hanging down over their Speedos. As Didier had pointed out, I

was trimming down, but even though I was anorexic compared to those guys, I could never imagine wearing anything that insubstantial at the beach. I felt much more comfortable in my knee-length swim trunks, which I rolled up now above my mid-thighs. I wasn't even beginning to relax yet, too much time in crowded, noisy airports made that impossible, but I figured an hour or so in the sun would get me started. And I planned to get plastered at dinner to make sure I'd get a good night's sleep.

I had just finished applying sunscreen, when I saw someone familiar descending the steps from the near entrance to the drinks hut, a hundred feet away. It was Peter de Jonge, shirtless and barefoot, in bright yellow knee-length shorts that made his tan look even darker.

Chapter Ten

HE HEADED right over, with a drink in each hand and a careful smile on his face. He looked very young, the way complete ectomorphs often do if they take care of themselves as they edge toward middle age. His shorts rode low on a taut belly and prominent hip bones. "What are you doing here?" I tried keeping my voice low so as not to attract attention, but it wasn't easy.

Peter handed me one of the plastic cups. "It's very good," he said. "A mojito. It has fresh crushed mint, and rum."

I wanted to slap the cup out of his hand, but I grabbed it and downed half. It was good.

"I thought you needed a drink. You looked pretty tense when you walked by the bar."

"You're spying on me. You're following me. Are you nuts?"

He shook his head calmly and settled down onto the sand, crossing his long runner's legs, waggling his bony feet a little to get comfortable. I sat down sideways on the chaise to face him.

A very young and very blond couple walked arm in arm along the edge of the water, leaning into each other, grinning, giggling, showily in love. A beefy bouncer-type went pounding past them, arms and legs pumping as if he were desperate to stay in shape and not melt away amid all this tropical ease.

"We've actually been here a few days," Peter said reasonably. "We

come here every year, almost. It's gorgeous, and my wife's family used to own all this land, so there's a sentimental attachment, a kind of tradition."

"Your wife's family? Wait. They're the ones who had a plantation, and an owner in the nineteenth century killed his wife and died in a fire?"

He cut his eyes at me. "How do you know that?" Then he answered himself: "Bruno. Bruno told you. He knows a lot of the history of this island, and the Pierces before they moved away. But he's not very popular back home, in Michigan. He's been doing family research in Nassau and he's also asked the Pierces for letters, documents, et cetera. They don't want anything to do with him, it could be very embarrassing. My father-in-law might run for governor some day, and who knows what might come out? It's bad enough there were slaveholders in the family—and that's not even widely known." These were strange, flat comments, but I imagined old scandals didn't interest him and he also seemed to dislike Bruno, whatever the value of his research might be.

"I don't want to talk about that. If you're not stalking me, or me and Stefan, how did we all end up here at the same time?"

"Dr. Borowski, Stefan, mentioned that he wanted to get away from Michigan very badly, and not wait until spring break, so I told him about this particular Club Med location."

"Without telling him you'd be here, too?"

Now Peter looked down into his plastic cup and fingered his soul patch. "You didn't return my call. I thought you might be backing out of helping me."

"I was!"

"Okay. But you're here now—"

"And what am I supposed to do? What the hell is going on?"

"My wife is here with me, and her father, who's president of Neptune College, and his personal assistant."

"Your father-in-law brings his PA on vacation?"

Peter nodded ruefully.

"And?"

"I want you to follow them around, observe them, maybe you'll find something out, hear something, see something. It's a casual place, and a fixed group of people, they won't be suspicious if you keep showing up."

He'd certainly thought this through, but I was still prickly. My getaway from Michigan had turned into a creepy reunion. "Okay, Peter, am I supposed to pretend I don't know you?" I gulped down the rest of my drink, crumpled the cup, and dropped it. Peter handed me his drink, which he hadn't touched yet.

"No, I can introduce you if the moment is right. But they won't suspect you're investigating. Just follow them, follow my wife, see what you can find out."

"You think the three of them are plotting something? About what? Against whom?" Out here on the glorious, breezy beach, away from the claustrophobic SUM, it all seemed loonier than ever, and I wondered if Peter might not actually be disturbed. He seemed calm and plausible, but maybe that's what lunatics were like. No drama, no foaming at the mouth, no dead giveaways. I'd never met *real* wackos, despite being in academia, so how would I be able to tell?

"I don't know what's going on," he said gravely. "But maybe you can tell me."

"Well, what if you're just paranoid because they don't know you're Jewish—" Peter didn't shush me but the way he glanced wildly around to see if I'd been overheard was just as effective, and I lowered my voice to finish "—and they might find out."

He shook his head.

"But don't you worry—and how can you live with a secret?"

"Haven't you?"

He obviously meant because I was gay. "As a matter of fact, no, not something like that. I came out young, thanks to my therapist, who basically told my parents there was nothing wrong with me."

Peter shrugged.

"Well, I don't even know what they look like," I complained, realizing it was not the best way to disengage myself from his mission. Despite my shock at seeing him here and feeling manipulated,

despite the paucity of the information he was sharing, I was mildly hooked. Again! I wasn't a PI, and he wasn't a sexy dame in trouble, yet the situation was enough like those in some of the novels I was teaching next semester to draw me in.

He sighed, as if I had asked a difficult question. "Claire is beautiful, short, dark-haired, and she's had—" He seemed too embarrassed to finish the sentence, so I guessed where he was going.

"She's had work done?"

Peter nodded. "Botox and implants. She looks great, but kind of…fake."

"And what makes her tick?"

"Claire's the only child of a direct descendent of Obadiah Pierce, the parson who founded Neptune in 1836 before Michigan was even a state. Family, background, that's all more important than anything else in the world. She told me when she was growing up, her parents were always saying, 'Remember who you are—you're a Pierce and the Pierces *are important.*'"

"Minor league Kennedys."

"In a way. Maybe worse. They haven't had as much power, and the stage is smaller. Claire's very active in the Neptune Historical Society and everybody defers to her. She basically runs the yearly festival, which has a parade and a home tour. Our house is a Michigan landmark," he said wearily. "Built by Obadiah Pierce himself. It's 1838 Greek Revival, and Claire leads the home tours every year. She eats that stuff up, showing off."

"But strangers trooping through your house, that must be tough."

"It's not my house, it's not my town, I'll always be an outsider." Peter glanced around as if wondering if we were being overheard, but as the afternoon was advancing and the beach cooling off, people had been drifting away, trudging over to a different set of steps— these were wide gray wood and led back up to a higher terrace with shower poles where they could wash off their feet.

Peter seemed so downcast that it occurred to me what he might really need was a shrink and not a PI, even an amateur one. Or may-

be a marriage counselor. He sounded fed up with his wife, but torn by that feeling.

"Do you mind if I get another drink?" he said, rising, and I didn't object. I watched him head to the bar shack, shoulders and head down. Was he in trouble, or merely troubled? I finished my second drink and realized I was feeling a little light-headed. While he was gone, a barefoot woman drifted by in a fuchsia caftan, a sun hat covering masses of curly black hair streaked with gray, and a straw bag that matched her caftan. Her pace was deliberate and graceful even across the sand, which convinced me she wasn't American. She stopped not far off, picked a chair, and started to disrobe. In her mid-forties, she was beautifully tanned and as stacked as Juno Dromgoole was, but as I studied her well-maintained body, I felt no stirring of lust or even curiosity. She smiled at me, companionable but reserved in a way that seemed very French, and then proceeded to coat herself with oil, adjust the angle of her chaise, and settle onto it.

When Peter returned, I had pulled over a chair for him and now we sat as if in a conclave.

"Tell me about your father-in-law."

He snorted. "Franklin Pierce is the kind of guy who wants to buy you a drink but you don't want him to."

"A blowhard? A bully?"

"He's hard to figure out. He's pretty cold, but he can go volcanic over anything. He won't be hard to miss. Red-faced, sixties, tall, arrogant. He's been mayor of Neptune, now he's president of the college, and the board of trustees does whatever he says because he's such a good fund-raiser, and because—"

"Because he's Franklin Pierce."

"Exactly. And if you see someone whispering to him, that'll be his assistant at Neptune College, Heath Wilmore. Have you seen *The Matrix*? He's like the weird guy in the black suit and dark glasses. He's a robot."

"But he must be good at what he does or he wouldn't be down here, would he?"

Peter sipped his drink and grimaced. "It could just be a status

thing, Franklin wanting a retinue, even of one person, but maybe not...."

"Why don't you tell me what you suspect?"

"Because you wouldn't believe me."

"I've heard some pretty crazy stories, I've seen some pretty crazy things." I was, after all, in a university English department which on a good day was a cross between *Village of the Damned* and *Lord of the Flies*.

"Will you do it? Will you investigate for me? I can pay you five thousand a week."

"Seriously?"

He met my surprised glance and held it: a quiet yes.

"I have to think about it."

He lowered his voice. "You have to think about five thousand dollars?"

Actually, I did, though I wouldn't say it directly. He was offering me too much money, he was too urgent. If he was right that something was up that was worth investigating, maybe it was far more serious than I could imagine. Five thousand dollars serious.

I temporized. "I'm on vacation."

"And so are they. And the money would buy you another vacation, just as good. Better, even."

He had me there. So much for my fencing skills. I relented. Sort of. "I'll talk to Stefan about it."

Peter was about to object, but I repeated myself and he backed off.

"Fine. I'm sure I'll see you at dinner."

I wanted to say, "Yeah, I'll be the one skulking behind the bougainvillea." I didn't.

I lay back down on my chair to get some sun and assumed he would slope off. With my eyes closed, I felt the past rise up around me in the crisp smell of sea water, the cry of gulls, the feeling of being encased, cocooned by the sun and the warmth: all the summertime beach houses my parents had rented on Long Island. Though I was a great swimmer as soon as I learned how, I had for many years

been shy on the beach, self-conscious about my body. Tanning, keeping the world out through my silence and closed eyes had been a steady relief.

I may have fallen asleep for a while, or merely daydreamed, but a sense of urgency bolted me up in my chair and I gathered my stuff together to hurry back to our room, not even enjoying the sights en route. When I let myself back in, Stefan was half-dozing in bed and he murmured, "Is that room service? I wouldn't mind being serviced." He'd set up our Sharper Image travel CD player and I could make out the dreamy, jazzy voice of Jill Scott.

He ogled me as I sat down on the side of the bed, but I ignored his lazy excitement. I recalled Whoopi Goldberg in *Ghost* saying that you couldn't just blurt out something startling to someone, and then turning to Demi Moore and saying, "Molly, you in danger, girl!"

I blurted, "Peter de Jonge is here."

"What? Where?" Stefan sat up and looked around.

"At Club Med."

"Are you sure? Maybe—"

"Stefan, I met him. We had a long talk."

"What the hell is he doing here?" Now Stefan looked confused, lines creasing his wide forehead. He pulled over a pillow to prop up one arm.

"What the hell are *we* doing here is the real question. He set us up. I mean, he wanted us here, he wanted me here, and that's why he told you about Serenity when you were talking to him about getting away."

Stefan shook his head almost as vigorously as a dog shaking itself after waking up.

"You're not making sense," he said.

"I know, but why change the habits of a lifetime?" So I explained it all, slowly, from my first conversation with Peter to this most recent one.

I expected Stefan to sputter, or to storm from the bed, or express anger and disappointment in some other way. He just shut his eyes, breathed in, and started massaging his forehead. It was quieter, and

it seemed much worse to me. He turned off the CD player and when he spoke, he was calm, but in that steely, introvert's way of his that always said to me: "Warning! High Voltage!"

"Nick." He paused. "You cannot take money from him. First, he's a graduate student in the department, and he wants to work with me. Do you know how fucked up that is? Second, even if you could, there's got to be some kind of law against it. You can't take money for investigating something. You need a license, you have to be licensed by the state, I'm sure that's true. If anyone found out, you could end up in jail."

It was not the tack I would have expected from him, this legalistic laying out of restrictions, but I responded in kind, sort of. "Hey, it's not like I took out an ad in the Yellow Pages, printed up business cards, and rented an office. He's asking me for a favor." I reached for the open bottle of water on the bedside table and took a slug.

"A favor? You don't even know *what* he's asking you to do." Stefan had seemed to like Peter and sympathize with him because of his hidden Jewish background; Stefan himself had only found out in his late teens that his parents were Jewish Holocaust survivors. They had raised him as a Catholic to try to shed their past and protect his future, but it had been a disaster.

Stefan shook his head and I could tell he was thinking of cutting Peter loose. I could almost always feel when Stefan's "inner voices" were at work, when he was furiously arguing with himself or me, but in silence.

"Stefan, what did you think he wanted, when he told you that he was interested in talking to me because of my crime-solving reputation."

"He's a graduate student—I thought he was doing research—they're always looking for ideas for papers, articles, a dissertation."

"He's looking for a lot more than that."

"Nick. Nick." He could have been a hypnotist snapping his fingers in front of my eyes to pull me out of a trance. "Don't do this. Whatever it is, don't do this. We're on vacation. We came down here to get away from everything crazy in Michigan."

"I know that. But it followed us down. Some of it, anyway."

"The Pierces are very powerful people. They're not the Fords, they're not Motor City royalty, but they're powerful. You should stay out of their way."

I stood and walked to the balcony doors. The view was changed now. The light had a different cast to it and more people were visible on the paths. It was late afternoon and I was starting to feel hungry.

"Aren't you curious?" I said. "Don't you want to find out what's going on? The whole thing is totally bizarre. The Pierces owning a plantation with slaves—the murdered wife—and now Peter de Jonge's suspecting his own wife and father of who-knows-what."

"It's bizarre because you want it to be. You were never like this before we moved to Michigan."

I flopped down into the chair closest to our bed, put my feet up on the matching hassock. "I never saw a dead body until I came to Michigan. I was never assaulted, either. Until I came to Michigan. Whatever my karma was back home, it's different now."

Just as I could sense what Stefan wasn't saying, he could often jump a few steps ahead of me.

Quietly incredulous, Stefan surveyed me as if he were preparing some kind of report. "You want to be a PI, don't you? You want to get out of teaching before you're kicked out and train in criminal justice or whatever it is and become a PI. That's why you were thinking about buying a gun and taking lessons. That's what it was really about."

Hearing it from Stefan made it sound true.

Chapter Eleven

STEFAN slipped from the bed and padded to the stylish bamboo desk to reach for the schedule of activities. He scanned it. "Dinner starts at seven-thirty. Let's go to the bar in the main building." Stefan was totally comfortable in the nude, and totally beautiful, but I didn't comment, not even on his powerful-looking, high-arched feet that I would have loved to massage right then to break the tension between us. It was a discordant moment. I was thinking how hot he was, he was for sure thinking I was crazy.

"You want a drink?" I asked. "We have this bottle of wine." It was not quite 6:00.

"I want a lot of things," he said ominously. "But I'll take a drink. A real drink."

I showered quickly, changed into sandals, taupe cargo shorts, and a black silk T-shirt. In the mirror I could see that I already had a little color from my time on the beach.

Stefan's face was grim when we headed out. He looked good in a blue gauze shirt, long jeans shorts, and Birkenstocks that somehow made his muscular, hairy calves appear bigger. Good and angry.

I didn't push him. With introverts, trying to lure or cajole them out of their brooding can be pointless. He wasn't a surly dog to be tempted by a biscuit.

With the sun starting to edge lower in the sky, the Club land-

scape felt even more secluded and private, despite the paths being filled with a few more people. It seemed now more clearly to be three long crescents set inside one another, radiating out from the water: first the beach, then the grass and paths, then the scattered buildings and pool. The air was cool and I relished the virtual silence, though I could hear some muffled noises from the bungalows we passed. Even though our mid-Michigan town wasn't noisy, there was still car traffic, planes passing overhead, and trains hooting in the middle of the night. All that was gone here—what a gift.

The bar was in a huge, two-story-high gazebo attached to the back of the main building—I hadn't noticed it before when Bruno gave us the mini-tour, but now it was lit up inside and out, and strings of white-yellow lights made it even more festive. Beyond the bar was a deck leading to a large glassed-in building where I could see waiters and waitresses in blue uniforms setting tables.

A dozen or so GOs were clustering in front of the round bamboo-fronted bar with its gleaming copper surface, looking as intent as football players in a huddle. I wondered what their lives were like, since they were required to perform almost every minute of the day: smiling, being helpful and outgoing.

The bartender was Bahamian, I assumed, an older, heavyset black man in a tropical shirt and black pants. He seemed removed from the eager conversation of the GOs, which was mostly English, but shifted now and then to French and Spanish. Removed, but not critical.

"Two mojitos," I said, and he helped me count off the right amount of tickets to pay for them. Stefan closely watched him crush the fresh mint in each glass, and when he had his drink he leaned back against the bar, taking in the view of the beach and the ocean. The square wooden white chairs out on the veranda and the ones closest to the bar were almost all empty at the moment. Perhaps people were still napping between the ordeals of tanning and dinner—or getting dressed. We had packed light, but I'm sure there were people with trunks-worth of clothes. Snacks of all kinds were laid out along the bar, but I'd stopped feeling hungry, though I would be again if the tension between me and Stefan built up any more.

Observing Stefan's silence, I was tempted to quote from *All About Eve* to him, the lines Celeste Holm says to Bette Davis at the beginning of her party that goes wildly off the rails: "We know you. We've seen you like this before. Is it over, or is it just beginning?"

I resisted. Instead, I asked the bartender about the ghost. He shrugged, polishing a glass and arranging limes and lemons in little bowls.

"Some have seen it." There was a crispness to his speech I thought of as very British, even though I couldn't hear much of an accent.

"Have you?"

"A friend of mine, security staff, he said something run by him once at night real fast, from over by that pool, and he could feel it. Cold, very cold. But nothing there. Other people, they say you could see it swimming in the pool at night. Ripples. Hear it, too. And nobody *in* the pool. But that stopped after they fill it with salt water."

"Why was that?"

Now he smiled for the first time. "You asking me? I'm not no ghost. I don't know the rules."

I excused myself for the men's room, which I could see was around the bar and down the veranda on the way to the dining hall. Two men were sitting at a table in the furthest corner, almost right outside the men's room door, arguing quietly. One was dressed in white down to his loafers, and looked like a retired diplomat: perfectly tanned and groomed, with his thick gray hair *en brosse*. The other wore black and was a younger, much trimmer version of his tablemate.

They stopped talking, leaned back from each other as I passed and went into the men's room, but as the door slowly closed I heard the younger one say, "Of course I offered him money. Franklin, he doesn't want money—he wants to keep working and then publish a book." The door looked solid, but perhaps because of all the tile inside the men's room and where they were sitting, I heard them clearly even at the urinals and then when I was washing up.

"That nigger's not going to publish anything about my family."

"He's French and Spanish, he's not a nigger."

Bruno. They were talking about the *chef de village*, it had to be.

"He looks like a nigger. He's a mongrel, anyway, and that's just as bad."

The casual vehemence with which they used "nigger" in a public place, even though their table was secluded, chilled me even more than the air of the men's room.

"Can't we get him fired somehow? Re-assigned?"

"That won't stop him from doing research."

"We'll stop him. We have to stop him."

"I'm working on it," the younger man said as sharply as if he were trying not to pound the table.

I felt trapped there, suddenly. Should I walk out quickly or slowly? Which would make it seem less likely that I'd heard their conversation? I tried for a brisk saunter, not looking at them as I made my way back to the bar.

"What's the bathroom look like?" Stefan asked, and I was grateful that he was talking to me, though the question was asked without enthusiasm. I'd been too taken by eavesdropping, however, to notice more than pale green tile on the floor and walls. Lowering my voice, I said, "There they are, in the corner. Don't be obvious."

"Who?"

"Franklin Pierce and his aide. You won't believe what they were saying—"

"To you?"

"Uh, no."

"If it wasn't something for you, I don't care." He ordered himself another mojito and the bartender studied him as if gauging whether he would be trouble or not. At the moment, Stefan had the simmering belligerence of an inveterate brawler, but it would burn off in the course of the evening, I was sure. It was too unusual not to.

I glanced quickly at Pierce and Heath Wilmore; they were just as Peter de Jonge had described them, Pierce red-faced and bullying, Heath Wilmore thin and insidious-looking.

One of the GOs came over. "I heard you talking about the ghost? I haven't seen the ghost, but I've seen what it does." He was the same handsome GO who had smiled at me on the veranda when we were filling out our cards, and he moved closer to us now, while the others watched him a bit mockingly as if he had just answered a dare and they were waiting for him to embarrass himself. Dressed in long-sleeved midnight blue Club Med shirts and chinos, they were all fairly young, all attractive in various ways, not least for being young, fit, and tanned—and in this setting. Other guests were starting to fill the bar area and the GOs began mixing among them, chatting them up.

He held out his hand. His tag said NIKOS and the flag was the Greek one, but he introduced himself as "Vincent. That's what everyone calls me."

"Why?"

He grinned. "El Greco, Vincent Van Gogh, that's how nicknames work around here." He was dark, tall and very lean, with the curly hair, large long ears, and wide, deeply inset, almost black eyes of an ancient Roman from North Africa, one of those faces you see on Roman frescos. He seemed as exotic as some opera prince-in-disguise. "I've worked in the old house, the blue one. And the doors close when you turn around, lights go on and off by themselves, things you put down are moved. A group of us helped Bruno straighten it up one day for a party, and in the morning? Every picture frame was crooked."

"Someone snuck in," I suggested.

He shook his fine-boned head. "It's locked. Bruno has the only key."

"Someone filched the key to have some fun."

Now he grinned. "Bruno's office is always locked."

"Then Bruno did it."

He looked disapproving. "Not him. Never. He thinks the ghost is a lie."

"Okay. Someone has to clean the house. Right?"

"Only during the day when it's open, never any other time. Before

I got here, they used to put some GOs in the wing that's closed up now, you know, to sleep? But they heard too many noises, felt hands touching them." He shrugged. "There's something going on there."

Stefan's breathing changed and I could tell he was thinking, "Bullshit." He didn't believe in ghosts, ESP, astrology, past lives, trickle-down economics, none of that stuff.

I was about to ask Vincent for more details when the woman who had smiled at me on the beach approached and entered the bar area. Heads turned.

It was quite an entrance: She didn't walk, she advanced, her steps marked by quiet determination and healthy self-regard. Her masses of gray-black curls were even more striking at night than they'd been in the glaring light on the beach, as were her clear blue eyes, flawless skin, round face, and her elegance. She bore herself like an eighteenth-century *maîtresse-de-titre* even though she was dressed casually in a long blue gauzy skirt and peasant-style blouse, with fat cerise and teal bracelets on both slender arms. Their cartoonish colors highlighted her tan. American women didn't walk like that, I thought, hell, they didn't look like that. American women gallumphed.

She called over the bartender to order something and was soon joined by a large, muscular man in jeans and white tuxedo shirt rolled up over enormous arms, a man who looked vaguely familiar. With power drill eyes and a Mount Rushmore face, his biceps, chest, and shoulders were so perfect and round that he seemed as massive and ungainly as an Edsel.

Stefan must have recognized him, too, because he muttered, "Shit."

"Who is that?" I asked.

"Clovis. Clovis Frescobaldi."

"Yeah," I said. "Shit." Just the right person to start Stefan on a my-career-is-crap slide. I'd read about Clovis in *People*. He was only twenty-six and had gotten a half-million-dollar advance for his debut novel called *Butchered in Bucharest*, in which a dead cop in Warsaw solves his own murder from heaven—it was described as *The*

Lovely Bones meets *Prague*. Critics raved about his savage pose, I mean, prose. Some called him "Dennis Lehane with the gloves off." He was the hot new thing, and was famed for having already been in his short life a car mechanic, a bouncer, a construction worker, an exterminator, a roofer, and of course a bartender before becoming an author. Where other white male authors had MFAs or Pulitzer nominations or teaching positions, he had street cred. He'd even served time for assault during college. Puff Clovis. Maybe a line of clothing was next.

The French woman (I assumed she was French, given her style and the Club's clientele) was coolly sipping a colorful drink while Clovis was speaking to her in low, urgent tones, clearly annoyed at her lack of reaction. God, I thought, this was a vacation island but there seemed a lot of anger in the air what with him, Pierce, Bruno, Anouchka at Reception. And of course Stefan.

Whoever the woman was, she didn't like Clovis's quiet tirade, which seemed to be endless, and she finally set her glass down, gave him a haughty look, and said airily, "*Toi, t'es un pauvre con.* So he is nice to me. So he flirts. Bruno flirts with everyone. He'd probably flirt with you if you gave him the chance. *Je m'en fiche.*" She shrugged.

Her melodic voice carried and I saw some of the GOs smirking, while guests were looking around to make out what the fuss was. I wondered if she was an actress or singer—she had that sparkle about her of someone used to being admired and more, used to talking about that admiration, assessing it like the value of a stock.

Clovis breathed in so deeply I thought he was getting ready to deck her or choke her or something, and all around the bar I could feel the quickly fired nervous energy of people ready to intervene. But Clovis's woman friend sauntered off to a distant table with a lovely view of the slowly darkening sky, and the confrontation fizzled out. For the moment. I checked, and Pierce and Wilmore were still at their table. Pierce was leaning back with his arms crossed like Julius Caesar refusing to hear a petition, while Wilmore talked and talked and talked.

Clovis asked the bartender for a rum and Coke, paid for it, and when it came, he took it up, and leaned back against the bar as if he not only owned it, but was thinking of demolishing it.

"What an asshole," Stefan muttered, and dissing someone like that was very unusual for him. Asshole, however, was basically what Clovis's woman friend had called him in French, so there seemed to be a budding consensus.

"Do you know him?"

"We were both at that huge book fair in San Diego last spring. Never talked. But everyone was talking about him, the other writers, I mean. I hear he believes his reviews."

I couldn't recall Stefan mentioning that he'd ever crossed paths with Clovis, but then Clovis's gusher of fame might well have made Stefan too envious to mention it. I knew that discussing his career jealousy didn't always help ease the pain of it.

Clovis eyed me and Stefan lazily, then squinted, brought his drink to his knife-blade lips and took a few slugs as if that might help his vision. Then he downed it and the slight tremor in his hand as he set it back on the bar said he was either still angry, or had already been drunk when he got to the bar. Right then, he looked a bit like Vin Diesel without the warmth or sensitivity.

"I know you," he called to Stefan, easing down along the bar a few feet, crossing the arms of a club bouncer over an equally massive chest. He studied Stefan. "Don't I know you. I think so. You have kind of a cult following, don't you." His dialect was the opposite of Valley Girl–speak where statements sound like questions: his questions were completely flat, affectless, with no hint of a rise at the end.

"Right," I said. "He used to have a cult following, then they all drank Kool-Aid."

Clovis didn't flinch or even look at me. He said, "Huh."

"But the FBI cleared him of any involvement."

"Okay." He nodded heavily.

Stefan dug an elbow into me. "Shut up." But he was clearly trying not to laugh.

Clovis lumbered off, and not in the direction of his friend, either, but down to the beach. He had the waddle of a power lifter whose thighs push each other apart.

Vincent had been observing all this quietly, and I asked him, "Bruno likes to flirt?"

He looked pained and said, "Where are you guys from?"

We had a pleasant chat about Michigan and Greece and his previous Club Med in Punta Cana. "Nice meeting you," he finally said, and headed for a table of newly arrived guests, asked if he could join them.

Stefan shook his head at me. "Nick, you can't ask him a question like that. Bruno's his boss. Saying anything could get this guy in trouble. And it would be bad publicity for the club to gossip about the *chef de village*. Just because a guest said so, why would you even think Vincent would tell you anything?"

"He told me about the ghost, didn't he? That's not exactly good publicity."

"For some people it would be. They could have mystery weekends, seances, the works."

He was right enough. But I didn't care. We were talking again. Stefan was relaxed.

"These are really good," he said. And he ordered us another round of mojitos. "We're on vacation, okay?"

I agreed with him, though I was already beginning to think of this trip as the start of my apprenticeship.

There were easily over a hundred people in the bar now, standing or at tables, dressed up or dressed down. I could hear lots of French being spoken, some German here and there, Italian, too. The crowd was all about our age or younger and I watched the GOs move smoothly from one group to another, smiling, shaking hands, slapping backs, knitting things together, making people laugh. They really were entertainers, I thought.

I didn't say anything to Stefan, but once or twice I caught Vincent eyeing me. I couldn't tell if he wanted to talk to me, or was

hoping to avoid me and had to keep track of where I was, so he could decamp if necessary.

But I didn't move, neither did Stefan. We basked in the warmth, the noise and color as if it had all been arranged just to please the two of us. I suppose every vacation supports that illusion—as long as things are going well.

Chapter Twelve

BRUNO made his appearance then, looking jaunty and elegant in a lime green polo shirt, pleated black slacks, and black fisherman's sandals. He moved through the crowd slowly, chatting with guests, consulting with GOs, eyes gleaming like Joel Grey's in *Cabaret*.

"He could be a politician," Stefan observed, and his voice had that meditative, recording quality to it that I recognized; I could feel him cataloguing Bruno for a future character in a novel. "Watch him— he's always looking at his next target, the next person to impress."

"That's harsh. Isn't that his job here, to be convivial?"

"I guess."

"He fascinates you, but you don't like him."

"I get the feeling his meter is always running. And I *don't* think his job is to hit on all the beautiful women."

He was certainly right about Bruno and females—it was obvious that his smile was brighter and more inviting, his hand clasp longer, his eyes wider with appreciation for every remark. It was vivid, but subtle.

"The question is," Stefan said, clearly working this out in fictional terms, "what's behind it? And, does he just think he's a stud, or is he really a stud?"

From nearby, an amused voice said, "Can't he be both? And a

klootzak, too?" It was Anouchka, dressed in huge-soled black sneakers and black leggings under a crimson, body-hugging silk sheath. Her hair was up in a vaguely movie-*Chinoise* way and she looked formidable. She didn't explain the Dutch-sounding insult, but raised her martini glass at us, then in Bruno's direction, set it down and disappeared into the crowd, not stopping to chat with anyone. I guess she wasn't on shmooze control.

"See?" I said. "I told you there was something going on between Bruno and Anouchka."

"I'm not convinced. She could just dislike him for her own reasons. Dislike the kind of person he is. Maybe he's a terrible boss."

"Where's your ear? That was really personal, and so was what happened at Reception."

"I'm not convinced."

I didn't understand why he was resisting the idea, unless it somehow conflicted with how he was already turning Bruno into fodder for a novel.

"Wait—what did you mean before, what's behind it?" I asked Stefan. "You're not saying Bruno's really gay or something. Bi? That the Latin lover thing is fake? That's so obvious and clichéd."

Stefan shook his head. "I mean, what makes people turn out like that."

"Oh. Excessive good looks, probably. Attention. Too much getting what you want."

Stefan was grinning. "Now who's harsh?"

"It's a guess, not a judgment."

Around us, the smell of cologne and perfume was battling the sea air, and the contented rumble was like far-off thunder. Wherever I saw someone in a Hawaiian-style shirt, I heard English, and it was usually loud. The French-speakers tended to be dressed more quietly (generally in black), and spoke that way, too.

Bruno headed our way now, and as soon as he fixed my gaze, I was getting almost the same star treatment he'd given the women guests. Well, I suppose it was actually me and Edith Wharton both who called out the glorious, seductive smile.

I think Stefan and I both felt a bit hypocritical when Bruno asked if we were having fun, and urged us to contact him directly if there was anything we needed. He seemed so sincere. But that was his gift. "There will be games and entertainment all day long," he said. "Much of that is to bring shy people out of themselves. That's why they come here: it's safe, it's fun, it's not embarrassing."

"It sounds like a cruise," Stefan said neutrally.

Bruno nodded. "We're on a giant cruise ship, you're right. Every all-inclusive resort is like that. And while some have more beautiful rooms or better beaches, no one else has the GOs, and that's why we have so many repeat visitors. They like being taken care of in that way, helped to enjoy themselves. The GOs will try to get you involved in pool games and sports, but don't feel awkward about saying no if you're not in the mood."

Before we could say much, there was a crackling over the sound system, which until that point had been playing elevator music with a disco edge.

A chunky male GO with Harpo Marx hair and a booming, gutteral voice was at the edge of the crowd that had grown to several hundred, spieling his heart out, welcoming us in French and English, telling us how beautiful we all were, how happy Club Med was to be our vacation choice.

Working his way towards the bar, I could make out Peter de Jonge in a tan blazer, his arm awkwardly around the shoulder of a woman who must be his wife. She was dark-haired, perfectly made-up, with a heart-shaped 1920s face: small lips, large dark eyes, button nose. Peter's hand was right under her prominent breast. Didn't that tickle? I wondered.

Harpo ranted some more, speaking much too fast, and suddenly he was announcing, "The King of Karaoke, our famous *chef de village* himself, Bruno Zaragossa."

There was loud, ragged applause. Harpo had spoken so quickly and his English sounded so much like French that I wasn't sure what he had been announcing. Bruno shook his head, dramatically reluc-

tant, and I could tell at once that it was an act. Harpo coaxed, Bruno demurred, people shouted and were soon chanting, "Bru-no! Bru-no!" though I doubted they knew why. They were on vacation, getting drunk, it was fun to make noise.

Bruno made his silky way to the microphone, which he took up expertly, starting his own quiet spiel as intimate as a lounge singer's. I heard the name Henri Salvador, and suddenly music came over the speakers all around the bar.

Half closing his eyes as if remembering someone wonderful, Bruno launched into a song I knew because Stefan and I had the CD at home: *"Aime-moi"* ("Love Me").

Bruno sang seductively, and a space cleared around him as if to give the feelings room to expand and sweep the bar area. His tenor voice wasn't big, but it was beautiful, smoky, elegant. It didn't seem that being deaf in one ear affected his singing at all. He held the mic just close enough to his lips to make you imagine kissing whoever he was singing about.

"Love me," he sang in French, slowly, romantically, and he looked somehow taller, unless that was a trick of the lighting. The words came slowly and it was easy for me to follow along without having to take an extra step of translating in my head.

Love me
Don't look any further.
Don't think of anything else.
Just love me.
Don't wait until somebody else
Enters my life one evening, by accident.
Love me.

I scanned the crowd. Women were warming to him, men were holding back their approval, but as the song continued, they began to relax, perhaps because they could feel the enjoyment in their lovers and wives.

The song oozed on, cocky, plangent, and with every few lines, Bruno picked a different woman in the crowd, singing directly to her as if his heart would burst without her love, but she'd regret it more than he would. How French could you get?

Bruno gave a tremendous performance. He was even starting to sweat a little and his forehead gleamed. Each woman he singled out preened a little, some more self-consciously than others, even Clovis's woman friend, who I would have thought above such blatant showmanship. Maybe she was just admiring the display of French popular culture.

Bruno crooned the last verse at Peter de Jonge's wife, moving forward into the crowd, which parted as smoothly as swimmers in an Esther Williams spectacle. Claire grinned and stood up even straighter, back arched and breasts high, as if she were on TV and waving to the folks back home. Soon they were just a foot or two apart. Peter's face was blank, but Claire was eating it up. With the last words, *"Aime-moi. Aime-moi,"* Bruno cocked his head at her as if to dare her to sing back or at least respond. She blushed amid the wild applause, the whistles and cheers. Peter nodded a bit dismissively, like someone acknowledging a good play by a football team he wasn't rooting for. Not ten feet back in the throng, I could see that Franklin Pierce, Claire's father, was enraged, his eyes popping, his face red under the tan.

"What's he so mad about?" Stefan whispered. I explained what I'd overheard between Pierce and his assistant when I'd gone to the men's room.

"They called Bruno a ni—?"

"Shh!"

Bruno bowed ironically, then swept his hands as wide as the Christ statue overlooking the harbor of Rio de Janeiro and shouted, *"Messieurs-dames,* ladies and gentleman, dinner!" And at that moment, the big glass doors to the dining hall were opened and waves of guests flowed toward the entrance.

"No trumpet fanfare?" Stefan muttered.

"Maybe at dessert."

"Pergolesi for the pêche Melba?"

"Bach for the baklava?"

Wisely, we dropped it. Stefan hated being caught up in a crowd, so we waited at the bar for the first surge of diners to move past us. He knew it didn't make sense, that the chance of panic breaking out and people running, getting trampled and crushed was highly unlikely, yet the possibility was always lurking for him. He was too conscious in those situations of his potential lack of control; this was a fear that he had inherited by osmosis from his Holocaust-survivor parents.

"You know, Bruno is a very strange duck," Stefan mused. "I can't figure him out."

I wished I could get Stefan's curiosity focused more on the Pierces and Peter de Jonge's request that I follow them around, but the next thing he said cheered me up.

"He wants to write a book about the island and the Pierces and needs their help, right? Access to family papers or whatever? But he was trying to make Peter jealous?"

"Is that it? I think he was just having fun. Peter's wife is pretty hot." As if she were part of the entertainment, some couples had come up to Peter's wife to chat and laugh about Bruno singing to her. When the de Jonges had fewer people clustered around them, I could see she had a highly aerobicized body (taut stomach, tight glutes) that reminded me of the many doctors' wives at our gym, some of whom worked out with a personal trainer every day, thanks to tons of disposable income and tons of disposable time.

"There are a lot of hotties here, so what? If Bruno were smart, he would have noticed how pissed off her father was. And that's on top of his not wanting Bruno to write the book."

As the guests thinned out, I caught Bruno sailing triumphantly into dinner, surrounded by a flotilla of admiring guests and GOs. Occasionally he moved around gracefully so he could hear better. He waved at Anouchka, who gave him a wry smile, and at Vincent, the

GO with the ghost stories, who was bearing down on her, but Heath Wilmore got there first and took Anouchka's arm, speaking to her very intently. I assumed he was making some kind of special request for his boss, something extra Franklin Pierce needed, or more likely just wanted, to show that he could.

Clovis followed at a distance, lumbering along beside the Frenchwoman, whose grace made him seem even more ungainly—as if that were possible. He was blustering and she was laughing so warmly and indulgently the set of his shoulders softened.

"There's such a thing as working out too hard," I said.

"That's not just working out. He juices."

"Steroids?"

Stefan nodded and now that the crowd had dispersed, he set off around the bar and down the veranda to dinner. "Look at his back," Stefan said. "The traps, the lats. They're unreal."

And indeed, from behind, Clovis looked like a Marvel Comics super hero, every muscle swollen and identifiable.

"He would not be a good person to argue with," Stefan opined.

"'Roid rage?"

"Exactly."

"Well, whoever his friend is, she's soothing the savage beast."

"For now. I don't think he'll be happy if Bruno does an encore."

"Neither will Pierce."

Now Claire was stalking into dinner, arms angrily crossed, her head down, with her father almost glued to her side. "Don't ever behave like that in public again," he was saying, still red-faced, and he either didn't care whether people heard him or not, or he was too angry to keep his voice down. She was nodding like a sullen adolescent who had blown her curfew. Heath let Anouchka go off into dinner by herself and was now walking along with Peter de Jonge as he trailed after his wife and father-in-law. As opposed to his ultra-serious mood with Anouchka, Heath looked like he was trying to make conversation to ease the tension. Peter seemed pretty sullen himself.

As we brought up the rear, Stefan asked me if I thought Franklin

Pierce was angry at his daughter for "encouraging" Bruno's histrion-
ics because he thought Bruno threatened his family pride, or because
he thought Bruno was a "mongrel" and it was a racist thing.

"Both."

We stopped in the wide doorway of the dining hall, struck by the
high, peaked ceiling that rose two stories and made the room look
like a huge tent, by the walls of glass facing the ocean, by the warm
cherry-planked floors, and the volume of excitement. It felt like hit-
ting a party or club well after things had gotten hot.

To our right along two walls was an L of stainless steel food sta-
tions and cloth-covered tables. In the center were dozens of round
tables of eight or ten seats, to the back were coolers marked VIN and
beverage dispensers, and to the left another veranda with more tables
that were already packed. We drifted towards the food. Everything
was labeled in French and English and there were easily a dozen
black men and women in white aprons and chef's toques to assist us.
Stefan and I wandered down the jostling main line behind people
piling up their plates, bemused, not least by the ice sculptures of
swans glistening in the bright light.

Of course there were plenty of salads and fruits displayed as artis-
tically as if they were in the window of a specialty food store, and
enough breads to choke a farmer. This must have been a Cajun-
themed night, because I saw jambalaya, jerk chicken, Creole rice,
fried catfish and dozens more dishes to choose from, from "aub-
ergines Baton Rouge" and "haricots noir louisianne" to roast pork
and rabbit. I confess, having things labeled in French even with a
translation made them sound better, like the cauliflower with cheese,
gratin de chou-fleur, though someone had Englished it as "gratin
collyflour."

Though it was all arranged in a fairly continuous line from appe-
tizers straight through to an island of desserts, I felt I'd entered a
maze. Each of the many steaming, appealing dishes and side dishes
looked and smelled so tempting that it seemed to lead off to another
direction.

"Just grab a plate and dive right in," Stefan said. "We're bound to like something."

"My problem is that I'm bound to like everything," I said.

"There's a gym here, remember?"

"It better have a liposuction station. Hell, we'd have to work out all day to handle a meal like this."

"So take small portions."

As per Stefan's instructions, we took small portions, but we put so much food on our plates it almost spilled over. I knew we'd be back for seconds and thirds of whatever we had missed.

"Wine," Stefan said.

We'd observed people at the coolers taking bottles of wine and assumed that was the procedure. I followed Stefan and as someone held a door open for us, we greedily got a bottle each of a Provençal rosé. Heading off to find a table, we passed the Frenchwoman, Clovis's friend, and she eyed our plates with amusement. Then she flicked her chin at the wine we were holding and said with mild approval, *"Ç'est pas de vinasse."*

The tables closest to the ocean side were all jammed so we found an empty one in a far corner and set our stuff down. "What did she say?" I asked. "I don't know that word *vinasse.*"

"It's not plonk."

That actually meant it was good. We'd seen plenty of French diners at elegant restaurants in Paris grudgingly admit, *"Ç'est pas mal"* ("It's not bad") about meals we knew were fantastic. Me, if I was having a good time in Paris, I tended to gush. It was what my parents thought was most American about me, and most embarrassing. Stefan played it cool when we were in France, trying to blend in, but if they were called for, I'd shoot off slangy superlatives like arcing Fourth of July rockets: *chouette, super, sensas.* That was another American aspect of my personality: I unconsciously wanted people to like me, especially when I was traveling, to think I was nice. Even back in New York, it had annoyed my mother and father when we'd go out to dinner. They weren't unfriendly with waiters, just reserved, while I couldn't resist chatting. Perhaps because of our American cult

of equality, we're at heart uncomfortable being served, we think there's something unbalanced and wrong in that relationship and we try to even it out. My parents had no such difficulty.

Stefan poured wine for each of us into little tumblers that felt very bistro, and we toasted without words. The room whirled around us like a kind of play with a huge cast, and Bruno cheerfully wove through it from table to table, looking even more like a politician than ever. Too bad there weren't any babies to kiss. GOs were sitting at tables and introducing themselves as if on a mission.

Chapter Thirteen

"CAN we join you?" a woman asked, sitting down with a plate mostly full of vegetables. She was followed by a man who could have been her brother: in their early twenties, they were both about five-six, as thin as greyhounds and with eyes just as large and liquid. They had on matching blue shirts and white shorts, which intensified the resemblance. He set down a bottle of red with his plate.

"We're newlyweds, sort of. From Michigan," she said, bustling in her purse to no apparent effect, then hanging it on the back of her chair. "I'm Courtney, this is Jason, and we just got married."

I gave her our first names and congratulated them on their marriage.

"We met at our health club, is that adorable or what? We're both in the Membership Department! Can you believe it? We both had individual discounts, and we have a family membership now, but too bad they won't give us an extra one via we met there."

Stefan looked at me and I'm sure he was thinking the same thing: *via?*

"What do you think of this food—isn't it kind of...?"

"Foreign?" I suggested.

Courtney shrugged and surveyed her plate as if it were a telegram with very bad news.

"Courtney's very particular," Jason explained, touching her

shoulder. "Are you okay?" he asked very quietly, with as much concern as if she were a pain-ridden invalid or a patient with a terminal disease.

She nodded, and said, "Well, at least this isn't a place, it's just an island. I hate places."

"We tried Venice last year," Jason explained. "She thought it was boring. London, too. So we figure we should stay away from—"

"Places," I finished.

"Right." Jason nodded.

Stefan glanced at me, widening his eyes just a little, and then he started to eat, slowly, cutting everything as carefully as if he'd been a feral child and were still uncertain about his table manners. These were his typical dinner party signals to me when things looked socially, conversationally grim: "You're on your own." It was easy for him to withdraw at times like that—he was an introvert and had such a rich interior life he could stay removed for a long time without feeling awkward or uncomfortable. I, however, felt the need to fill in the silences.

Though Courtney was taking on that responsibility with more gusto than she had for the food. "I thought this place would be less crowded. I mean, it's nowhere and everything, and all the way east and there aren't any more islands out there." She peered briefly at the veranda as if to confirm there was no land in sight. "We needed a getaway and they also said there was a good gym here but it's, like, so—" She hunted for a word. "It's like Bangladesh or something. Retarded. I mean, can you believe all the cardio equipment they have is some bikes, and treadmills and step climbers? No ellipticals! Can you believe it? I am not kidding. Really. And you can't use cell phones here! How do they expect people to be communicative?"

Courtney's mild case of malapropism didn't seem to register with Stefan anymore. I glanced at him, but even the references to working out didn't deflect him from his task of ignoring our table mates. I did catch him glancing around as if willing someone else to join us, but nobody did. I looked around, too, trying to see where the Pierce party was, and Clovis and his friend, but couldn't tell. Too many people

were standing and walking around with full and empty plates, and there were probably over two hundred diners there.

"So where you guys from, and how long have you been together?" Jason asked, and in response to my being startled by the personal question and his pegging us as a couple, he pointed to our hands. Stefan and I had never had a ceremony, but we had bought matching platinum rings to wear on our right ring fingers on our tenth anniversary. Courtney was picking at her food, shoulders slumped, eyes down.

"Hey, it's cool, I'm very liberal. My brother's gay and was kicked out of the army when they found out." He said it almost cheerfully, as if it were a badge of family honor, and I was tempted to say, "That's nice," but I was actually wondering if he'd ask how large our mortgage payments were next.

Before I could reply, Courtney observed, "Wasn't that Bruno guy really kewl? Kind of like Elvis. Or Ricky Martin!"

"Awesome," Jason agreed with good humor, mouth full. But he wasn't done with me and Stefan. "You're American, but where are you from?"

"Michiganapolis," I admitted.

"Hey! Michiganapolis… I bet you're at the university. You look like professors. Intelligent."

I nodded for both of us. And since I knew what the next question was going to be, I said, "Stefan teaches creative writing, and next semester I'm teaching composition and a mystery course."

Courtney sat up straighter. "I love mysteries!" she squealed. "I read three a day."

"Three?"

She and Jason nodded proudly. "I took a speed reading course, because I don't care about the verbalization, I just want to keep reading the story. Who wants to get hung up on details or anything?" Then Courtney must have remembered what I'd said about Stefan because she shifted gear and said to him brightly, "You teach writing?"

Stefan kept eating.

"At the State University of Michigan?"

He speared a marinated brussels sprout and chewed it thought-fully. He swallowed, then mumbled what might have been a "yes." But that didn't stop Courtney, who apparently thought he was shy, and that it was her mission to bring him out of himself. She might even have been inspired by the efforts of the GOs.

"I used to think I'd write a novel in my spare time, but I'd rather just work out, and read mysteries, especially if they have cats in them, or little old ladies in England. Those are the best."

Jason nodded agreeably, waiting for Stefan to respond. I was cracking up inside, because no matter how hard Courtney tried to engage him, Stefan was not interested in a conversation with her. In fact, if she had burst into flames at that moment, he wouldn't even have emptied his wineglass on her to put it out.

"Omigod, I just realized something! You're Nick Hoffman, aren't you? The professor at SUM who keeps getting in the papers because of murder? I've read about you. Wow! I will tell everyone I know that I met you. The people in my broadcasting class will go nuts." She added parenthetically, "I want to be an anchor."

"You must watch a lot of CNN," I guessed.

"Yes! I glorify those people—I watch them every chance I get. They speak so beautifully! And it doesn't matter what the story is, like a bombing or a lost dog that found its way home, they treat everything equidistant. Shoot, if I knew you'd be here, I could have, like, prepared some questions to interview you and get extra credit."

We were saved from having to comment, or I was, anyway, by Anouchka joining our table and introducing herself. She and Court-ney instantly sprinted off into talking about the fitness classes, the scheduling, the different instructors, and soon Courtney was brag-ging about how wonderful her gym was back home. Jason added his own comments now and then, and Stefan relaxed. I kept feeling, though, that Anouchka was studying us.

"Are you enjoying the show?" Anouchka asked me.

"The show?"

She waved. "All this, everything. The service, the food, the atmo-sphere, the sunset. It's all entertainment."

"You left out Bruno's song."

She smiled.

"I loved his song. I don't usually like anything French. They're snooty and say mean things about Americans, but the song was pretty," Courtney said. Then she hopped along to something else, asking Anouchka, "Is the disco fun? At eleven?"

Anouchka nodded. "Some of the GOs are excellent dancers—like Vincent. You should go."

Jason took his wife's hand. "We'll be there!"

"What about the ghost?" I asked Anouchka, filling my glass.

Courtney and Jason both grinned with delight. "There's a ghost at this Club?" he asked. "Where?"

Anouchka rolled her eyes. "People say they've seen it. Some GOs, some GEs—that's the local staff. Never a GM, though."

"How about you?"

Jason echoed my question. "Yeah, how about you?"

"I don't believe in ghosts. But things have happened in the office behind the reception desk area. Things…move. Pads. Clipboards. Pencils and pens. I can always hear the door opening, so it can't be anyone playing tricks on me. And it happens too fast, even when I'm by myself. I'll put something down and it won't be in the same spot when I turn back."

I probably was goggling at Anouchka just like the newlyweds were. The matter-of-fact way she described what she'd experienced made it utterly convincing.

"But I don't believe in ghosts," she repeated.

"Then what—?"

"I couldn't tell you. I just don't believe in ghosts. Not that kind of ghost, anyway." She dug into her rabbit stew and Jason poured her some red wine from the bottle in front of his plate. "You have to try the white chocolate bread," she said. "It's at all the meals. It's addictive."

"Maybe tomorrow," I said.

"Don't go to sleep," Anouchka warned me. "There's a show after

dinner. Singing. Well, lip-synching. Some of the GOs are superb. Costumes, wigs. They work very hard rehearsing. It's fun."

The thought of amateurs pretending to belt out the Stones or whoever didn't thrill me, but the other Michigan couple sitting with us bought it and Courtney almost squealed: "I love transvestites!"

Jason smiled at us as if we had both either been transvestites, were considering it, or all our best friends were. Just then the stocky GO who had introduced Bruno passed and Anouchka called him over. His name tag read CLAUDE and close up, I realized the Harpoesque hair was really a very good wig.

"Tell them about the ghost," Anouchka instructed, and his freckled, round face grew serious. "Okay. When I have worked the bar on the beach, things fall off the shelves, the blender turns on and off without being touched. Ask around. It's not just me."

Anouchka threw her hands out in a "Who knows?" gesture and thanked him. His mood shifted to manic energy and he loped off.

Stefan suggested seconds, and I followed him. "Can we find another table?" he asked when we were far enough away.

"That would be rude. Maybe they'll just go away by themselves."

The dining room was noisier than ever and hotter, too, the wine having loosened everyone up, and all around us tables seemed to be competing as to which could be the loudest and laugh the most. Claude was clearly circulating to stir things up.

As we worked down the line, Stefan piled his plate even higher, one third of it reserved for thick slices of the *pain au chocolat blanc* that looked as rich as cake. We sampled some as we threaded our way back to our table, and it was as potent as a peaty single malt.

"Is it hard being a GO?" Stefan asked Anouchka when we were seated again, and we all looked at him because he'd been relatively silent for so long. He waited for her answer while chewing on his second piece of the exquisite bread.

"Yes and no. You work sixty–seventy hours a week, six days a week. Nobody comes for the money. It's the experience. Club Med isn't just about the sun and the beach, the sports, the games, the

shows. It's about reawakening people's spirits, helping people reconnect to themselves and everything around them. Reshaping how they see the world itself. The GOs create the spirit that defines Club Med."

Courtney sighed with pleasure. Anouchka's answer was as impressive in its own way as Bruno's song, and I suspected that she believed it, at least while she said it, though it sounded like something out of a brochure. Even if it was the official line, that didn't make it untrue.

"What about the food?" Stefan asked, and I wondered if he was just curious or was beginning to think he might set a book here or someplace like it. "How do you stay slim?"

"Most GOs gain weight eventually. Even if you try not to."

Courtney looked dubious, given her low opinion of the Club cuisine, but Jason nodded happily as if he were planning on a return with too-tight clothes.

Then Stefan changed the mood by asking if Bruno was hard to work for.

"He's very demanding," she said neutrally. "He should be. This is like a hotel and he's the manager—he has to make sure everything runs smoothly."

"What could go wrong?" I asked.

"Everything, anything. Staff conflicts, guests drinking too much, sexual harassment, lateness for the GOs or their not working hard enough or having the exact right attitude. But that's just like at any hotel or resort."

"Did you know someone's staring at you?" Jason said to her. "Three tables over? By the entrance to the veranda?"

Chapter Fourteen

"OH, GOD. Vincent," Anouchka sighed, head down. "Don't look."

I didn't expect anything more, but then she said, "It can be a hot-house here."

I thought of Byron's couplet: "What the gods call sin and men adultery/Is much more common where the climate's sultry."

Anouchka looked at us a bit defensively, I thought. "People want things they don't deserve, and they can get too intense about rela-tionships, especially when they've over."

We were all silent, filling in the gaps she had left. Our silence seemed to bother her, and perhaps feeling we weren't believing her, she said quickly, "In a big city, Vincent would be a stalker, but here, there's not so many places to hide."

This turn in the conversation alarmed Courtney, who asked in a thin voice, "Is he really dangerous?" Jason was frowning, too.

Anouchka took Courtney's hand and squeezed it. "No, no. I was exaggerating. This island is perfectly safe, there is zero crime here. The chief of security is a retired policeman and he loves it here. All the guards do. There's never any trouble. Working here for the guards is like retirement, it's heaven."

Relieved, Courtney and Jason excused themselves and a GE ap-peared soon after, clearing their plates, chatting low-voiced with Anouchka.

I admit it, I was nosy, and now that we were alone with Anouchka, I prompted her: "Vincent?" He had seemed like a nice guy, but of course that was when interacting with me and Stefan, who were GMs. That didn't tell you anything about how he'd be with a woman who had dumped him, which I assumed was what had happened. I wanted the details, though.

"I'm not an American," Anouchka replied sweetly to my one-word question, and the tropical night, the wine, the good food, and being so far from home all worked together to keep me from feeling even remotely criticized. In fact, I admired her tact, her training, and I took her reply to mean that she kept her private life private.

"Have some more bread," Stefan urged me, putting what he hadn't eaten on my plate. In other words: "Shut up." I did what I was told. It was both good and good for me. Anouchka watched me with enjoyment, and she poured herself more wine.

"Who's that Frenchwoman?" Stefan asked, his plate cleared. "The elegant one with dark curly hair?"

Anouchka replied that the Club was probably sixty percent French at the moment, and his description fit a number of GMs.

"She's with the big guy." Stefan didn't want to say Clovis's name. "The American."

"Ah, the muscle man. She's Dominique Grosbisous."

"The literary critic?"

Anouchka shrugged.

"You know her?" I asked Stefan.

He nodded. "She's been a bestseller in Europe and she has her own talk show. In France she's so well-known they just use her initials when they talk about her: DG." Before he could say anything more, there was someone shouting near the entrance door and the sound of a chair being overturned. It was Clovis, bellowing, "Leave her alone, you prick!" He was facing off with Bruno.

Around us, diners were standing or craning their necks to see what was going on. Bruno seemed completely unfazed by Clovis's bunched fists and bristling muscles. Dominique Grosbisous stood up and put a hand on Clovis's shoulder, but he shook her off and she

fell against the table to a chorus of *boo* from the Americans and in-drawn breaths from everyone else. Someone helped her up and several male GOs were gathering around Clovis, ready to tackle him, I guess. Clovis looked like *he* was ready to punch out Bruno, who was grinning widely, and Clovis took a wide, drunken swing at him that could never have connected, but when he saw Bruno still standing, Clovis's whole body said, "Huh?" Bruno shrugged broadly, circled with his arms up to show the room he was unharmed. The GOs hustled Clovis away and Bruno jauntily announced, "At tomorrow's dinner show you'll get to see *me* try to hit *him*."

"Fucker, I'll kill you!" Clovis shouted from outside, and hearing it offstage made it seem comical. I couldn't help laughing, and people applauded and stomped their feet. From other tables I heard assertions that the whole thing had been staged, and was either very funny or in poor taste. Stefan was trying not to smile, but I could tell he was pleased to see Clovis humiliated.

Anouchka said good-night and slipped off.

Stefan said, "I told you."

"Told me what?"

"I told you he was dangerous."

"Clovis is just blustering. He hasn't really done anything."

"Yet."

Anouchka had stopped to talk to some other GOs and when she headed out the door I saw Vincent appear from out of a corner to follow her with all the cringing stealth of a jackal about to dart into a crowd of larger beasts ripping apart newly killed prey.

"Now, *he's* probably the one who's dangerous," I said, pointing. "Clovis is big and loud, but Vincent was charming, wasn't he? Those are the ones who surprise you."

Stefan snorted. "The gym lovebirds from Michigan probably have half a dozen people buried in their backyard."

The tables were half-empty by this point as diners wandered back to the bar, to sit or stroll outside, to gossip about the scene Clovis had made. Stefan asked if I wanted to graze at the dessert table, which had not yet been cleared, but I said the white chocolate bread

was all I needed, aside from coffee. He brought back two mugs and it was strong and very good.

"Naturally," I said, "this place is French—they couldn't have bad coffee. It would be sacrilege."

"Bruno handled that well," Stefan said. "The scene with Clovis."

"Are you surprised? Sangfroid is a French term."

"I bet he handles everything well," Stefan said speculatively, looking down into his cup as if he could see a scene for a book where someone like Bruno was the central character.

"If he's a capable administrator, he should." I was intrigued to see Stefan in the process of musing aloud about someone who had already lost a measure of reality to him in the process of transmutation into fiction.

Around us, GEs were clearing the tables, working closer and closer to ours, but I was enjoying the growing solitude and didn't want to head out where there were more people right now. And whatever planned entertainment was ahead that evening, I thought sitting on the beach with Stefan would be much more fun.

Living in Michigan, I'd missed the feeling of being on the edge of something that I'd grown up with on the East Coast. I loved the idea of water stretching endlessly out into itself, a question more than a fixed quantity, as even huge Lake Michigan seemed to me when we were up at our cabin or down in Saugatuck, the Midwest's version of Provincetown. Though the illusion was spoiled when I'd contemplate the water and suddenly recall that Chicago was on the other side. Here, I wasn't even imagining continents or countries when I gazed out at the water. It was a strangely soothing combination: the limits of land, the unlimited sea.

"You look lost in thought," Stefan said.

"Not lost. Traveling. What do you think about the ghost?"

"You mean the ghost stories."

"Same thing."

"Not at all. People tell ghost stories, but that doesn't mean there's a ghost."

"To me, it's the opposite. If there are so many stories, there has to be something to it."

He surveyed the room, but seemed to be taking in much more. "This island is a place that would breed stories like that. Beautiful. Isolated. Dark history. And now, all this idleness, amazing food, nothing to do."

"Nothing to do? Are you kidding? Did you look at the schedule of activities? Snorkeling, tennis, kayaking, scuba lessons—"

"That's the guests. The GMs."

"Well, you can't say that anyone on the staff is idle—they're working their tails off, everybody is."

"But you heard what Anouchka said. I can see it—this place is like a colonial outpost in the desert. You'd see mirages there."

"Anouchka is very wise, you should believe what she says," Bruno threw off, walking over to join us, setting down a bottle of the rosé and a glass. "She's one of the best. If she stayed with Club Med, she'd become a *chef de village* for sure."

"Where is she going?"

He sat down to our left, poured himself some wine and downed half a glass, and I could sense a change in the atmosphere of our corner. There was suddenly a zone of privacy around our table; though the GEs kept cleaning and clearing, they held back even when he caught someone's eye and smiled. Was it respect, politeness, or something subtler I wasn't able to register, given that I worked in such a toxic environment in Michigan?

He shrugged. "Back to Amsterdam, I assume. She used to act, on a television show, but she is now an artist, very good, too. She can do anything. A superb eye. Oils, engravings, mixed media. Is that correct? I mean—" He hesitated. *"Techniques mixtes."* I was growing fond of the way Bruno cocked his head to hear better from his good right ear—it was endearing, and I could imagine that women might find it made him even more devastating.

"Why is she here?" Stefan asked.

"Excuse me?"

Stefan repeated his question a bit louder.

"Ah." Bruno nodded. "Many of our GOs are talented. There are gymnasts, landscapers, brokers, yes, brokers! Some want to own restaurants or have their own small resorts. Have you met Vincent? Yes?

He's studying to be a pilot back home, and probably will fly big jets some day. Claude, with the hair, yes? Claude is an engineer. Many are between careers, or taking a break, or changing. Anouchka came here for inspiration, for the colors."

I thought of Van Gogh heading from Holland to the South of France, or Gauguin going all the way to Tahiti.

"She's only staying one season." Bruno nodded sagely. He was drunk. Close up, he was even handsomer, the lines fanning out from the corners of his eyes giving him depth, or history. Maybe I was drunk, too.

"This probably isn't a good time to chat about Edith Wharton," I said, and Bruno grinned. A grin like that, flashing on like a spotlight, was a powerful weapon. No wonder he had outraged Clovis and Franklin Pierce. He was blindingly handsome and so, even his easy charm could be wilfully misread as arrogance, could cast a scalding light on your own shame and leave you feeling angry and exposed.

"But what about the ghost?" I asked.

"Yes?" His blue-gray eyes went a bit dim.

"Anouchka said she doesn't believe in ghosts, she kept saying it, but things have happened at Reception...."

"The moving pens and pencils?"

I nodded.

"She's right. She doesn't believe in ghosts. And objects move around her."

Stefan cleared his throat. "You're saying she's telekinetic?"

Bruno frowned, obviously not familiar with the word but when he worked it out, he laughed. "No, no, no. It's simply that many things can happen here, whether you believe in them or not."

"The magic of Club Med?" I asked.

"Something like that." I sensed there was a lot he could tell us, if he wanted to. He was teasingly evasive, but not drunk enough, I thought, to be pressed for more information, or to absently spill facts unprompted while talking about something else.

I was dying to ask him about the Pierces and their unwillingness

to help him with his book, but that would have been using information that Peter de Jonge had given me, and somehow that didn't seem ethical. Or was I being too scrupulous? Mulling that over made me realize I had promised Peter—hadn't I, even weakly?—to follow the Pierces around and see what I could discover.

At that moment, with the fatigue of travel, the rich food and wine, and the excitement of the whole day starting to weigh me down, all I wanted to discover was how comfortable the bed and pillows were back at our wonderful room. Even though the coffee was strong, I could feel myself starting to shut down for sleep.

"Gentlemen," Bruno said stagily, bowing his head. A few reddish-blond curls fell onto his forehead in a perfectly casual manner, then flipped back up. "I should depart." He stood a bit unsteadily, and said to me, "See you later," and winked. Then he made his way to the exit, not quite weaving, but close. I wondered how much concentration it took for him to walk as straight a line as he was able to manage.

"Should we go and help him?" I asked, not knowing what the wink was about.

"That's what his staff is for. They'll help him if he needs it."

We sat there for a while in companionable silence and I woozily thought of lines from a Christopher Isherwood novel, lines Stefan had used when he dedicated his first novel to me: "There are some people, they are like countries. When you are with them, that is your country and you speak its language. And then it does not matter where you are together, you are at home."

Eventually, though, I started to feel somewhat embarrassed to be the last ones there, and we left with nervous smiles at the GEs piling plates and wiping off tables around us. The noise outside from the bar was surprising—as if a whole new troop of guests had arrived, energetic and excited. The intensity didn't press in on me, and it didn't stir me, but it buoyed me up as if I were floating in a pool. I felt more deeply relaxed, somehow, than I had all day.

"Let's go to the beach," I said.

We nodded and smiled our way through the hundred or more people milling around with drinks. Thankfully, I didn't see Peter de

Jonge anywhere, or the Pierces and Heath Wilmore, but three different GOs greeted us and reminded us of the lip-synch show coming up later and the disco at 11:00 in a separate building further down the beach past the gym. We smiled and thanked them, and said we were going down to the beach to be alone. They all nodded heartily, as happy as if it had been their idea, and instead of feeling annoyed the way I did when an evening was spoiled by telemarketers, I felt genial, at ease, even after having said the same thing three times.

"That's really sweet of them," I said to Stefan.

"You are smashed," he noted. And he was right, because I had no intention of being roped into any planned activity. Shy, I wasn't. Being brought out of myself was not what I needed.

Stefan found a stone path down to the beach, and we followed its soft downward slope. We slipped off our sandals, and holding them, headed off to sit closer to the water, enjoying each time the cool sand grabbed at our feet. The sea had retreated away from the Club, and down here the party noise was almost drowned out by the waves. Settling down onto the glowing sand that night was like entering an engraving: the black sea ruffling and foaming white, the moonless sky above it almost more white with stars than black with their absence. We were alone and sat side-by-side, breathing in the cool air that smelled—that night, anyway—of pure freedom.

PART III:

Island of Lost Souls

Chapter Fifteen

SITTING on the beach with Stefan in the cool evening air, floating free from all my responsibilities and troubles so many miles away, I felt more than relaxed. I felt both perfectly at home, and revived. The temperature hadn't dropped much even out here and the air was caressive. Just hanging out there was glorious, as wonderful as being seated in a glowing concert hall with perfect acoustics, surrounded by the music, or standing on a hill top with a view of nothing but valleys, trees, and clouds, the vista taking you completely out of yourself while you felt at the same time nurtured, safe, caressed.

We lingered. We fell silent. We talked about the fiery skies. The week ahead. About former vacations, drifting from one pleasant scene to another, with the sea our soundtrack and noise from the Club drifting through as if sampled by a DJ.

"What do you want to do now?" I asked at last, near midnight. It was always like this: back home we'd be ready to go to bed at 10:30 or 11:00, but on vacation, we'd stay up sometimes until dawn.

"We missed the talent show." Stefan grinned at me.

"Good," I said.

"We could check out the disco."

"Possibly."

Dancing and crowded, smoky clubs weren't our scene except when we traveled. I had come to see the truth in something Bette

Midler told an interviewer, that after thirty, she got tired of the raving and just wanted a nice dinner with a good bottle of wine.

Just then, a hundred feet off to our left, we saw Dominique Grosbisous head briskly down to the water, almost running. She was barefoot, looking as determined as someone rushing to catch the last ferry of the day. Or drown herself. The thought occurred to both of us and we rose to watch her more closely. But she strode into the water only ankle-high, moving with a pantherish grace. Then she stopped and bent over to wash her hands again and again.

"Weird," Stefan murmured.

Dominique stood up and stared out to sea. What was she up to? Thinking of a late-night swim? Why not go to the pool, then? Or was she engaged in some kind of private ritual?

"This is about Clovis," Stefan suggested quietly.

"You mean she's gonna wash that man right out of her hair? Then how come she's only washed her hands?"

Stefan shrugged. "Does it matter? She must want to get away from him. All that macho bullshit. He's embarrassing. He's a jerk."

"He's also famous, and she's not, at least not in the U.S., really. He's young, and she's not. She has media clout in Europe, and he doesn't. It's a perfect business exchange."

"Cynical man."

"Hey, it's pretty French, it's right out of Colette." I started humming the title song from *Gigi* and Stefan mock-punched my shoulder to make me stop. He had a good ear from all his childhood years of studying piano and couldn't stand my singing or my humming.

Whether Dominique sensed or heard us, she moved away from us down the beach and then angled back up to the bungalows, it seemed, striding calmly now, as if disburdened. The breeze played with her hair and her dress and I couldn't help but think of Byron's lines, "She walks in beauty as the night/Of cloudless climes and starry skies." Here, the lines didn't seem like a cliché, and I could imagine that if I were at Serenity long enough, probably all the poetry I'd ever memorized would come drifting back.

With Dominique out of sight, we rose and turned to head back

up the silvery beach. The buildings of the Club seemed like an archipelago of light stretching off as far as we could see, beautiful and sad, a diminution of the lights stretching across the Caribbean sky. There was a fragility to them, framed as they were by the surrounding darkness, which was mildly oppressive.

Stefan seemed to pick up my mood because he said, "How about another drink?" and we walked to the still-crowded bar area where the noise had a surprisingly festive note to it. After all that food and given the time, I would have expected people to be logy or cranky or jet-lagged, but the hilarity seemed genuine to me. We ordered mojitos and the bartender smiled at me while he made them. "Seen any ghosts?"

"Not yet."

Stefan and I toasted each other and when we glanced around, I was glad that all the people I'd been observing and speculating about that evening were nowhere in sight now. I'd imagined a week of anonymity, of swimming, sitting by the pool, sleeping late, complete distance from everything and everyone. But from not knowing or even recognizing anyone when we arrived, I'd gone to feeling a bit hemmed in by Peter de Jonge and his party, Clovis and Dominique, even Bruno, Anouchka, and Vincent. This had cut down on my sense of escape. I assumed some of these people might be off in the disco, a building further down from the dining hall from which we could hear an insistent techno beat. I decided to stay away from it, at least tonight.

At the bar, GOs were still working at making people comfortable, as if each and every one were a cruise director. I admired their patience. They seemed genuinely outgoing and dedicated to their work. Several passed by and told us we'd missed a hilarious talent show and encouraged us to go to the disco, but we declined, our mood having shifted as it often did on holiday. The changes were almost always mutual and we rarely disagreed about what to do.

"So, what now? Ready for bed? A walk? Another drink?" Stefan asked, setting down his empty glass on the bar.

"You know, I'd love to go swimming. In the pool."

His look made it clear he didn't think we should.

"Why not?" I said. "Are you worried about there not being any lifeguard at night? Or that we'd be making noise and waking people up? The pool isn't close enough to any of the bungalows, and nobody's in that blue house. I'm a good swimmer—you know that."

Stefan shook his head. "I just don't feel like shlepping back to our room to get a bathing suit."

"Who needs one?"

He grinned and the idea clearly delighted him. We wandered off along the path that we thought led to the pool but found ourselves circling back to the bar area before we chose another. The paths felt very romantic since they were dotted with nineteenth-century-style lampposts, and when we approached the blue house in its cordon of palm trees, it was lit up as glamorously as a monument in Paris, with beams of yellow-white light shining up from every corner. Yet there was also something faintly sinister, given all the ghost stories, as if it were lit up like this to eliminate any and all shadows. The house was so starkly bright and set off from everything else around it except for the pool that I found myself thinking of pictures of the old No Man's Land in front of the Berlin Wall before it was torn down.

That chilling image almost made me change my mind about taking a swim, and there was something a bit spooky about the line of hedges that formed a wall around the pool area, shrubs I couldn't recall seeing earlier. But I was feeling sticky and started to pull off my shirt over my head as we walked toward the chaise longue–surrounded pool, which reflected the house's blare of lights. I had almost gotten my shirt off when Stefan shouted, "No!" He grabbed me and pulled me backwards but I could barely see and I stumbled against him, almost toppling onto the stone walk.

I yanked my shirt off angrily and demanded to know what the hell was wrong—had he seen a snake or something?

Stefan shook his head grimly and lifted his chin at the pool, while he himself backed away a step. His face looked frozen and I didn't want to advance toward the stone coping around the pool. But I did, somehow feeling distanced by the fear that radiated from him.

When I saw what had shocked him, I almost laughed aloud with

the kind of stupid horror you feel facing the sickly incongruous. Looking like the figure floating in Gloria Swanson's pool at the opening of *Sunset Boulevard*, a man was floating face down, arms and legs spread. From his height and build, and the lime green shirt, I recognized Bruno Zaragossa.

I felt oddly calm and detached, watching myself watch Bruno's body, observing how the hands and feet hung lower, how his hair spread out in the water, how the water had darkened his clothing, recording every detail.

"I'll get help!" Stefan shouted, and ran off to Reception. It was like the old cliché of the husband told to boil water while his wife was giving birth at home: he rushed off eagerly, obviously glad to be gone, glad to have a mission. I slid the shirt I was still holding in one hand back on.

Help for what, I wondered. He was surely dead. I could imagine answering the question "How did you know?" by saying nothing more than "Experience."

I studied the body. I could picture Bruno getting even drunker when he left us at our table in the dining hall, and slipping or tripping and falling in, too bombed to save himself. But if that were so, why? What had led him to sedate himself so heavily with booze?

I was alone there, surrounded by enormous trees that cast weird shadows, and every rustle reminded me of the ghost stories, but I didn't hear or feel anything supernatural. I did start to feel dizzy, though, and I crouched down, then sat on the cool stone, closing my eyes against the night and the darkness at the center of that bright, bright pool, and covering my head with my arms as if to ward off a coming blow. I wanted to disappear, to melt into the night air and have nothing to do with what I'd seen and what had happened, to be untouched and unstained, to erase it all from my mind.

But a surge of anger flowed through me and brought me back to my feet. What an idiot Stefan was to push our vacation forward, to bring us here, and I was just as much to blame. Why couldn't we have waited until spring break? I smacked the side of my head as if I were a vicious teacher cuffing an unruly child.

Some male GOs I didn't recognize ran past me and several

jumped into the pool. Stefan came running to me and said, "What are you doing?" And he grabbed my offending hand and held it away from both of us as if I were holding a weapon. I shook loose.

The GOs swam to Bruno's body and pulled him to the pool's stone edge, roughly handing him up to other GOs who had him down on his stomach, water spraying from his body, his mouth lolling open. One of the GOs began CPR but it looked hopeless from the start. Bruno's body seemed even more pathetic now face up, the beautiful smile dimmed, the striking eyes empty. There was some kind of injury on the left side of his head—the hair there looked different and his skull was dented, somehow.

We both turned away. I explained to Stefan, "I just freaked out there for a minute. I was thinking how stupid we were to come on this vacation."

"That's helpful," he said dryly, and I couldn't keep from smiling a little.

"Yeah, doesn't make any sense, does it?"

"If it's any consolation," Stefan said, slipping an arm around my waist, "once I started running, I didn't want to stop. I don't know what I was thinking. I wasn't thinking. It felt good to be moving, moving fast, moving away. Then I remembered we're on an island, and no matter how far I run—" He shrugged. "This is horrendous."

Yes, Bruno was dead, but that wasn't his point; I understood what Stefan meant exactly. Death had entered our lives yet again, and each time it happened, it was a blow that you could never completely recover from. It would work on us in ways we could not predict.

"The doctor's not on the island," Stefan told me. "That's what I heard at Reception. He was evacuated this morning to Nassau with appendicitis. His replacement is supposed to be coming in tomorrow but there are predictions of a storm and the airport in Nassau may be socked in."

"They don't need a doctor, they need an autopsy to find out what happened."

Word had somehow spread and the pool area was filling with more and more GOs (but no other GMs) who looked anywhere

from panicked to stunned. One or two were at the point of tears, eyes squeezing half-shut, lips trembling, and I thought I heard someone say, "I knew this would happen."

"Who found him?" a British-accented voice boomed, and we all turned. A short, very black man in dark blue shirt, pants, and tie with an elaborate name tag stood there surveying the scene, arms akimbo, round face taut with disgust. His tag read CAMPBELL SCOTT.

"I did," I managed. "We did." I gestured to Stefan.

He stalked over to us, his shiny black shoes sounding as heavy as boots. He shook his head at the body and spat, "Muddafuck." Then, as if he were a bouncer grudgingly allowing us entrance to the hottest club in town, he waved us over to the lounge chairs and said, "You wait there." I had not seen this man before, but assumed he was head of Club Med's security.

He walked over to the body, studied it, bent down to look at the stone edging the pool in one spot, and shook his head angrily.

"Drunk again."

Several of the GOs nodded with various levels of embarrassment. Clearly Bruno's drinking was no secret.

"He musta tripped. See dat piece of stone missing?" Again he shook his head. Pointing to four burly GOs one after another, he ordered them to take up the body and bring it to the kitchen as if he were sending troops into battle. "They'll know which freezer to use." The GOs hesitated, perhaps shocked by his callousness or the image of their *chef de village* amid the food supplies, but Scott clapped his hands like a sultan and they obeyed. I couldn't watch it and I stared down at the stone, memorizing the cracks and gradations of gray, waiting until I could feel they were gone.

"Okay now," Scott said, steely-eyed and disapproving of us for his own reasons. Did he blame us somehow for this disruption of his idyll or did our presence as GMs embarrass him for Club Med? "I'm Campbell Scott, head of security at this property. I'm an ex-cop so don't bullshit me now."

Stefan started, "We were walking to the pool to take a swim—"

"You don't see that sign there?" He jabbed a stubby finger angrily

at a sign on one of the far pillars supporting an urn. Even from here the sign clearly warned against using the pool without a lifeguard present.

"I was a high school swimmer," I said defensively.

"You're not in high school anymore," he shot back at me, blasting me with an angry up-and-down look as if I were one of those obese shut-ins on the front page of the *National Enquirer*.

Stefan and I managed, between us, to get out our short recital, despite hostile interruptions. There wasn't much to say: We hadn't seen or heard anything suspicious. We got there about 12:30 or so, maybe later. Stefan spotted Bruno first. I assumed he was dead from the way he was floating. I stayed behind while Stefan went for help. That was about it. The GOs had drifted off by the time we were done with our account and Scott finally seemed satisfied we weren't lying or leaving anything out. He rubbed his hands together as if they'd somehow been dirtied by talking to us, nodded a few times, and surprised us by saying thank you. Then he marched off, to inspect the body, I assumed.

Chapter Sixteen

I started to say something to Stefan, but he told me to wait till we got back to the bungalow, and after he took one quick look into the pool, we hurried to our room, turning on the lights and closing the door as if pulling up a drawbridge. Silently, we hugged as if we were on the brink of never seeing each other again. Then Stefan moved away to open the bottle of wine and pour us each a glass. We sat on the well-cushioned rattan chairs opposite the bed and drank in silence until I decided to put on a CD. I picked Susan Graham's beautiful songs of Reynaldo Hahn, the French composer who was a friend of Proust, set the volume low so as not to disturb anyone, and took my seat again. Stefan and I exchanged a long, dark look that said many things I was sure we would untangle.

"Why was the security guy so rude?" I wondered. "It didn't just seem like his personality. He was going out of his way, like he was trying to intimidate us, didn't you think?"

Stefan nodded and took a long sip of wine. He stood and sat back down, crossing his legs as if doing yoga. I envied his flexibility and his calm, because even if I could do a yoga pose, I wouldn't be able to get into it now.

"Like he wanted to shut us up or something," I said, thinking it through by talking it out. "But what for? Bully us so we wouldn't say anything here at the Club? But why would he care?"

"It's bad publicity."

"But you know what people are like. They'll hear about Bruno's accident and feel sad or whatever, imagine it was them for a few minutes, or someone they love, stay upset or quiet a few hours at the most, and then they'll go on relaxing and having fun. The news won't really shake them. Especially here. They'll be eating and drinking and having fun like nothing ever happened. Accidents can even make people feel safer, like on the highway, and you feel thankful it wasn't you when you drive by the wreck, the ambulance. I know I've felt that way sometimes."

"It wasn't an accident," Stefan said as calmly as someone laying out Scrabble tiles at the beginning of a game to make a word of only medium points.

"No?"

"Don't you remember?" Stefan said. "Don't you remember Bruno's face when he told us about his sister drowning? How devastated he was? I do. He looked terrified. He wouldn't go near that pool if he could help it, and his room faced the other way."

"But he was drunk tonight—you saw that." I leaned back into the chair cushion. "And it sounds like tonight wasn't an exception."

"Fine. Bruno was drunk. But he had a phobia about pools. I don't care how drunk he was, he wouldn't be right at the pool by choice. And trip? He'd have to be standing on the edge." Stefan finished his glass and rose to bring the bottle over from the table, poured some more for both of us, then set it down on the floor. He seemed wide awake, and completely focused.

"He got lost," I suggested.

"No way. First, he's the *chef de village*." His eyes flickered and he corrected himself: "Was. He would know every twist and turn here. And look at all the lights at the house—you couldn't miss them, even if you were drunk. Somebody must have lured him to the pool, somehow. And killed him, or made sure he would die."

It was a bizarre statement to make in that coolly luxurious room with its vibrant colors, pretty posters, and inviting bed.

"How can you be so sure?" This was a complete reversal for us.

Usually I was the one claiming to have figured out something dire, and Stefan was the nay-sayer, sometimes as caustic and closed-mouthed as Elinor Dashwood in *Sense and Sensibility.*

"You saw he had some kind of head wound? It was on his left side...." He let the statement trail out like a kite being drawn higher by the wind.

"His deaf ear."

"His deaf ear," Stefan repeated approvingly, as if I were a good pupil. "If you snuck up to him on that side, you could surprise him and—"

"Knock him out?"

He held the wineglass to his nose and breathed in as deeply as if he were the oracle at Delphi snuffling those volcanic vapors that were supposed to have inspired her visions. "Knock him out, or just knock him into the pool. And he'd be too drunk to save himself even if he went in conscious."

"Why did you look at the pool just now, before we headed back here?"

"Scott made a big deal about a piece of stone missing from the ledge around the pool, remember? Well, there's one at the bottom of the pool and it's big enough to be used as a weapon."

"But if the stone had been loose, it could have fallen in when Bruno did, right?"

"Right, right, right. What's important is the left. *Bruno's* left. How big a coincidence would it have to be that Bruno slips into the pool or falls into it and hits his head on the side where he's deaf? Of all the possible ways he could fall into the pool? And how believable is it that he drowns in a pool when he's phobic about them?"

I shook my head, unconvinced by his reasoning. "You're so positive." I held out my glass to him and he poured more wine. It suddenly hit me this was wine that Bruno had left for us. It felt unbearably morbid to be picking apart the circumstances of his death so soon after meeting him, and yet how could we not talk about it? If we ignored it, we'd end up like those sad couples in restaurants who study the menu, other customers, their fingernails, their plates, the

walls, the very air over each other's heads, but say little or nothing to each other.

"It all adds up," Stefan insisted. "I *feel* it."

Stefan seldom appealed to intuition, so this was a sign of how deeply certain he was.

"God, we'll never talk about Edith Wharton," I said, feeling idiotic to even think such a thing, let alone say it.

"What?"

"Bruno was an Edith Wharton fan. He was *my* fan. When do I ever have fans? You have fans, you're a novelist. I'm a bibliographer. I have nitpickers contacting me, or people asking me recondite questions, but not fans, never fans."

To his credit, Stefan didn't mock me for this burst of self-interest and self-pity. He just considered his wineglass.

I asked if he thought Bruno had felt a lot of pain.

"How would we know? He was looped, but even drunk you'd feel something being hit on the head, wouldn't you? And for sure you'd know you were going into the water."

"If he fell face first, maybe he would have swallowed water so quickly it would be over fast. Or he could have had a hemorrhage and been dead before he hit the water." I wanted it to have been a quick death; that balanced the sordid nature of how he had died, the shameful exposure of his body and his alcoholism to all of us who had gathered around the pool. In movies, hell, in life, people always cover the dead man's eyes and face, but Bruno had lain there ignominiously, and then been hauled off—to a refrigerator.

Relentless, Stefan said, "His face looked untouched, it was just the side of his head that looked— If he fell face first, it's unlikely he would hit the left side of his head."

"You weren't there, you don't know that."

"You don't want it to be a murder," Stefan said, sounding almost disdainful. He uncrossed his legs.

My rejoinder was somewhat pugnacious, due to the late hour, the wine, and the stress: "And you don't want it to be an accident."

"No, you're wrong. I would be glad if Bruno's death was accidental, but I don't think it is. It can't be."

I set my empty glass on a small side table and shook my head. "Listen, I'm worn out. Let's talk about this in the morning. I need to go to sleep."

Stefan agreed that we should drop it for now, and as we washed up, both of us moved around each other a bit like wary somnambulists. I was sleepily annoyed at the tension that had flared up between us so suddenly and a little confused as to why we were disagreeing about what we'd both seen. A terrible night was certainly bearing some strange fruit. We turned off the air-conditioning and slowly, quietly pulled open the balcony door behind the shutter doors to hear the sea while we fell asleep. As I slid under the covers in the dark, I hoped that everything would be clearer tomorrow, but what seemed clearest of all was what I saw when I closed my eyes and lay back on the soft pillows: the outline of Bruno's body floating in that pool, the GOs desperately trying to revive him, the body being carried off.

Those images of Bruno played on the inside of my eyelids when I started to wake up, but dissipated when I opened my eyes, as did my previous skepticism. I'd had one of those nights of churning epic dreams with vertiginous, confusing changes of place and identity, the kind where you can barely keep up with your own subconscious, but all I remembered now was the sense of frantic activity.

Stefan was already awake, staring at the ceiling, and when he turned to look at me as if expecting a continuation of last night's argument, his dark eyes narrowed, I said: "Do you think we killed him?"

"What?!" Stefan sat up jerkily against the headboard.

"You ran for help, but we could have pulled him from the pool. We're strong enough. And I know CPR. I could have tried reviving him right away. What if he was still alive when we found him? Didn't that occur to you?"

"No. Not until now." He reached to cup my chin in his hand. "Nick, we panicked. You can't blame yourself for that. It was natural. But I don't think those few minutes made any difference."

"We'll never know." I felt then what Joyce Carol Oates calls "the heavy sorrow of the body." I felt trapped in my own physicality, as

weighed down as I'd been at the pool last night, unable to move toward the pool and try to save Bruno, unable to even picture that possibility. What had happened to all my years of swimming, my life-saving practice?

"I don't know what to say," Stefan told me helplessly, as I pushed away his hand.

"I do. You were right yesterday. I don't want it to be a murder, but I'm just as sure it is as you are. It's too coincidental, and it doesn't make sense that he'd be there at a pool, when he had an aversion to them."

"What changed your mind?"

"Sleeping on it, I guess." I felt as if I'd gone to bed in the middle of a storm and woken up after it had passed, leaving behind the gift of crisper, cleaner air. Whether there was storm-related damage, well, that I'd have to see. But right now I felt clear-headed.

And badly in need of a shower, and breakfast. As the hot water poured down onto me in the large shower stall and Stefan brushed his teeth at the bathroom sink, I thought how ordinary these moments were, and how precious, because I was alive to appreciate them.

Dressed in nylon shorts, T-shirts, and flip-flops, we headed outside. The warm air, light blue sky, and foaming waves started working on me right away like the soothing hands of a masseur. I could feel myself slow down, and I surveyed the other GMs on various paths all idling along toward breakfast with as much quiet, languid pleasure if they were sheep in a romantically landscaped British estate like the one in *Brideshead Revisited.* I knew they were all individuals with their own lives and their own vacations, but they seemed inextricably part of the romantic setting. Even the runners on the beach seemed becalmed somehow, swimming through the buoyant air. Had someone really died here last night—had I seen the body? It was beyond incongruous.

Yet we carried the evidence with us in a way. As we moseyed along to breakfast, we were passed by GOs who all seemed to have heard that Stefan and I had discovered Bruno's body, because their

broad smiles ended at their watchful eyes. Though the island resort was small and probably had no more than five or six hundred people in it, I felt the same sense of constant movement and activity I felt back at SUM where backpacks and swinging arms were omnipresent. Here, it was tans and smiles.

"Humor me," Stefan said, leading me along a path that would take us to the blue house and the pool rather than directly to the dining hall. There were people already out at the pool, oiled and lying in the sun, and their presence was like huge scrawls of graffiti over a poster that made it harder to read. Bruno had died here last night but it was not the same place now in the bright morning filled with the flight of exotically colored parakeets from palm tree to palm tree. Quick-drying cement had been used to fix the cracked edge of the pool and caution tape marked off the spot. Stefan walked over, making an elaborate show of taking in the scene as if he hadn't known the pool was there before. I didn't want to go over there, and I knew what he was looking for. When he rejoined me, I wasn't surprised when he said, "That chunk of stone in the water is missing. Either it was cleaned up, or someone came back to get it and get rid of it."

I nodded. But whichever explanation held true, it didn't change how I felt about his theory from last night. And I didn't let his discovery spoil the morning's good mood. As we neared the dining hall, I was glad we had a whole week here, despite what had happened last night, and what we both thought it meant.

Though not as phantasmagorically lavish as dinner, breakfast was still a food festival, with chefs standing by to make omelettes, in addition to an impressive array of softly scrambled eggs, bacon, sausages, pancakes, grits, a cold cereal bar, bagels, plain croissants, croissants *au chocolat*, brioche, Danishes, a fruit table, even a station for smoothies and shakes. Of course, there was also the white chocolate bread, which people were talking about in adulatory tones. I suppose all this food and these vacationers enjoying it should have struck me as obscene or at least indecent after Bruno's death, but I was hungry, and so were they.

I didn't see any of yesterday's cast of characters except for Claire de Jonge sitting with Heath Wilmore. She looked very fetching, squeezed into a white-and-black striped tennis dress, though I couldn't imagine her serving anything other than herself in it, given how tight it was, just short of shrink-wrapping. In fact, she looked very tight with Heath, talking with the wide-eyed animation of someone who's just gotten off a monster roller coaster and is amazed at not having puked or broken into tears.

The way Heath draped himself in his captain's chair was as subtly jarring as the moment in *The Portrait of a Lady* where Gilbert Osmond is discovered grossly violating 1870s social protocol by sitting in the presence of Serena Merle, who is on her feet. Heath worked for Claire's father yet he seemed cocky and overly at his ease with her. Last night, however, he'd been clearly deferential to Franklin Pierce, and even Peter de Jonge in a subtler way.

Thinking I might restrain myself, I brought just coffee and scrambled eggs to a table outside, but it was a silly expectation, and Stefan's full plate and his silence at my selection echoed that realization, so I went back to forage for more. There were only half as many people at breakfast as had been at dinner. Conversation was more muted, clothes brighter but more haphazardly put on, and faces and hair less put together. It was as if we were in an upscale student dorm after an all-nighter. GOs circulated as always, spreading cheer, knitting together strangers into a community, encouraging the shy, and I couldn't sense any general panic or stirring about Bruno, so I assumed the news had not spread, yet. Could it be kept quiet indefinitely?

Chapter Seventeen

STEFAN and I ate in companionable silence, punctuated by comments about the food, the view, our relief at not being in Michigan. As I sipped my strong coffee at our veranda table with a view of the sea that demanded to be painted, photographed, and extolled in a Pindaric Ode (if one had the time and the talent), I did not feel superior to those inside who had no idea Bruno was dead. Nor did I feel burdened. I was ready for Stefan to take the next step.

Which he did after a second helping of everything he liked most and another few cups of coffee. We were sheltered by a curve in the veranda, but he spoke quietly just the same.

"Did you check them out?" he asked. "Back in the dining hall? Heath and Claire de Jonge?"

"I did."

I told Stefan how Heath's posture had recalled to me that famous scene in James's novel (famous to people in our field, anyway).

He didn't stay with that. "I was thinking of something else. He looked happy. He looked relieved. Didn't you say he was frustrated yesterday when he was talking to Pierce?"

"'I'm working on it!'" I quoted.

Stefan nodded a few times.

I said, "You think he knows Bruno is dead."

"I think he knows Bruno is dead."

I continued to lay it out. "And whatever kind of threat Bruno posed to the Pierce–de Jonge family, it's over. Or they think it's over. That includes Claire."

"And Peter?"

"No, he was out of the loop, remember? He wanted me to follow them around, he said they were up to something. His father-in-law, his wife, and Heath."

"You think Peter suspected this was going to happen?" *This* meant Bruno's death.

I shrugged. I'd met and talked to Peter at length, and knew these other people at least by sight, yet talking about them this way, they were infinitely remote. Stefan and I could have been gods on Mount Olympus in that Harry Hamlin movie *The Clash of the Titans,* surveying the chessboard where humans played out their miniature lives. And Bruno's ignoble death, made more awful by the strong possibility of murder, was fading in its wretchedness, and becoming something almost theoretical as we worked out possibilities.

"Maybe he just picked up that they were going to put pressure on Bruno, try bribing him? Peter would have told me everything he knew, wouldn't he?"

"Nick! You've been reading all those PI books and you can ask that? Clients never tell the whole truth, they always hold something back."

"In books, maybe, but he seemed sincere." I didn't comment on his calling Peter my client, just appreciated the reference.

"If you say so. Okay, the Pierces want Bruno not to do research on their family and not to publish his book," Stefan said thoughtfully. "And they offer him money and he doesn't want it. So what happens next? Kill him? Why not threaten him, rough him up or something?" He looked suddenly confused.

"Maybe that's what was supposed to happen? And the death wasn't murder but manslaughter. But if Heath wanted to kill Bruno, why do it by the pool with all the glare from the lights at the blue house? You're pretty exposed standing there."

"No, it's more private than that, Nick. You forgot that hedge, it's

as tall as I am, and you'd have to be standing at one of the breaks in it to see inside."

I wondered if this had just come to him, or if he'd been putting the pieces together in the morning, when I found him gazing up at the ceiling.

"I double-checked that before," Stefan added, "when we stopped on the way to breakfast."

"But still," I said. "Why do it at the pool as opposed to someplace else?"

Neither of us could come up with an answer to that. Stefan said he needed more coffee and he took both our mugs back inside for a refill. While he was gone, I saw Dominique Grosbisous and Clovis walking along the beach, barefoot, pants rolled up midcalf. He had on a long-sleeved white shirt whose tails fluttered in the breeze and she kept squashing her big straw hat down to keep it from blowing away. They splashed in the edge of the surf like kids kicking piles of leaves. There was something stagy about their intimacy and ease together, the way they fake-bumped against each other as they walked. They reminded me of actors in a filler scene in a movie, the kind with a romantic song blasting out clichéd sentiments to make up for a hole in the script. Perhaps Dominique and Clovis wanted everyone to know last night's contretemps was barely a memory now for them.

Just as Stefan returned with our coffee, Clovis swept her up in his huge arms and held her high, whirling her around while she beat at his chest, laughing helplessly and shouting, *"Arrêt! Arrêt!"*

"It's a commercial," Stefan said, sitting down, cutting his eyes at the oh-so-happy lovers. Her hat fell off, she wriggled out of Clovis's arms, and they both chased the hat as it spun and skidded down the beach. "No, it's a plug for the Lifestyles Channel."

"What about Clovis?" I asked. "Forget Heath being happy, that could be about something totally different. Clovis was enraged yesterday. He's volatile enough to kill someone. He *told* Bruno he'd kill him. And now he's showing off how loving and sweet he is, even though he's a mope."

Stefan grinned. "A mope? What's that?"

"A thug. He's a big thug."

"You've been reading too many PI books. You need to update your invective."

"Fo' shizzle, dawg." That was "certainly" in hip-hop slang.

"Don't act superior because you managed to sit through one or two rap videos."

"Hey, those brothas are slammin'."

"Okay, okay. You've made your point, whatever it is."

I checked the beach where Dominique was clapping her hands while her swollen swain did cartwheels that left huge depressions in the sand, given his bulk.

"He's pretty happy today," Stefan observed dimly as if Clovis were a biplane flying overhead, trailing a banner blaring how much money he made as a writer.

"Happier than Heath."

"You think—? But why? Why would he kill Bruno?"

"Are you kidding? It's the power of shame. Bruno humiliated him in front of several hundred people. Clovis could never let that go when he's so flammable. This is a guy who served time for assault."

"That's what they say, but what if he's as phony as Vanilla Ice? What if he didn't have all those jobs and didn't come up the hard way? What if he's got a trust fund somewhere?"

"Even more reason to go off the deep end. If he's got all that to hide, he can't let anyone show him up as a fraud. It's too risky. He's got too much invested in his image. Add that to his temper, and—"

"It's a stretch."

"Of course it is. Murder is a stretch for most people. They have to stretch past their usual limits. But they do."

"Good morning, good morning, good morning!" Courtney, from last night's dinner, appeared with a half-empty tray and her husband. Both were wearing white tennis shoes, gray sweat pants with matching headbands, and dark blue T-shirts. Despite their age, they had the childish feel of little twins cruelly dressed alike by parents who thought it was cute.

"Can we enjoin you?" she said as she and Jason sat down.

I wanted to say, "Be my guess" to match her off-kilter English, but I didn't. I was on vacation, wasn't I? And she wasn't my student.

"Last night was so much fun! In the talent show, they had all these wigs and costumes and they even did drag, one of the guys was dressed like Madonna, if you will. He was totally laughable! It was so funny! They were all great. I love lip singing!"

I waited for her husband to correct her and say it was lip-synching and explain that laughable and funny weren't synonyms, but he seemed oblivious to her linguistic errors.

Jason looked at us expectantly since the magic words "Madonna" and "drag" had been mentioned. I think, as certified queers, we were supposed to *ooh* and *aah* or at least nod approvingly, because our lack of response evidently puzzled him.

"You missed the disco," Jason noted, pitching into his omelette. Was our presence there also required, since gay people had invented disco?

"We were on the beach," I said, a bit embarrassed that I felt I had to explain myself.

That let us off the hook because Jason and Courtney grinned at each other and I felt we could have been newlyweds and they our grandparents. Courtney's grin faded, though, as she surveyed the croissant, mango slices, and sunny-side-up eggs on her plate. "Do you want me to get you something else?" Jason murmured. "You sure? Are you okay?"

Courtney shook her head disconsolately, then perked up when she said, "Omigod! The dancing was a spectacle."

"Spectacular," I thought.

"They have this little raised stage at the disco and the GOs—is that what they're called?—some of them would get up and really bust a move. Great bodies. Amazing definition and vascularity. I think we just missed Vincent or something because he's supposed to be the best, but the other guys could really shake their shit around."

I did a double take, and Courtney blushed a little and explained, "I had a Jamaican friend who used to say that all the time." She

hurried on: "Wasn't Bruno's song last night terrific, and that fight afterwards? Wow. I would love to have two studs fistifying over me like that. You think it was for real? I mean, is Bruno really a flirter or does he do that just to have fun and make people feel attentive? Though I did hear from somebody, who was it, that last year one of the GOs ran off with somebody's wife. But maybe that's just a rumor. There are some hot guys here, though, so I can see it as a happenstance."

With Bruno's name mentioned by someone else, his death didn't seem so distant. Our faces must have shown distress because Jason said, "You don't think so? Or, what, you didn't like his song?" You could almost hear his wheels turning as he tried figuring out what we might have against Bruno or GOs running off with guests, and if it were somehow connected to political correctness, but he came out blank.

"We were just thinking about something else," I tried, and they accepted it.

"We have to hurry so we don't miss the power yoga class," Courtney told Jason, and they were soon off.

Stefan went right back to our previous discussion. "If the doctor's replacement gets here today, it's not likely to be anyone with criminal experience—"

"But even if that's not the case," I said, "the chief of security has made up his mind, and if it's widely known that Bruno drank, they won't think there's anything to investigate. Death by misadventure, or whatever it's called here in the Bahamas. Besides, I've read enough to know it's very hard to prove whether a drowning was accidental or murder, and most accidental drownings are caused by alcohol anyway. He probably didn't have a chance to fight, so there wouldn't be any defensive wounds. It all looks pretty clear if you don't look too closely. And they can just shrug off the missing piece of stone."

We chewed all that over a bit.

Stefan shook his head as if shooing a fly. "I just thought of something. Don't dead bodies only float after they've been in the water a while, and there's decomposition, and gas? Isn't it the gas that makes them float?"

"It does, but a corpse can float if there's air trapped in the clothes, or if body fat keeps it buoyant, which wouldn't be true with Bruno since he was in pretty good shape. Or, I guess, he could have been dead already when he fell in and not taken any water into his lungs."

We considered that together as if puzzling over one of those mathematical problems involving trains departing different stations at different speeds.

"Anyway, nobody's going to be telling us the details of an autopsy. Tourists who barely knew him? We don't have any claim to the information."

"We could try to get a look at the body," Stefan suggested glumly, as unprepared as I was to take a closer look at Bruno's corpse, and dubious, too, about our chances.

I seconded his lack of enthusiasm. "Suppose we could sneak in to wherever they put him, we're not trained. Reading mysteries and books on forensics isn't like being a doctor." Or even a real PI, I thought. "All we can do is try to figure out who was responsible."

Stefan said, "Yeah, and report it to Chief Scott?"

"Report it to someone."

"So you're banking on Clovis," Stefan brought out, changing the subject a bit.

"Yes. He's an obvious suspect, maybe not as much as Heath Wilmore, but—"

"It could be more than Heath," Stefan said. "What if Claire de Jonge was involved? You remember how Bruno was singing to her and how much she enjoyed it? And she looked so happy talking to Heath. What if Claire's central?"

"I'm not following you."

"What if she was the bait? Bruno couldn't stand pools, but that's where he died. Maybe Claire arranged to meet him there—"

"Puh-leeze. What would be wrong with a nice quiet corner of the beach?"

Stefan shook his head. "Easier to drown him in a pool than in the ocean, and last night the tide was out." He was silent and I supposed he wanted me to imagine somehow dragging Bruno out to sea. I did,

and admitted it was unlikely. I was impressed that Stefan had been exploring so many twists and turns of this case. But Claire? Peter's wife? I asked Stefan how that could be possible.

"She's under her father's thumb, first of all. We saw that. And she worships her family name—isn't that what you said? So, that's two. Third, she's a sex trap and Bruno looked hooked."

"A sex trap? This, from a novelist? Very sad."

Stefan swatted that away, undeterred. "When Peter talked about her, did it sound like she was the love of his life, that he was crazy about her?"

I considered our conversation on the beach. "No. I didn't pick up much affection."

"I thought so." Stefan crossed his arms with a Q.E.D. certainty. "He doesn't trust her. He doesn't trust any of them. And that's why he asked you to investigate. Now you have even more reason to do so."

"But you said it was unethical, or at least screwed up, for me to take money from Peter." I was only half-seriously playing devil's advocate with him.

"I know I did. That was before somebody died who we think was murdered. Now it would be unethical not to investigate."

"Come on," I said, picking up my tray and moving down the veranda to an open table near the door. Stefan followed with a slight frown and I explained I wanted to see if Heath and Claire de Jonge were still inside, and if they were, wait for them to leave.

"You stay here," I said. "I'll go get coffee."

Inside, more tables were filled than before and the deeply contented hum in the room was like a blast of music. Heath and Claire were still at their table, still talking away and looking very comfortable, though somehow out of synch. There wasn't an empty table even close to where they sat, so I couldn't eavesdrop. I headed back to our outpost.

"I guess I have to shadow him," I said to Stefan, sitting down and handing him fresh coffee. "Or her." It didn't seem very promising and when I tried to imagine how Dashiell Hammett, Raymond

Chandler, or Loren D. Estleman might have written the next scene, I was stumped. We weren't just on an island, we were at a resort, a world within a world that was so small they would surely spot me if I trailed after either one. How was I going to gather any information? A disguise, perhaps? I'd be as ridiculous as Charlie Chan's overeager Number One Son.

But Heath and Claire appeared at the entrance just then and he said, "Tell your father I'll meet him at the gym in half an hour." His tone was anything but familiar, and I wondered if we'd misinterpreted what I'd seen inside. Maybe his ease, and Claire's animation, were due to their being out from under Franklin Pierce's surveillance.

Chapter Eighteen

CLAIRE and Heath parted, heading in different directions, but before Stefan and I could confer, Peter de Jonge appeared at our table with a tray. Had he been inside briefly with his wife and Heath or had he just gotten there? Peter joined us without even saying good morning, looking very lean and tanned in a red tank top and super-long white cargo shorts.

"I want to apologize," he said, ferrying food and drink from his tray onto the table, then turning to set the tray on a table behind us. "I want to apologize for not being completely honest."

It was such a good moment, Stefan and I both prolonged it, attentive, accepting, eyebrows up, waiting for more.

Peter met our eyes without awkwardness. "I should have been straightforward about asking you to come down here. You would have said no, and then I would have figured something else out. But this way, I'm sure you ended up feeling taken advantage of or manipulated and that was wrong of me. I shouldn't have done it." He lowered his eyes briefly.

It was so unexpected a display of contrition, it didn't trigger a sense of vindictive triumph in me, but a desire to assuage his embarrassment. "Well, we could have ended up in worse places than this," I said indulgently.

"No, I should have been up front with you and with Dr.—

Stefan." Peter shrugged, surveyed his scrambled eggs and set to, enjoying them like a weight lifter having his first pizza after months of food restrictions in training for a show. Peter ate the very crisp bacon with his hand. I could never manage that level of insouciance. My bacon typically fell in my lap.

Stefan looked at me, nonplussed by Peter's apology.

"You can forget about my hiring you," Peter said to me, his mouth somewhat full. "For now. Down here, anyway, I mean. We're cutting short our trip. My father-in-law, he's just informed us that he has urgent business in Michigan he has to get back to, and if the weather clears up around Nassau—there's a big storm warning— we'll be flying there tomorrow morning, then home. So there's really nothing you can do here."

"But you worked so hard to get me involved," I said, testing him. "To figure out what was going on. Can it really wait?"

"It has to. We're leaving tomorrow."

"If the weather permits," Stefan pointed out.

Peter smiled. "Things usually go the way Franklin Pierce wants." A cloud drifted across his sunny expression and he didn't seem so laissez-faire now. There was history in that comment. "I'll call you in Michigan," he said abruptly. "Sorry." He hurried off as if the whole conversation had actually been painful for him and he couldn't hold himself together any longer.

"What the hell was that all about?" I muttered. "He wants me to investigate like crazy, then suddenly he doesn't?"

Stefan folded his hands and then reversed them, cracking his knuckles. "Why the sudden turnaround? What's different today?"

I lowered my voice since we were so close to the door and people were passing through it in both directions. "Don't tell me you think *he* killed Bruno—or he's implicated in it? Because if that's so, and I can't imagine why, then I don't think he's going to be happy if I find out."

Stefan was stroking his handsome chin. "I can imagine why. What if Claire's been cheating on him, and what if she was sleeping with Bruno here? Same reasons as Clovis. Jealousy, rage."

"So that means we're looking at Clovis, Heath, Peter, Claire. How are we going to figure out what happened and who's responsible?"

Stefan looked as confused as I was. "Whatever happened, we only have a day to put the pieces together, if the weather does change in their favor. Figure out when Bruno died, who really wanted him dead, and who had the opportunity to do it."

I rose. "Time for a workout," I said, and Stefan nodded. We downed our coffee and hustled back to our bungalow to change for the gym, where Heath had told Claire de Jonge he was meeting his boss. En route, Anouchka passed us on a parallel path, humming and looking almost jubilant. If she knew Bruno was dead— and why wouldn't she?—then his demise had given her nothing but pleasure.

She waved and grinned a good morning at us as broadly as if she were about to burst into song. Stefan and I turned to watch her stride powerfully away from us, and I wondered if there was anyone who was truly sorry that Bruno was dead.

The stone chapel that housed the gym looked like it had been gutted to the joists and rafters before being retrofitted with new windows and air-conditioning. Inside the open door, neatly lettered signs pointed upstairs for yoga and aerobics. A voice drifted down from the second floor and I heard an instructor saying in hypnotic succession, "Downward dog...jump to the front of your mat...raise up to a back bend—" That was the power yoga class, where you moved from one *asana* (pose) to another quickly enough to build up a sweat by the end of the class. I'd tried it back home and it had worn me out.

About forty by forty feet, the mirror-lined, high-ceilinged main floor of the gym was well-stocked with free weights and Cybex machines for working various muscles, and one whole wall was glass so you could work out to the inspiration of rolling surf and blue skies. Or would it feel like punishment? Every minute spent inside, a morsel of Paradise lost?

Perhaps because the gym was almost empty, it was very cold.

More bodies would have brought up the temperature. The reddish sound-absorbing floor tiles looked new, as did the glossy ivory paint on the ceiling and exposed areas of wall. I didn't understand why Courtney had been complaining at dinner the previous night that the gym was primitive; you could get a great workout here. Stefan had shown me that years ago, wanting me to know all kinds of equipment and many forms of workout so that I could walk into any gym in the world and get a good hour or two of exercise whether there was a pool available or not.

Pierce and Wilmore were there, as we had hoped. But they weren't locked in incriminating conversation when we got there, though they weren't very far apart. At the front of the room, Pierce marched away on a treadmill with ominous solidity. Out of his suit, thick-necked Franklin Pierce looked almost as muscular as Didier Charbonneau back in Michiganapolis. His shoulders and back were well developed and the black biking shorts and skimpy black tank top didn't look ridiculous as they might on most seniors. They were the trophies of a very proud, very strong man.

In black sweat pants, Nikes, and a Neptune College T-shirt, Heath was doing bicep curls nearby with fifty-pound weights, facing a mirror. He was the kind of wiry guy with no chest but big shoulders and arms that seemed to have been hung on the wrong body. He had perfect form with each hard repetition, knees slightly bent, back straight, shoulders neutral, only his pumped-up biceps working, and slowly. It was not hard to imagine him using one of those arms to strike Bruno down.

Suddenly Pierce snapped his fingers. "Heath, *towel.*"

Heath Wilmore put down his weights and brought a small white towel over to Pierce, who used it to wipe his forehead while he kept a steady, strong pace. Then he handed it back, and Heath returned to his workout, draping the towel on the metal rack of dumbbells.

A minute later, another imperious finger snap. "Heath, *water.*" And Pierce's assistant stopped what he was doing to carry a plastic bottle of water over to his boss, and wait while he took a slug. There was no thank you, and Pierce didn't even turn from the view while

he ordered Heath around. This happened several more times, and Heath was always as blank-faced as a native servant in some 1920s British colony, betraying nothing.

From what I'd seen of him so far, and from Peter's description of him as a bully, I imagined that Franklin Pierce was like this every day. Cold, callous, unfeeling. Stefan was evidently thinking the same things, because when Pierce was done on the treadmill and Heath trailed after him out the door, he said quietly, in case his voice might carry, "Put that thug at the top of the list. He's not a bully, he's a dictator. People are ants to him. He'd crush anybody who got in his way. And he wouldn't need his flunky to do it for him, either."

"But why should we be surprised?" I asked as the door to the gym closed and we were alone in that over-chilled room. "He's a college president, isn't he? And what about Heath—anyone who puts up with that treatment has to be full of rage or he's not alive."

Though the door was closed, I was sure I could hear Franklin issuing some contemptuous orders to Heath, something to do with his plane and his pilot, and the door opened again, Heath returning to the dumbbells.

Turning his back to Heath and facing me, Stefan said "You stay here," so low I was almost lip-reading. "I'll follow Pierce."

I couldn't object because Stefan was off, leaving me alone to figure out how to unobtrusively interrogate a man who might have committed murder or been involved in a conspiracy to commit murder. I wasn't afraid—though maybe I should have been—because it was late morning, there were people upstairs and on the paths outside, and if he had killed Bruno, it had been in a spot far more isolated than where we were now. And I wasn't drunk and easily overcome.

I made a show of wiping myself off with my towel and peering around to decide what to do next, trying to keep from working my way over to Heath too quickly. I adjusted the seat and arm handles of a gleaming white Cybex "pec deck" and proceeded with a warm-up set at lower weights, then pyramiding up, taking the repetitions slowly to show I was serious about working my chest, not just a vaca-

tioner trying to get into shape between lavish meals. I didn't want him to write me off.

"Nice gym," I said as I finished with the pec deck and looked around again, strolling to the humming water fountain near the door. Heath shrugged a loose agreement and I took a long drink.

"For a resort," I added.

"I've seen bigger," he said, and his tone wasn't informational, but mildly aggressive, as if he had to put me in my place, unless he was always like this after a session with Franklin Pierce, passing on the negative vibes. He reminded me a little of the gunsel played by Elisha Cook, Jr. in *The Maltese Falcon,* someone tough on the surface, tough with a weapon in his hand, but easily disarmed. Wilmer, which was close to Heath's last name. Was that what had triggered the association?

It didn't matter, and I couldn't stop talking, though, now that I'd started. I found a bench ten feet back from the mirror, brought over twenty- and thirty-pound dumbbells to do regular arm curls and hammer curls, and started to work out, staring straight ahead as if totally engrossed in my quest for physical perfection.

"Working hard," I said, as Heath set down his weights and let out a deep breath, stretching his back.

"Hardly working." He grinned, and I felt I'd slipped past some kind of boundary with him. It was the same kind of mindless exchange I'd seen other guys have at the health club Stefan and I belonged to. But there was an edge; now that his boss wasn't there, he carried himself as he had while sitting at the breakfast table with Claire de Jonge that morning.

"You've been here before?" I asked.

"Serenity?" He nodded, not quite looking at me, not quite looking away.

"Food's good."

"Stay away from that white chocolate bread—too many carbs." He went back to shoulder presses, his form perfect, his strength admirable, given his build. I did some triceps work with the same weights I'd been using, desperately aware I might not have another

chance to talk to him alone before he left tomorrow, if the Pierce party did leave.

"Great place," I said inanely, taking a break. "Beautiful beach. Beautiful rooms. Staff is really friendly."

No comment.

"Heard about the ghost?" I asked.

"That's just bullshit."

"A lot of people believe it."

"Yeah, well…" He let that trail, his opinion of people in general conveyed by the sarcastic twist to his thin-lipped mouth.

"Too bad about last night." Head down, I watched in the mirror for his reaction. "I mean about Bruno."

"Bruno?"

"Bruno Zaragossa. The *chef de village*."

"Tall guy, yeah. What about him?" Heath sat at a Cybex shoulder machine, set his shoulders and back correctly, and started pulling back the handles to work his posterior delts and his back. His face was impassive; only his eyes seemed to narrow with the effort.

"He drowned last night."

"They found him washed up on the beach or something?"

If Heath was trying to fake me out by not mentioning the pool, it was a great move.

"He was in the pool," I said.

"The pool. Huh. How do you know?" He was resting between sets and eyed me coldly. "Maybe it's just a rumor, like the ghost crap. You shouldn't spread stories like that."

"I was there, I saw him."

"Yeah?" Heath rose and advanced a few steps. "What did you see?" His fists were clenched, and the veins up and down his arm were popping.

"I was walking by the pool after midnight, with a friend, and Bruno's body was floating in the pool, it looks like he was drunk and fell, and my part—my friend ran for help—" I broke off my headlong recital, realizing with embarrassment that Heath was much better at eliciting information than I was. And annoyed that I'd changed

my relationship to Stefan. It was a verbal twitch I could not shake when talking to a stranger.

"So he is dead? For sure, huh?" Though Heath's face was as blank as ever, I could swear I heard the wheels turning inside.

Heath strutted over to the weight rack in front of the mirror to replace the dumbbells he'd left on the floor, and each one clanged loudly on the metal as he fitted it back into the grooves. Was I imagining it, or was he racking the weights with deliberate noise, making a point of how big they were? Unless he was celebrating and this was his small version of ringing some church bells.

"I guess he was in the wrong place at the wrong time," Heath said flatly, turning and heading for the door. "That can be dangerous" were his parting words.

The door closed and I broke out into a sweat. Did he know what I was up to? How could he? I closed my eyes and breathed in and out a few times, seeing the way he'd wielded those big dumbbells like weapons, his shoulders and arms taut and pumped. Was he threatening me or just making an observation?

Stefan would not be happy that Heath knew I'd been there at the pool last night, that I hadn't learned anything but had instead divulged information that I should have kept to myself. No, wait, I had learned something important. Heath's lack of sympathy or surprise seemed unreal. He'd overplayed his hand in pretending not to know who Bruno was at first. He'd been negotiating with Bruno, after all, to try to stop him writing and publishing that book. Why go so far in acting like he didn't really know Bruno unless he was involved in some way with Bruno's death and covering that up?

Chapter Nineteen

I PARKED myself over at the fountain and drank a lot of water, considering my next move. Bruno had died between 10 P.M. when we left the dining hall and 12:30 when we neared the pool. We had to narrow that down somehow and find out where he'd been, who he'd been with, and who had seen him—and be discreet about it.

First, I returned to our room to shower and change. On the way there I passed a black woman in blue uniform dress and comfortable shoes carrying towels, and her unforced, easy "Good morning!" shook me out of myself. News about Bruno's death could not be widely known, could it?

"Beautiful morning," I said, stopping, enjoying the warmth, the clear sky. "Is it always like this?"

"We get clouds, storms, sure, it can happen, but the beautiful mornings, they come back," she said, moving on.

I spoiled the moment by asking if she had ever seen the ghost.

She sped up, saying over her shoulder, "No ghosts here. None." As if the very mention of the word opened up a vortex of trouble at my feet and she had to distance herself from it.

In our room, showering again, I wondered how Stefan was doing, and even what he was doing. Had he managed to strike up a conversation with Franklin Pierce, had he followed him discreetly, seen anything suspicious? Stefan was much smoother than I was, and

though he wasn't chatty by nature, that might help him, I suspected, with someone as overbearing as Pierce.

Dressed, I headed right to Reception to find out if anyone knew the weather forecast for Nassau, and if the bad weather was heading our way. A short, glistening-toothed Italian GO named Paolino told me that no flights could leave or land at Serenity today, but the prediction was for a clearing tomorrow morning. I must have looked glum, because he said, "Do not worry. Nothing bad will happen here—no rain, no storm. Or, maybe a little rain, but it goes quickly."

I thanked him just as Anouchka exited Bruno's office, closing the door softly, and headed away from us down the veranda. She looked like an athlete or a tennis pro in white sneakers, shorts, and polo shirt. I followed and stopped her by a gentle tap on her shoulder that startled her so much she almost tripped.

"Sorry!"

"No, it was my fault," she assured me, "I was thinking of too many things." And then a switch seemed to flick on because she put a hand out and led me over to some rattan chairs on the veranda. We were surrounded by masses of bougainvillea and alone except for passing GOs as we sat very close together. She crossed her muscular, tanned legs and leaned forward confidingly. "I heard the news. I am so sorry what happened to you yesterday."

"Excuse me?"

"At the pool. The discovery… Terrible. A terrible thing to see. A tragedy." Did she mean Bruno's death, my being there, or both? "This morning, I didn't know."

"Didn't know—?"

"That Bruno was dead, that you were there, after."

Anouchka was anything but happy now and I felt deeply embarrassed for having misjudged her before when she walked by me and Stefan, and I had assumed she was glad that Bruno was dead. The Club Med geniality was set aside now, and I felt in touch with the real, sorrowful woman behind the PR façade. She was even more beautiful than usual, sadness adding a kind of blur or sheen to her

face, looking like the way some movie stars used to be filmed with a soft-focus lens in close-ups.

"Such a thing to happen here," Anouchka said. "It's very rare. Here, or at any Club Med."

"Bruno drank a lot? People knew?"

"Some." She nodded, eyes down, hands coming together in her lap as if in prayer. "It was very difficult—" She was on the verge of tears.

I hurried to reassure her. "It's not your fault, it's not anyone's fault. You can't make someone stop drinking."

"Yes, I know. But to watch it happen…" Now she met my gaze fully. Eyes glistening, she said, "Would you do nothing? He hated for anyone to tell him he was in trouble. He wouldn't listen. And now we see what it led to." She was as weary and bitter as a social worker who's watched a client self-destruct and end up back in jail.

"Last night," I said. "Where was he after dinner?"

Anouchka sat back and surveyed me curiously. "Where was he? What do you mean?"

"Was he at the talent show, the disco, the bar?"

"Obviously he was at the pool, that's all that is important, no?" She squinted at me as if one of us were having trouble with the language.

"But before that."

She leaned her head back and looked up as if trying to picture an appointment book. "He was at all those places. It's what the *chef de village* does. He has to be everywhere. Why are you asking?"

I couldn't answer that with anything better than a shrug. But I persisted. "Did you see him drinking more after dinner?"

"Yes. No. I—" She bit her lip. "I assume he drank more after dinner. Sometimes he did, sometimes he didn't."

"You weren't there?" I guessed. "You didn't see him?"

This seemed to relieve her because she smiled. "No, I was in my room a long time after dinner, off-duty, writing letters home."

"And then?"

"Sorry?"

"After you wrote letters?"

"I went to sleep," she said briskly. "I was tired. We are very busy here, we are always busy."

That I could believe, but I wasn't any closer to narrowing down the time of Bruno's death or figuring out the steps he took between dinner and drowning in the pool.

"Nick!" Stefan was at Reception and heading over, holding some towels. Anouchka smiled broadly and warmly, rose, and said, "If you need anything, please let me know." She headed back down the veranda, and Stefan took her seat, shaking his head. "I couldn't get anywhere with Pierce. He was at the bar, having a vodka martini, so I ordered one, too, just to have an excuse since I hate them, but I couldn't get him talking."

I recounted my not very satisfying encounter with Heath back at the gym, and Stefan agreed that Heath's pretending not to recognize Bruno's name was suspicious. And I shared that I'd gathered nothing from talking to Anouchka. Before he could comment, I said, "Look!"

Off on a path several hundred yards from us, framed by wildly leaning palm trees that almost crossed overhead, Heath Wilmore was talking to Anouchka. Even with my shades on, the sun was in my eyes. I couldn't hear what they were saying, but Heath seemed to be demanding something of her and she kept shaking her head. Finally she stopped and I thought she passed something to him—but maybe she just touched his hand to placate him in some way.

"Did you see that?" I asked, as Heath walked away from her and she made for a distant building. "What was that about?"

Stefan frowned; he looked tired and doubtful, as if he were at the point of saying he didn't really care, and suggesting we just give up what passed for our investigation and resume our holiday.

To stop him, I suggested we sit by the pool a while before lunch.

"It won't feel weird?" he asked. "Being there?"

I didn't reply that feeling responsible as I did for Bruno's death, or at least guilty for not having done anything to save him, I had to go there sooner or later and confront the scene of my failure. Instead, I

quoted a Don DeLillo novel we'd both read, *Mao II*: "'When there is enough out-of-placeness in the world, nothing is out of place.'"

"That suits most occasions, doesn't it?" He smiled ruefully and pulled a tube from his pocket: "I didn't forget our sunblock."

We made our slow way to the blue house and its pool, passing and passed by dozens of GOs and GMs, everyone looking busy but relaxed. At the pool, a radio was playing and some kind of elaborate and silly dancing game was going on, with about twenty people lined up around the edge, doing the Macarena or something like it to Latin-beat music. The leader was Vincent, who looked even darker with his chest and legs bare. Dense curls formed a "T" on his torso, the upper bar stretching across his tight, well-defined chest, the perpendicular one running straight down his six-pac into his blue flowered, knee-length bathing trunks.

"Who let the dogs out?" Stefan murmured.

"Woof."

We weren't the only ones taking in Vincent's scenery. The dancers were mostly women, American and French (the latter wore far less) and they followed his every move. He was loud and brash on his portable microphone, shouting at them about fun and sun and other nonsense. Stefan pointed to Claire de Jonge stretched out on a chaise at the far end of the pool directly opposite the steps to the blue house. She wore a bikini the color of those yellow Hummers and I flashed on an image of her driving one; it was the fuck-you vehicle perfect for the kind of woman she seemed to be. There were empty chairs near her and Stefan led me over there, but kept mum while we arranged them to our liking, kicked off sandals, pulled off our shirts, passed the sunblock back and forth. His chair was closest to hers and I could feel him casting about for some way to start a conversation with her, but he didn't. I was fresh out of chat.

The dancing game ended a few moments later with applause and wild praise from Vincent, who touted Happy Hour and more coming amusements over the course of the day than anyone could keep straight without a Palm Pilot. Claire took that opportunity to slip on a bathing cap, stand up, and plunge into the deep end of

the pool near us, where she proceeded to do a slow but flawless butterfly.

To my surprise, Vincent sauntered over and said hello to us. "Not game players?" he said cheerfully, scratching his chest.

I shrugged, and Stefan didn't respond, but he sat up when Vincent said, "Thanks for trying to save Bruno last night."

"We didn't do anything, we just—"

"No, you were great. May I?" He gestured to a seat and pulled it over, sat down between the ends of our two chaises longues, legs invitingly spread, heels down and toes up. "Some people panic, they don't know how to respond, but you did the right thing. You called for help."

I didn't look at Stefan, who surely knew what I was thinking about that comment.

"Bruno drank a lot?" I asked abruptly, desperate to crowd out my shame-ridden thoughts.

Vincent tilted his head, considering. "More than some, not as much as others."

"Did you see him last night? Was he drunker than usual?"

Vincent hesitated. "Maybe. But it's not as if it was usual for Bruno, it wasn't every night or even every week. He wasn't an alcoholic, not at all." This didn't square with Anouchka's take on Bruno's drinking, and I wondered why there was such a difference between them. If I raised it, though, that would reveal we'd been asking questions more than casually, and might prompt his wondering why.

"What kind of boss was he?"

Vincent smiled painfully. "Bruno was the best. Everyone loved him. That's why they're keeping a stiff upper lip now. He loved Club Med. He loved Serenity. And we would never let him down. The GOs are 'messengers of happiness.' That's what our handbook says, and it's true."

Before I could ask another question, Vincent said, "It must have been very difficult for you, discovering him. What brought you there?"

Stefan answered. "We wanted to take a swim."

"You're not supposed to when there's no lifeguard on duty."

"Is there one now?" Stefan asked him.

"Of course," Vincent nodded. "Me."

I wasn't sure that sitting with his back to the pool was adequate lifeguarding, but I didn't think it was my business to tell him.

"Was it just you? Just you two?" Vincent asked.

"Until the GOs came, yes." I studied his face, trying to figure out what he was after, because it seemed certain now that he'd joined us with some kind of agenda. Then the answer seemed to emerge because he thanked us. "I'm glad you haven't been telling everyone about last night," he said. How did he know—were we being watched? "It's very sad, very disturbing, but it is our responsibility to make sure that you, the GMs, have the best possible vacation."

"Messengers of happiness?" I offered. Vincent nodded enthusiastically.

Before the conversation could develop further, Claire de Jonge emerged from the pool, shook water out of her ears, and sashayed back to her chair as if she were modeling that tiny, tight, bright yellow bathing suit. She yanked off the bathing cap and beamed at Vincent, gave him a throaty hello, then donned sunglasses and lay back in her chair with an Audrey Hepburn insouciance, which was undercut by large, round breasts that barely moved, advertising their augmentation. Vincent gave her a quick but thorough once-over as if he were doing an identity scan and he took himself off to sit at the head of the pool, after thanking us again.

"Nice boy," Claire said. "There are a lot of nice boys here." She added silkily, "As I'm sure you've noticed."

I couldn't figure out if it was a put-down, a joke, or what. I hadn't spotted any other male couples here, so I guess that Stefan and I stood out of the crowd whether we wanted to or not. I decided to ignore her remark.

"Is this your first time here?" I asked.

She did something between a laugh and a grunt that wasn't very attractive, but I don't think anyone had ever had the nerve to tell her.

"We come to Serenity every year, me, Daddy, my husband, and sometimes Daddy's assistant." She waved airily. "We used to own all this. All this land," she specified. "Our family."

She paused and I said, "Wow," which I think is what she expected.

At any rate, she went on. "But then the taxes got too heavy, or there was a hurricane, or something happened and they had to sell the property."

For someone who was fiercely proud of her family tree and her historic home back in Michigan—according to her husband—she seemed very cavalier about the facts. I would have expected a veritable tour-guide spiel.

"Does it bother you to see all these people traipsing around on your history?" I asked.

"Why should it?"

I was trying to get a rise out of her, hoping she would say something while her guard was down or at least taking a break. "That house." I pointed. "It's yours, it could have been, anyway."

She shrugged. "We have a summer house on Mackinac Island, and another on Sanibel. Who needs one down here?"

Stefan raised his eyebrows at me, as if to say, Drop it, you're not getting anywhere, "Have you met Bruno before?" I asked.

"He's new this year," she said complacently, stretching one gleaming leg out, then the other. Her toenails gleamed with aquamarine polish. If Anouchka resembled a lean and vigorous athlete, Claire had the languor and smooth body of a concubine. "But he's a lot of fun. That torch song last night. Delicious."

I exchanged a glance with Stefan, who mouthed, "She doesn't know he's dead." I was also thinking she wasn't very bright. But more importantly, I couldn't believe that indolent Claire de Jonge had been involved with her father and Heath Wilmore in anything inimical to Bruno. Heath and Franklin Pierce, yes, they could have been plotting and planning something. But I just couldn't see her knee-deep in some kind of "conspiracy," as her husband, Peter, had suggested to

me on the beach yesterday afternoon and back in Michigan, where he had intimated darkly that there was a connection between Neptune—and by extension Heath, Claire, Franklin—and all the strange happenings on SUM's campus. So if Peter was full of shit about his wife, why? I needed to talk this over with Stefan—and soon.

Chapter Twenty

IT WAS starting to get too hot for me out there anyway, so I suggested going back to our room to change for lunch.

Claire wriggled her shoulders luxuriantly as if there would be more sunshine for her now that we were leaving, and she murmured something that might have been *"Bon appétit."*

We left, and I had the uncomfortable feeling that Claire was eyeing me with disdain, though that may just have been my paranoia. Once past the hedge, Stefan said, "What a bitch. She's like a bad 'Dynasty' rerun, but that might be a tautology."

"Sure, she's nasty, but look at her father."

Stefan convinced me we could just take in lunch even sweaty (as I was) and oily (as he was), so we put our shirts back on and headed where everyone else was going: the bar and the dining hall. As we approached, I saw last night's bartender and when I made a bee-line for him, I could see from the look in his eyes he knew both that Bruno was dead and that Stefan and I had found the body. He didn't exactly draw back as if we were contagious or bad luck, but he held himself much more stiffly than before and he didn't smile.

"What can I get for you?" he asked. He was civil, but not friendly.

"Did you see Bruno last night?"

"I see him most nights, if I'm on."

"Was he drinking?"

The bartender shrugged and looked around as if hoping one of the crowd heading into lunch would interrupt us by ordering a drink.

"Was Bruno an alcoholic?"

Now he looked angry, and I was sure it was only my being a guest that kept him from telling me to go screw myself.

"I don't gossip about no staff. I don't gossip about nobody."

"It's not gossip, he's dead."

He shook his head warningly. Voice low, he told me, "Bad talk is still bad talk. And whether Bruno drank too much or no, they say it wasn't any amount of drinking, it was the ghost that led him there to that pool and pushed him in." He nodded like a judge pronouncing sentence.

"Why?"

"He wanted to steal Her secrets, is what I hear. And he lived in Her house when he shoulda stayed in a bungalow like all the other *chefs de village* before him."

Stefan had wandered off and was waiting for me at the doors through which dozens of people were streaming with as much excitement as if they hadn't eaten breakfast that day or any other meal all week. I couldn't continue asking questions, because Franklin Pierce strode up to the bar and demanded a vodka martini (how many had he had today?). He was dressed like a mogul: beige cashmere sweater, white silk pants, and Gucci loafers.

When his drink came and was paid for, the bartender busied himself far away from both of us, and I gestured to Stefan to go on in and I'd follow.

"You're from Michigan?" I said to Pierce.

He looked in my direction, if not exactly at me. He nodded and drank some of his martini.

"Don't you have a house in Neptune, a Greek Revival house? Really beautiful?"

He didn't respond to the flattery, just cut his eyes at me and asked how I knew.

"I did a house tour there once." I was making this up, of course.

"I don't remember you," he said, and it sounded like a warning. "And I don't know why you're talking to me."

The bartender chuckled, standing over by a display of pretzels and chips.

"I don't like fruits," Pierce went on, downing his drink and waving wide-armed to welcome Peter and Heath. "Come on," he said, "I'm starved, and the air is better inside. Where the hell is my daughter? Is that wench late again?" He laughed.

Peter and Heath both glared at me as they passed and the trio went on into lunch. Peter was explaining about Claire and Pierce was evidently complaining about me, because he said, loud enough for me to hear, "Christ, you can't go anywhere without running into fags."

When I looked up, the bartender seemed abashed by Pierce's ugliness and his eyes had softened. "A lot of them that come here are like that one," he observed. "Big shots. Gotta put people in their place. What they think is their place. I see it all the time." He walked over and leaned toward me. "Okay, now, why you want to stir up trouble when the *chef de village* is dead? He had a bad end. You can't change it. Let it be."

I was on the point of telling him that I may have inadvertently ensured Bruno's end by not jumping into the pool as soon as I saw him floating there, but I was too ashamed, so I slunk off to lunch. The food was half as lavish as dinner, half again as sumptuous as breakfast, and I found myself longing to just gorge on the white chocolate bread and coffee, as if I were an angry, frustrated pre-teen unable to express my emotions in any other way. But Stefan signaled for me to come over to a corner table, where he had already set down plates for us brimming with fresh seafood and fruit. "If we're going to overeat," he said, "at least it can be healthy food." But of course there was also a bottle of rosé, and I poured a glass while filling him in on my adventure at the bar. Stefan looked by turns surprised and furious.

"I could take him," Stefan said, face red from having slugged back a tumbler of wine.

"Whoa! Sea air is supposed to make people relax, not turn them macho."

"Don't joke about it. He's despicable. I just hope he tries that shit on me."

I shushed Stefan, because he was getting as loud as someone on a cell phone in an airport, and people at neighboring tables were looking over.

"Forget brawling. We have to figure out this drinking thing," I said, glad no one had joined our table yet, though the crowds kept streaming in and tables were filling rapidly. "Anouchka says one thing, Vincent something else, and the bartender's kind of in the middle."

"Okay, why does it matter?"

"Because I feel like things are out of focus somehow, that something doesn't add up."

I couldn't untangle what I meant, and just then Dominique Grosbisous appeared nearby, tray in hand, scouting for a seat. She looked elegant in a black pants suit, with her hair tied back in a loose ponytail. She turned, saw us, and made an elaborate funny face that said, "May I?"

I held out my hand and invited her to join us with *"Je vous en prie,"* and she sat down.

"American?" was her first question, and Stefan grinned.

"I confess."

"Mais votre copain, il a l'air d'un—" She peered at Stefan, but couldn't quite decide what his nationality was. In rapid-fire French, Stefan told her he was American, too, and in a few minutes they got over her praise and his false humility about how well he spoke.

"But we shall speak English, yes?" she said, and her words were as beautiful and clear as diamonds laid out on blue velvet by a jeweler in the first phase of courting a customer. "Especially if Clovis is to be joining us, which might happen. He has the name of a great Frenchman, but speaks not one word. He says French is repulsive, can you imagine? *Il dramatise les choses.* He is melodramatic." She smiled graciously, holding a huge peeled shrimp up to her mouth, toying with it, then biting it in half.

"Was that melodrama last night when he tried to hit Bruno?" I asked.

Dominique shook her head. "His temper, no, that is very real. And dangerous. When he disappeared last night and didn't come back to the room until very late, and this morning I heard that the *chef de village* had drowned, I cursed him: 'You idiot!'" She made murder sound like a faux pas.

"You heard about Bruno?"

"Two GOs, they were speaking in French. Canadian French, but I understood it." She smiled at the joke and I couldn't believe the placidity with which she could imagine her lover was a murder suspect. Was it heartless or was she a terrific actress? And why was I thinking of something else at the time, but unable to pin it down?

"Very sad," she said, surveying her full plate. "He was quite charming. And I was silly to enjoy his flirtation, but Clovis was more foolish to object." She caught us staring at her and started to laugh, gently. "He didn't assassinate Bruno." She used the hyperbole to mock our obvious suspicion. "Clovis passed out somewhere on the beach. You should have seen him—*quelle pigaille!*"

So he was an unholy mess, but nothing she had said exonerated Clovis, whom I had all but forgotten in the previous hours. Just then I saw Heath Wilmore, across the dining hall, edge away from the table where he sat with Franklin Pierce, Peter de Jonge, and other people I hadn't met. He was leaving.

I leaned over to Stefan and whispered that I was going to follow him, and left, assuming that Stefan would find out more from Dominique. I dropped a parting *"Au plaisir"* to her and quit the table to the sound of their overlapping voices in French. Stefan would cover for me beautifully, and Dominique would marvel at his French, whose excellence I hoped would lull her into revealing more.

So Clovis had been missing last night. And drunk. And looked like crap when he got in. I could see him punching out Bruno or just giving him a massive shove that sent him into the pool, perhaps hitting his head on the way down. But if Clovis were drunk, would he have the presence of mind to snatch up a loose piece of stone from the pool's edge and use that as a weapon? Why would he need to,

anyway, given how strong he was? And how did he and Bruno end up at the pool that Bruno avoided? These questions did the spin cycle in my head as I made my way to the main entrance to see if I could spot where Heath was going. Smiling GOs passed me, and everyone appeared to know who I was because the smiles seemed more than familiar.

Heath looked like he was heading back to the bungalows, and there were enough people on every path for me to follow at a distance without seeming obvious, so I set off after him, hanging back, painfully aware that the best I could do if he stopped was duck behind a palm tree like Inspector Clouseau. Yet I felt compelled to follow him because I was sure that he or Pierce or both of them were involved in Bruno's death.

The weather, of course, was glorious, and cast the whole enterprise in a surreal light: murder seemed totally out of place amid the sunshine, the warmth, the steady beat and roll of waves—at least to me. This was an idyll. But wasn't there an Agatha Christie novel called *Evil Under the Sun*? That was a Poirot novel, I thought, but despite being Belgian like that sleuth (well, Belgian-American), perhaps I was becoming more like Miss Marple, able to sniff out evil. There was danger in that, and promise as well if I did leave teaching and followed the path of a private investigator.

I had sped up while chewing on this and had to slow down and keep more people between us. Heath surprised me, though, by veering off in the direction of the pool and the blue house. What was he doing? Then I saw that he didn't head for the hedge and the pool but turned off to the right to go around the front of the house, facing the beach. I hung back but when I crept along the empty path that he'd followed and peered around the blue stucco corner, I couldn't see him. Had he gone inside? How? It was supposed to be locked and I thought only Bruno had a key.

The porch in front of the house was surprisingly floored in weathered gray marble that was inset with large black marble diamonds, and I walked to the door past heavily shuttered windows and a black wrought iron bench whose twin was farther down. The tall

double doors were closed, but what did I have to lose trying them? If someone found me, I'd come up with an excuse or just fall back on the aggrieved American act. The bronze door handle turned easily and I entered without the hinges squeaking.

I was stunned by what I saw, and just barely remembered to close the door behind me. I stood in a twenty-foot-high room that ran almost the length of the house and it looked like a private fantasy, some nobleman's gift to a mistress. The white walls and ceiling gleamed from many coats of glossy paint. Green and gold bas-relief vines twined around every inch of molding in sight, all of it reflected in the pale oak floor polished so highly it shone like an ice rink. Three evenly spaced chandeliers were also entwined with carved vines and leaves as if they had grown from the walls and each white sconce and marble-topped console table around the room was similarly decorated. At either end of the room was a fireplace with more sinuous vines climbing the busty caryatids that held up the green marble mantels. It was elegant and enticing, a room for infinite amounts of lounging, though I imagined that the white-and-green Chinese Chippendale–style furniture had been withdrawn by previous owners so the room could be used for dancing. There weren't any paintings on the walls or any bibelots, but the room itself was artwork—no, *artful*—enough. My delight in the decor had temporarily blocked the pursuit of Heath from my mind, but as I stood there in awe, I heard noise from above.

Chapter Twenty-one

I MADE out two doorways at either end of the room. Those on the right seemed to lead to a dining room or pantry on the side of the house where the windows were sealed up, those on my left to a hall and a staircase with steps and banister as polished as the floor. I moved in that direction as slowly and quietly as I could, though if anyone appeared on the stairs there would be nowhere for me to hide and I couldn't make it out the door fast enough. I started to breathe more shallowly, and images of struggling with Heath flashed through my mind, jerky and surreal as an MTV video. Stefan might have thought he could "take" Franklin Pierce, but having seen Heath working his gnarly arms at the gym, I knew he could easily knock me out.

As I approached the doorway whose lintel was wreathed with more of those carved vines, I realized I didn't have to worry about being punched out, because Heath was very busy upstairs. He was humping Claire de Jonge. Her throaty cries of "Harder! Harder!" were unmistakable, as were his equally imaginative grunts: "Take it! Take it! Take it!" Bedsprings were the continuo of their piece, and the acoustics were everything you could hope for, if that was the kind of musical entertainment you liked. Screwing the boss's daughter—what a high for him, for both of them, and what a way to get back at an autocrat.

But why meet here, and how? Then I remembered Anouchka leaving Bruno's office that morning, and then soon after passing something to Heath. Had it been a key? That was likely, but why would she give it to him? What connection was there between them?

I eased myself around the stairs and hid underneath them, back against the wall. Nobody would spot me, and I wanted to hear what they said afterwards. But I had forgotten that they were stealing time from the day to get together, because their congress (their concert?) ended with a rush of porn movie shouts and they were quickly dressed and hurrying down the stairs. "You first," Heath said. "Check to see if the path is clear. I'll follow you."

When they were gone, I had to sneak upstairs to what I assumed had been Bruno's room. There were several doors on this side of a long central hallway, and the first that I picked opened onto a fifteen-by-fifteen bedroom that had clearly been just used. The air smelled of sex, sweat, and perfume and the white chenille bedspread was messily flung across the bed and pillows. The whole room felt stark and forbidding: all the furniture was white laminate—bureau, bed, bookcase, desk, desk chair, armoire—except for a wicker armchair, but even the cushions on that were white. I couldn't help thinking about an idiotic line in one of Michael Cunningham's overwritten novels about a bedspread teaching someone "the patience of whiteness." What I was being taught here was *impatience*: I wanted to hurl things around and violate this barren place. The only color came from the books and photos on the top of the bookshelf. And, when Bruno was there, from his tan, his eyes, his hair. Had this room been designed as a stage set for seduction, something to throw all his charms into high relief?

I searched the room—what else made sense now that I was there? I looked for a diary or journal or letters and didn't find anything. There was no laptop in sight, nothing connected to research—disks, note cards. The book titles I scanned on the shelves were all novels and mysteries, with a heavy dose of Sherlock Holmes and Ngaio Marsh, and Edith Wharton, of course, in English and French. My

own book on Wharton was there, and I confess it gave me a thrill, even though I was trespassing and Bruno was dead.

Amid a welter of framed photographs of Bruno around the world there was one of him in Amsterdam—unmistakable from the canal behind him and the seventeenth-century canal houses. He stood with his arm around Anouchka, whose hair was permed, and they looked like much more than friends.

I backed away from the photos and sat down in the armchair as if pushed into it. I closed my eyes and replayed all my conversations with Bruno and Anouchka. I'd suggested to Stefan at first that there was something between her and Bruno, but this went deeper. Bruno had said he was born in Holland despite his last name, and hadn't he seemed to know an awful lot about Anouchka's artistic talents? They'd obviously been lovers there, but who had followed whom to Serenity, and was it a welcome arrival? Or was it stalking? Hadn't she talked about stalking at dinner with us, complaining about Vincent? Or had we just assumed it was Vincent? Maybe nothing Anouchka told us added up. Bruno had also said she was a TV actress for a while. Maybe the sadness about his death was faked and she had suckered me in. I felt exhausted and dazed.

I opened my eyes with a start as if I'd fallen asleep for a moment, and maybe I had. On the floor near the chair was a French paperback I instantly recognized, the Flammarion edition of Edith Wharton's *The Mother's Recompense* (*La récompense d'un mère*) which I remembered Bruno had said he was re-reading. I knew this edition very well because it had an introduction whose chilling last line called Wharton's story of a strange love triangle a hell without fire, and therefore more infernal. I reached for the book to check the exact French wording of that line and a slip of white note paper with the Club Med logo on it slid out onto the white-rugged floor.

All it said was *"Midnight. Pool."*

But it was signed by *me*: *"Nick Hoffman."*

I could feel my throat drying up. Who had forged my name so well, and why? The note's implications were immediately clear. If there were to be an autopsy and an investigation of Bruno's death,

my being at the pool and this note would point to me as a killer, even if I hadn't drunkenly stumbled onto the scene with Stefan. The murderer was probably hysterical with glee that Bruno's death had turned into a cliché of the mystery novel: the person discovering the body was the actual killer. Had I been set up?

The room felt half its former size and airless. I was feeling like I was in a sauna with the heat turned too high, but I was paralyzed. Think—think—think! I couldn't leave the note—it had my signature—it was exactly my signature. But if I destroyed it, someone might find out somehow. I was trapped.

Though why would anyone find the note? The security chief had closed the book on Bruno's death last night. There hadn't been any signs of turmoil among the staff or ongoing interrogations, and this room looked as if it hadn't seen any visitors but Claire and Heath. Which brought me ineluctably back to Bruno's book. Sure, he had a computer at his office—who didn't? But would he work on a manuscript only there and nowhere else? He would never have any real privacy in his office with so many people arriving and Reception right next door. This room was a perfect retreat.

It was obvious. Anouchka was key. Hell, she *had* a key. She gave it to Heath—there was no other way he could have gotten in. It seemed to lie there before me like a game of solitaire just waiting for one or two more cards to be placed properly. So, what if Anouchka had stolen Bruno's laptop and everything connected to his book about Serenity and the Pierces, and given all that to Heath? I couldn't see how Heath and Anouchka could have teamed up together, but maybe it was nothing more complicated than her overhearing Pierce and Heath talk about Bruno and his book, just as Dominique had overheard two GOs discussing Bruno's demise.

If it was true that Anouchka had stolen things for Pierce, I didn't know why, but maybe it was something as simple as money. Bruno couldn't be bought off because it was his book, yet Anouchka, who was younger and had no investment in his publishing, might not care what happened to the book.

Which would explain why Franklin Pierce had changed plans

and wanted to leave Serenity early. Mission accomplished. Bruno was dead, and the book project was spiked. But there was no way to prove this. I couldn't stop Pierce's plane from leaving and I doubted I'd be able to get into his room the way they did in movies, where people snuck into hotel rooms while chambermaids were making them up. Unless Stefan and I cooked up a scheme together, but there was hardly any time left and Pierce's or Heath's rooms might already have been made up by now.

And what if Anouchka were more deeply involved than I imagined? It came to me then that she was a good possibility for forging my signature. She knew Bruno was wild about Wharton and admired my book, and she had access to the card with my signature, and Bruno said she had an amazing eye and had done engraving. That explained why he'd winked at me at dinner and said he'd see me later. He meant later by the pool, not just a general good-bye.

But what would have made him think I would choose the pool as a place to see him, and why would he imagine I'd want to see him alone? It didn't make sense.

Nor did staying where I was. I decided to take the note with me as evidence, for Stefan at least, and I walked downstairs, my footsteps echoing on each stair and the air getting cooler as I descended, even though the house was air-conditioned.

I realized I might be locked in, and started cursing, but advanced on the door anyway. There was only one lock and it opened as I turned it. I stepped outside and closed the door quietly, trying to act inconspicuous, but it was pointless.

"Hello," Vincent said, coming from the direction of the bungalows. He didn't ask what I'd been doing inside, just eyed me in a silent question.

"Have you seen Anouchka?" I asked.

He smiled, then frowned. "Were you looking for her in there?"

"No."

It was an interesting kind of stand-off. He was a GO and meant to facilitate my enjoyment of Club Med. I was a GM and in a sense his superior, but I felt vulnerable because he'd caught me trespassing.

"You've been very curious," he said, coming closer and taking me by the arm. When I tried to pull away, his grip tightened, and he steered me over to the wrought iron bench and made me sit down while he leaned over me. "Asking Anouchka questions. Asking lots of questions."

"She told you?" The metal felt cool against my back.

He sat down. "She tells me everything." His grip loosened a bit, but he didn't let go. "Just like Bruno told her everything."

"So they were lovers."

"Now and then, but she was very tired of Bruno. She left Holland to get away from him. Too demanding, too special."

"Special?"

He pronounced it then the French way: *spe-shyahl.*

"You mean bizarre," I explained, and didn't ask for details. "But Anouchka said you were bothering her. Stalking, almost."

"Did she? Did she really?" He let go of my arm, and even though I could make out what looked like the outline of a butterfly knife in one of his pockets, I didn't try to run. There were people just the other side of the house, sunning by the pool, and others a few hundred feet away on the beach. I didn't feel Vincent was going to hurt me. He was going to *inform* me. I could feel the pent-up narrative inside him, as if I were in a film scene where the villain regales his captive with the full scope of his villainy. Except I wasn't a captive, and I wasn't sure if Vincent was a villain or not.

He prompted me. "Well, did Anouchka say I stalked her?"

I thought about it, and realized she hadn't, not really. I had simply jumped to that conclusion from the things she said. And now it seemed she was trying to make it seem like she wasn't involved with Vincent, and didn't like him.

"Anouchka can be very convincing, very expressive," he said. "But tell me how you got inside." He gestured at the house. I explained about Heath and Claire and he laughed. "This must have been Claire's idea, since Bruno fucked her there at least once. He takes all his women there."

"And the book?"

"Bruno's book? There wasn't much, but it's gone." He snapped his fingers and made a whooshing sound.

"And Heath Wilmore paid Anouchka to steal it?"

"Very good. Now you want to know about last night? I shall tell you. We knew how much Bruno hated the pool and I thought it would be good to make him go there against his will. But how? A woman? No, because he would be suggesting to meet her by the front of the house instead. So when you arrived, and Bruno was so crazy to talk about Edith Wharton, we picked you."

"But he could have told me about it, or changed the meeting."

"Then we would have tried something else."

"Why?"

"We wanted to scare him. Anouchka did, anyway. Me, I wanted to hurt him."

Vincent was beautiful and crazy, and I confess the combination had me spellbound. "You hit him with the loose piece of stone from the edge of the pool."

He looked at me as surprised and impressed as if I were a psychic who'd told him the name of his third-grade teacher. Then he nodded. "Bruno was very drunk. He fell in. He drowned." Vincent shrugged. "That was a bonus."

If I had been listening with fascination up to that point, now I was horrified at his matter-of-factness.

He must have sensed the mood change, because he leaned forward and spoke with real passion as if to win me over to a cause. "Listen, I could have dragged you into the house and made it look like you fell down the stairs, but I didn't!"

I stopped breathing for a moment and my thoughts were flattened, crushed.

"I wanted Anouchka all for myself," Vincent was saying. "I had her all for myself, until Bruno showed up."

"Aren't you afraid that—"

Vincent headed me off. "Afraid you'll report me? To that asshole Scott? He's the real drunk. But no. You can tell what you wish, to anyone you find, but I have something better." He grinned and

leaned back with all the complacency of Mel Brooks saying, "It's good to be king."

I didn't want to ask, but I did, anyway: "What? What would you say?"

"I'll explain that you've been trying to fuck me since you got here and when I kept saying no, you got very angry and threatened me." He nodded, having figured it all out, whether with Anouchka's help or not, I couldn't tell.

"So that's it?" I said, thinking of the dishonest Angelo in *Measure for Measure* taunting Isabella with "My false will o'erweigh your true."

"That's it." And Vincent strutted off, leaving me feeling as bruised and shocked as if I'd been in a car crash and tossed into a ditch. I understood at last why villains confessed not just in books but in life. The need for violence was over now that he'd gotten rid of Bruno. This was what he had wanted: to humiliate me, to triumph over me with words, with cleverness, with strategy.

Epilogue:

Dark Victory

OF COURSE, none of it was going to seem completely real until I got home a few days later and called Sharon to tell her about it. And so after we were unpacked and the laundry was going and Stefan was sorting his mail, I made some Milano blend decaf and headed for my study.

When she answered, Sharon's voice was clearer than usual and she seemed happy to hear from me—and wide awake. I filled her in on Bruno's death and she was suitably astonished, and full of questions.

"What happened to Vincent?"

"He stole Franklin Pierce's plane. He was a student pilot, Bruno told me that. And he disappeared later the afternoon that he confessed to me, nobody knows where. His plane never landed in Nassau. Pierce went berserk—it took three GOs to hold him down and I thought he'd have a stroke. He was talking about lawsuits. Anouchka wouldn't admit anything to me. I did tell the new doctor that I thought Bruno's death was suspicious, but after he examined the body, he said I should stop watching 'Marcus Welby, M.D.' and 'Quincy.'"

"An older gentleman, I take it?"

"Yes. And not going to rock the boat."

"Vincent wasn't really confident he could shake you off, despite the in-your-face confession."

"I guess not. So he left Serenity."

"And the jet was…?"

"The jet? Oh, I think they said it was a Gulfstream."

Sharon sighed. "I bet it was lovely inside." I assumed she was remembering her glory days as a model and her many rich friends. "And Peter de Jonge?" she asked. "What about him?"

"I told him the things I suspected, and I told him what I knew for sure—that his wife and Heath were having some kind of an affair. He wasn't as shocked as I thought he would be, so I asked him if that was what all the hugger-mugger was about, if all he really wanted was for me to find out for sure that his wife was cheating on him, and talking about conspiracies and connections to the weird stuff at SUM was just his way to get me hooked."

"And…?"

"Well, he didn't deny it."

"He's a rat!"

"Well, it's what private investigators do a lot of, isn't it? Look into possible adultery. I should have figured it out."

"But how could you and Stefan stay on the island, knowing what went on?"

I sighed. "It was beautiful. The beach was perfect, the sky was clear, the food was amazing, the drinks kept coming. It wasn't hard to get used to, for either one of us."

Then I asked how she was.

"I keep chewing on a quotation," she said. "It's a line I read in college in *A Farewell to Arms.*" I waited for her to dredge up the quotation, and it came a bit unsteadily: "'The world breaks every one and afterward many are strong at the broken places.' I hope that's true, Nick." She enunciated carefully, perhaps because she was afraid I wouldn't understand her, or maybe because her hearing was bad. That seemed to come and go.

"But I'm better," she assured me, her voice softer now, almost muffled—as if it were something swathed in cotton batting.

"Really?"

"Well—" She admitted she still felt dizzy from time to time, as if

her brain wasn't getting enough oxygen, especially when she tried the squatting that she was supposed to do rather than bending over. I had seen one of these dizzy spells and it had terrified me. She went pale, had to lie down, and seemed suddenly unreachable behind the wall of fear and confusion. Her doctor had talked about tiny blood clots being the cause, assuring her they weren't life-threatening, just a side effect of the surgery. "Just"!

But even on her good days, like this one, when she felt up to conversation, she still tended to feel fogged in.

"It's almost like being depressed, but I know it's physical now, not emotional."

"What does your doctor say?"

"Nothing helpful. When I said that coming back to myself from the surgery seemed slow, he got very offended. He told me, 'My patients always recover quickly.' You know what neurosurgeons are like—God in those Renaissance paintings, in a cloud surrounded by adoring angels. How the hell do I have the nerve, a mere mortal, to question him? But I really shouldn't complain," she hurried on, obviously not wanting to linger on her condition, and seeming to gain strength with each passing sentence. "My health is boring."

"It's not boring to me, not at all, no way, no how."

"That's kind."

"It's not kind, honey, it's *true*."

"Thanks." She abruptly changed the subject: "Nick, I'm thinking of becoming a vegetarian." She sounded almost cheerful.

"Really?"

"I look at food and it just doesn't seem attractive anymore, and I think of where it came from. It seems awful."

"Maybe it's just the surgery and the anesthesia not having completely left your system that's making you feel like that. You know what would be *really* awful would be running down your food like you were a cheetah on one of those nature specials, felling it, grabbing onto its neck until you smothered it to death and then ripping bloody chunks out of it while it was still warm. At least we're more evolved in how we get our food. We go to the supermarket."

"That's something to be grateful for," she said dryly. "Thanks for the reminder."

"How are your folks?"

"You know what? My parents have been great. They're here just enough, but not too much. And the people at that synagogue I joined on the West Side? They've been amazing—people bring over food, ask if I need shopping done."

"Any cute guys?"

"For you?"

"No, silly, for you."

"Oh, I'm a real catch right now. I look like Quasimodo and I feel like *Guernica*, so the last thing I want is a boyfriend who pities me. But the rabbi's not bad...."

"You go, girl!"

"This girl is going very slowly."

"Well, I may be able to spend more time with you."

"Really? When? How?"

I explained. And explained. And explained.

"Oh, sweetie," she breathed more than once. "I wish I were there."

"To see Chapter Twelve of the Rise and Fall of Nick Hoffman close up?"

"No, no, no. To give you a hug, and bake some cookies, though you'd have to put them in the oven since I can't bend down. We could sit up all night, well, all night for me, which nowadays is until ten—"

"And solve the world's problems."

"Uh-huh. Most of them, anyway. Now tell this to me straight, Nick. You've been in trouble with your department before, and told me it was the end, your career was over, they were going to drum you out of academe. Is this really as bad as you think?"

I gave the question as much consideration as if she were Regis Philbin asking, "Final answer?" and a quarter of a million dollars were at stake. "It is. My new chair thinks I'm hostile and snide. He dislikes my attitude."

"Okay, let's assume the worst and look down the road. You don't get tenure and you go without a fight. What will you do? You probably don't want to come back to New York, do you? Though that would be heaven for me."

"I'd love it, too." I sighed, thinking of all the time we could spend together, imagining the talks, the quiet lunches, the slow and healing walks, the eventual swimming that she would be able to do with me. But returning to New York would also mean seeing my parents more often, and despite my age, my degrees, my bibliography, and my years of living away from home, defending my sense of myself as an adult against them on a daily or even weekly basis would make me feel like one of those beachfront communities endlessly dredging up more sand to fight the erosion of storms and hurricanes. When I told them I was taking a job in Michigan, they had responded with as much alarm as if I'd said I was planning a boat trip up the Nile and would fly the Israeli flag en route.

"Can you look for a job somewhere else in Michigan, teaching?"

"I could probably pick up some classes at a community college."

"You don't sound enthusiastic."

"I'm not."

"But what do you want to do, sweetie? Would you spend more time up north at the cottage?"

"No, I'd want to get further away than that. I'd love to go back to Mackinac Island."

She sighed. "I still have the beautiful postcard you sent me of the porch at the Grand Hotel—well, I have all your cards and letters. I can't remember what was so famous about it, though. Wait. It was Victorian, and there were lots of columns, right? Oh, and geraniums. Tons of geraniums. See? My mind works, eventually."

Any time now that Sharon had trouble remembering something—trouble that was perfectly normal given that she wasn't in her twenties—she ascribed it to her surgery, and it felt far too frightening—like the beginning rumbles of a landslide.

In my best Tourist Bureau voice, I said, "The Grand is the largest summer hotel in the world, with the longest porch." But I wasn't

really mocking those legitimate claims. I could picture sitting there a few summers back with Stefan in white wicker rockers, looking out past the bright red geraniums in their forest green-and-white Chippendale-style planters to the miles-long span of the Mackinac Bridge connecting Michigan's two peninsulas, arching over the spot where Lake Michigan and Lake Huron met. There were no cars allowed on the island and as ever-present as the sound of gulls was the jingling of reins and the steady *clop-clop* of horses leading carriages and wagons up and down the narrow nineteenth-century streets. The food at the Grand was lavish, the pace serene, the setting hypnotic.

"What would you do up there?"

"I don't know. Eat fudge? Bike around the island?"

"You'd need that if you kept eating the fudge."

"You could come with us. You'd knock 'em dead walking into the dining room at the Grand. People have to dress for dinner and there wouldn't be anyone as gorgeous as you. You in Chanel—wow! And they have an amazing wine list."

"Oh, yes. I'd look wonderful drinking Château Latour with a straw. I may always have to drink things with a straw." If the left side of her face never came out of its temporary paralysis, she meant. And though it was not the most terrible fate, perhaps because straws made you think of milkshakes and being young, it was a sign of other potential compromises.

"We'd tell everyone you're some eccentric countess."

"Sweetie, they'd see my face and they'd know—but it's a great fantasy."

She was right, that's all it was, since the last thing Sharon wanted to do anymore was be looked at, given how horrified she was by the stiffness on one side of her face, a face that had belonged to a model. But she didn't seem to mind my attempt to entertain her.

"I wish hats with veils were in. People from my synagogue want me to come to the Hanukkah party but—"

"If you wear one, it'll be in."

"Nick, those days are over. Back when I had a perfect figure and you thought teaching was fun."

"You look great, and I still love teaching, it's everything else connected that drives me crazy."

"But that's part of the package, isn't it?"

I told her that I had thought about taking courses in Criminal Justice and becoming a PI of some kind.

"Nick, I don't think you can count on suspects confessing the way Vincent did. And don't you think it might be dangerous?"

"Oh, jeez, I have no idea."

"You sound so Michigan! 'Oh, jeez.' I love it."

And then I told her about my visits to a local gun shop with Juno Dromgoole because I'd been contemplating buying a gun.

"Are you shocked?"

"Nick, I've had a surgeon messing around with my *brain*. Nothing can freak me out anymore. And I'm glad you went to a firearms boutique, from the sound of it, as opposed to Guns R Us, though even that would be better than stealing one. With Juno around I could see the two of you breaking into a gun shop like Arnold Schwarzenegger does with that cute girl in—"

"Commando?"

"That's the one. Don't they steal missile launchers and berets?"

"You're making up the part about the headgear."

"Possibly. But to tell you the truth, Nick, even if you said you wanted to be a mercenary, or join the Foreign Legion—is that still around?—I wouldn't get too concerned. You're always complaining that Stefan's French is better than yours, so it would be good practice, wouldn't it?"

"Sure—I bet they use the subjunctive all the time and read Proust when they're not on a mission."

"Proust and the desert sounds like a good combo to me."

"It sounds too complicated. And you know what that guy says in *The Blue Dahlia*, don't you?"

She relished film noir as much as I did, and I could hear the delight in her voice. "No, what?"

"Something like, 'When your life gets too complicated, you get unhappy, and when you get unhappy, your luck runs out.'"

"Wasn't Lizabeth Scott in that one?"

"I'm not sure. I'm teaching a mystery course next semester and I still have trouble keeping the names straight of those sisters in *The Big Sleep*, so don't ask me."

"Maybe it was Veronica Lake? I could do that, grow my hair long and wear it down over one side of my face."

Before I could reassure her that it wouldn't be necessary, she said, "Now, sweetie, I want to say something. If you ever need help? Financially? Please, ask me. Anything. It's all going to be yours anyway."

"What do you mean?"

"You're in my will," she said unostentatiously. "The apartment, and pretty much everything else. You're closer to me than anyone— you know that."

"Don't talk about wills!" I didn't want to think about endings—I wanted to always imagine us young and hopeful, Sharon in her twenties appearing on more and more magazine covers, impossibly beautiful, and me on my own college years' voyage, reeling with drunken delight from one newly discovered author to another, as dazzled by Lawrence Durrell and Anaïs Nin and Virginia Woolf and James Baldwin as a visitor to Florence gaping at the *David*, the Duomo, and the glories of the Uffizi Gallery.

"There's more. I'm going to be sending you a medical power of attorney to sign and send back. After my parents, you'll be listed next. I want somebody I love to be making those decisions."

"Sharon!"

"I should have done it before the surgery, but—"

"Why do you need it?"

"Nick, just because I survived the surgery doesn't mean that I'm safe, that it's all over now—the worrying, I mean. We can't ignore reality. "

"Says who?"

Sharon didn't argue, but I knew she would come back to the topic when she was ready, whether I was or not.

"I wish I could take a leave of absence and stay with you," I said.

"Oh, sweetie—you would get sick of it." She sounded much more energetic.

"Yeah, right!"

"Sick of me—I'm not much fun now."

"I could read to you. Big fat books nobody ever gets to read, but hopes to some day. Like, *War and Peace* or *Clarissa*—"

"That's a definite mood elevator."

What cheered *me* up was picturing the cool, playful beauty of Sharon's apartment, and knowing how much she loved it. I know meditation experts tell you to picture water flowing over a rock, or waves on a beach, but picturing Sharon's East Side apartment was what sent me to a place of rest.

The entry hall was floored and walled in rose marble (very flattering for the complexion, Sharon had noted), mirrors reflecting the stone back from the ceiling. There were mirrors everywhere, in fact, in the lavish black-and-white Deco bathrooms, even in the ultra-modern kitchen above and along the counters, where other people would have had tile or granite. The whole two-bedroom apartment was full of light. But the sheen, the perfection were playfully broken up throughout by teddy bears on the Victorian chaise, a ten-foot-long stuffed silk dragon hanging from the living room ceiling, wind-up dogs, antique trains and cars jostling with family photographs in wacky frames on top of the upright piano whose wood was a veritable explosion of carved fruit and leaves and urns.

It was an apartment of delightful surprises, full of slyly amusing neon sculptures in the most unexpected spots. And you'd sit in a chair looking out at the Fifty-ninth Street Bridge and glance down to find three carved swans reflected in the black-stained floor that was so shiny it was like a lake. Or one day you'd notice a colorful Woolworth's alarm clock stuffed into an open silver drawer.

The only sign of her former career was the richly framed and brocade-matted photo of her over the ebony mantelpiece. It was my favorite, from *Glamour*, in which she was wearing a lilac silk portrait-collared dress that made her look like someone Sargent would have painted: rich, assured, and supernally beautiful. Whenever I

called her, I tried to think of that photograph, in that apartment, and it calmed me.

Did it calm her now, or was it depressing? Would she take it down? Even though she hadn't gone overboard on plastic surgery and somewhat calmly accepted getting older and losing her striking looks—or at least having them become blurred, smudged by time—disfigurement was something much harsher. If her damaged "seventh" nerve didn't regenerate entirely, she would never have full mobility on one side of her face, never look quite balanced and normal.

"You know something?" Sharon said, her voice fading. "When it started, when I started seeing the doctors, one after another, I never wondered why it was happening to me, or got mad at God or anything like that. I didn't feel picked on, you know? But I did wonder why it couldn't have happened when I was younger, and prettier, and had more time to…"

"To what?"

"More time to feel that I had more time."

ACKNOWLEDGMENTS

Serenity is loosely based on several wonderful Club Med resorts in the Caribbean. However, I've taken some liberties with Club Med operating procedures, and of course, this is a work of fiction and the characters and situations in this book are not in any way based on actual individuals or events.

I owe a big debt of gratitude to a number of real Club Med staffers and administrators who were very helpful in my research for this book. Nadeige Martelly was a consistent, cheerful source of speedily delivered information in response to a flood of questions. My thanks go as well to Anita Chakrabati, Daniel Aucoin, Julien Cartigny, Valerie Bihet, Jo Moore, and Kevin Batt for their time, and most especially Philippe Bourguignon, Club Med's former CEO, without whom this book could not have been written.

Comme toujours, merci mille fois à Gersh.

Gersh Kaufman

ABOUT THE AUTHOR

An escaped academic, and author of fourteen other books, Lev Raphael is the "Mysteries" columnist for the *Detroit Free Press*. An award-winning novelist and essayist, he has reviewed for NPR, the *Washington Post, Jerusalem Report, Boston Review,* and other publications. He lives in Okemos, Michigan and welcomes visitors and e-mail at www.levraphael.com.

MORE MYSTERIES

♨ FROM PERSEVERANCE PRESS ♨
For the New Golden Age

Available now—

Death Duties, A Port Silva Mystery
by Janet LaPierre
ISBN 1-880284-74-X
The mother-and-daughter private investigative team introduced in *Keepers*, Patience and Verity Mackellar, take on a challenging new case. A visitor to Port Silva hires them to clear her grandfather of anonymous charges that caused his suicide there thirty years earlier.

A Fugue in Hell's Kitchen, A Katy Green Mystery
by Hal Glatzer
ISBN 1-880284-70-7
In New York City in 1939, musician Katy Green's hunt for a stolen music manuscript turns into a fugue of mayhem, madness, and death. Prequel to *Too Dead To Swing*.

The Affair of the Incognito Tenant, A Mystery With Sherlock Holmes
by Lora Roberts
ISBN 1-880284-67-7
In 1903 in a Sussex village, a young, widowed housekeeper welcomes the mysterious Mr. Sigerson to the manor house in her charge—and unknowingly opens the door to theft, bloody terror, and murder.

Silence Is Golden, A Connor Westphal Mystery
by Penny Warner
ISBN 1-880284-66-9
When the folks of Flat Skunk rediscover gold in them thar hills, the modern-day stampede brings money-hungry miners to the Gold Country town, and headlines for deaf reporter Connor Westphal's newspaper—not to mention murder.

The Beastly Bloodline, A Delilah Doolittle Pet Detective Mystery
by Patricia Guiver
ISBN 1-880284-69-3
Wild horses ordinarily couldn't drag British expatriate Delilah to a dude ranch. But when a wealthy client asks her to solve the mysterious death of a valuable show horse, she runs into some rude dudes trying to cut her out of the herd—and finds herself on a trail ride to murder.

Death, Bones, and Stately Homes,
A Tori Miracle Pennsylvania Dutch Mystery
by Valerie S. Malmont
ISBN 1-880284-65-0
Finding a tuxedo-clad skeleton, Tori Miracle fears it could halt Lickin Creek's annual house tour. While dealing with disappearing and reappearing bodies, a stalker, and an escaped convict, Tori unravels the secrets of the Bride's House and Morgan Manor, which the townsfolk wish to hide.

Slippery Slopes and Other Deadly Things,
A Carrie Carlin Biofeedback Mystery
by Nancy Tesler
ISBN 1-880284-64-2
Biofeedback practitioner/single mom/amateur sleuth Carrie Carlin is up to her neck in snow, sex, and strangulation when her stress management convention is interrupted by murder on the slopes of a Vermont ski resort.

REFERENCE/MYSTERY WRITING
How To Write Killer Fiction:
The Funhouse of Mystery & the Roller Coaster of Suspense
by Carolyn Wheat
ISBN 1-880284-62-6
The highly regarded author of the Cass Jameson legal mysteries explains the difference between mysteries (the art of the whodunit) and novels of suspense (the hero's journey) and offers tips and inspiration for writing in either genre. Wheat shows how to make your book work, from the first word to the final revision.

Another Fine Mess, **A Bridget Montrose Mystery**
by Lora Roberts
ISBN 1-880284-54-5
Bridget Montrose wrote a surprise bestseller, but now her publisher wants another one. A writers' retreat seems the perfect opportunity to work in the rarefied company of other authors...except that one of them has a different ending in mind.

Flash Point, **A Susan Kim Delancey Mystery**
by Nancy Baker Jacobs
ISBN 1-880284-56-1
A serial arsonist is killing young mothers in the Bay Area. Now Susan Kim Delancey, California's newly appointed chief arson investigator, is in a race against time to catch the murderer and find the dead women's missing babies—before more lives end in flames.

Open Season on Lawyers, **A Novel of Suspense**
by Taffy Cannon
ISBN 1-880284-51-0
Somebody is killing the sleazy attorneys of Los Angeles. LAPD Detective
Joanna Davis matches wits with a killer who tailors each murder to a
specific abuse of legal practice. They call him The Atterminator—and he
likes it.

Too Dead To Swing, **A Katy Green Mystery**
by Hal Glatzer
ISBN 1-880284-53-7
It's 1940, and musician Katy Green joins an all-female swing band touring
California by train—but she soon discovers that somebody's out for blood.
First book publication of the award-winning audio-play. Cast of charac-
ters, illustrations, and map included.

The Tumbleweed Murders, **A Claire Sharples Botanical Mystery**
by Rebecca Rothenberg, completed by Taffy Cannon
ISBN 1-880284-43-X

Keepers, **A Port Silva Mystery**
by Janet LaPierre
Shamus Award nominee, *Best Paperback Original 2001*
ISBN 1-880284-44-8

Blind Side, **A Connor Westphal Mystery**
by Penny Warner
ISBN 1-880284-42-1

The Kidnapping of Rosie Dawn, **A Joe Barley Mystery**
by Eric Wright
Barry Award, *Best Paperback Original 2000.* Edgar, Ellis, and Anthony
Award nominee
ISBN 1-880284-40-5

Guns and Roses, **An Irish Eyes Travel Mystery**
by Taffy Cannon
Agatha and Macavity Award nominee, *Best Novel 2000*
ISBN 1-880284-34-0

Royal Flush, **A Jake Samson & Rosie Vicente Mystery**
by Shelley Singer
ISBN 1-880284-33-2

Baby Mine, A Port Silva Mystery
by Janet LaPierre
ISBN 1-880284-32-4

Forthcoming—

Face Down Below the Banqueting House
by Kathy Lynn Emerson
Shortly before a royal visit to Leigh Abbey, home of sixteenth-century
sleuth Susanna Appleton, a man dies in a fall from a banqueting house. Is
his death part of some treasonous plot against Elizabeth Tudor? Or is it
merely murder?

Evil Intentions
by Denise Osborne
Wealthy socialites and a group of recovering substance abusers benefit
from Salome Waterhouse's Feng Shui practice. When one of them, the
former fiancée of Salome's nemesis, Duncan Mah, finds a body on her es-
tate, Salome becomes embroiled in a world of evil intentions.